Little Sister

Little Sister

MY INVESTIGATION INTO THE MYSTERIOUS

DEATH OF NATALIE WOOD

Lana Wood

with Lindsay Harrison

DEY ST.

An Imprint of WILLIAM MORROW

DEY ST.

LITTLE SISTER. Copyright © 2021 by Lana Wood. All rights reserved. Printed in the United States of America. No part of this book may be used or reproduced in any manner whatsoever without written permission except in the case of brief quotations embodied in critical articles and reviews. For information, address HarperCollins Publishers, 195 Broadway, New York, NY 10007.

HarperCollins books may be purchased for educational, business, or sales promotional use. For information, please email the Special Markets Department at SPsales@harpercollins.com.

FIRST EDITION

Designed by Paula Russell Szafranski
Interior art © Renaissance Art / Shutterstock.com

Library of Congress Cataloging-in-Publication Data has been applied for.

ISBN 978-0-06-308162-8 (hardcover)
ISBN 978-0-06-321422-4 (international edition)

21 22 23 24 25 LSC 10 9 8 7 6 5 4 3 2 1

FOR NATALIE.

I smile because you are my sister,
I laugh because there is nothing you can do about it.

—Unknown

A DREAM OF NATALIE

I was walking through a forest dense with a variety of trees.

Every inch of ground was covered with fallen leaves, and no earth was visible . . .

I looked up from the path and saw Natalie sitting on the ground, her legs drawn up and her arms around her knees. She looked upset, and kept pulling on the small sparrow-like brownish wings on her back. I told her to stop as they would soon grow into beautiful white wings for her.

She looked at me . . . And I woke up.

Little Sister

INTRODUCTION

On the morning of November 29, 1981, movie star Natalie Wood was found off the coast of Catalina Island, drowned after a tumultuous Thanksgiving weekend cruise aboard a yacht called *Splendour*. With her on that cruise were the yacht's skipper, Dennis Davern; her friend and *Brainstorm* costar Christopher Walken; and her husband, Robert "R. J." Wagner.

Like most people, I couldn't believe the news until I saw it on television. Natalie was my big sister and my best friend, and I'd grown up following in her footsteps and watching her on the big screen. The shock of losing her so suddenly and the relentless grief of learning to live without her were indescribable. And to lose her in dark water, the one thing in this world that terrified her all her life, made her death seem even more cruel.

I couldn't make sense of her loss, and I turned to R. J. for

answers. After the funeral I asked him what happened to my sister, and he would only say: "It was an accident, Lana."

L.A.'s renowned "coroner to the stars," Dr. Thomas Noguchi, officially declared Natalie's death an "accidental drowning."

The Los Angeles County Sheriff's Department closed the case after two weeks.

I accepted the "accident" explanation because that's what "they" said; because it was all I had; because I wanted to; because it hurt too much to *not* accept it and to let it enter my mind, even for a moment, that maybe it wasn't an accident after all. Of course, I wondered how the accident happened, but R. J. didn't care to discuss it, and I had no one else to ask. Besides, in the end, knowing how it happened wouldn't bring back my sister, and ready or not, my life had to go on.

I was the single mom and sole supporter of a seven-year-old daughter at the time, and the only remaining child of a widowed mother I'll politely call eccentric. Trying to balance my grief with caring for them and maintaining a career so I could support us, while simultaneously sorting through a tsunami of interview requests and the usual Hollywood rumors, was . . . overwhelming. It seemed as if every day a new book or article or tabloid headline about the life and death of Natalie Wood was hitting the newsstands. I couldn't begin to keep up with them, nor did I want to. It was an accident. She was gone, she shouldn't have been, and the pain was almost unbearable. What more was there to say?

Still, I kept wanting to reach out to R. J. We had never been close, per se, but we were family; I felt we should have been grieving together and comforting each other. And then, when he was ready to talk about it, he could finally tell me what happened to Natalie that night, and I could stop lying awake imagining a thousand different scenarios that ended with three able-bodied men

alive and well on the *Splendour* and my sister lying dead on the coast of Catalina.

But R. J. quickly made it apparent that not only did he want nothing to do with me, he'd come to think of me as an enemy. I couldn't understand it. It hurt, a lot, and it only added to my confusion, so I went on trying to mend that fence and doing what I needed to do to care for my family.

Natalie was never, ever far from my mind. I circled around thoughts of not just how she died but also how she lived: countless memories of us together, some of them precious, some of them not so much; the times we laughed together; the times we cried together; the times we were mad at each other like sisters but loved each other too much to let it last; the times she was my hero, my protector . . . The realization kept hitting me over and over again that if the situation were reversed, if I'd gone away for a weekend and not come back alive, she would never have tolerated not knowing. She would have moved heaven and earth to get to the bottom of what happened, for her own sake and for mine. I owed her the same, but I felt powerless, and on top of that, I didn't know where to begin.

Then one day, ten years after Natalie died, I got a phone call from out of nowhere that slowly but surely changed everything . . .

At this point, I've lived for forty years without Natalie, which is more time than I got to have with her. Four decades of major life milestones, of happiness and sadness, and through it all I've wished I could see her growing older beside me.

Now, in my seventies, I know that my traditional fallback position—my "go along to get along" approach to life—won't suffice. For too many years I didn't feel I *could* get involved, out of fear that I had nothing to contribute, no way to break through the deafening tabloid noise. I was also terrified of the possible

repercussions of digging deeper when everyone seemed to be saying there had been no foul play, that it truly was an accident.

Telling this story is the bravest thing I will ever do. It's the best way I can think of to honor Natalie's legacy, tell the unvarnished story of our lives, and uncover the truth behind that fabled night on the *Splendour*.

1

"It couldn't be Natalie."

t was the night of November 28, 1981, and I couldn't sleep. I had this vague, icy feeling that something, somewhere, was wrong; I just had no idea what it was. So my mind was racing around all over the place trying to find that fire I needed to put out.

It couldn't have been my daughter, my only child, seven-year-old Evan. She had been sleepy and content when I put her to bed an hour ago.

Mom had been staying with us for a while, and she was okay when she went scuffing off to her room shortly after dinner. She'd been fairly fragile since Dad had died a year earlier. Then again, "fragile" had always been one of her comfort zones. Mom had a beautiful condo to live in for the rest of her life, compliments of my sister, Natalie. Natalie and I had been taking turns moving her in and out as she grew increasingly unstable and in need of support.

Money. Maybe that was it. God knows, I'd lost plenty of sleep about money over the years. Six marriages, and not a single dime of alimony, ever. (Is there a word for "the opposite of gold digger"?) Now I was a single mom with a little girl to take care of, with an

occasional $150 a month of child support from her father, Richard Smedley, which would have been plenty if Evan had been a gold-fish. But he was living in Texas with a new wife and kids by then.

I'd given up on my acting career, or my acting career had given up on me, after my last movie, a complete mess of a horror film called *Dark Eyes,* or *Satan's Mistress,* or *Demon Rage.* (The producers kept changing the title, as if that were the problem.) Thanks to a lot of persistence, a lot of phone calls, and a lot of friends in show business, I'd transitioned into a project development job for producer Ron Samuels, who was married to Lynda Carter, star of the hit *Wonder Woman* series. It was a good job, challenging and demanding. It was also a much-needed steady paycheck. So no, at least that night, it wasn't money that was keeping me awake with this awful sense of undefined dread.

It couldn't be Natalie. She was away for a weekend that sounded like a press agent's dream headline: Natalie Wood, her husband (for the second time) Robert "R. J." Wagner, and their guest Christopher Walken, Natalie's costar in the almost completed film *Brainstorm,* off on a three-day cruise to Catalina aboard their yacht *Splendour.* Also on board was R. J.'s employee Dennis Davern, the *Splendour*'s skipper and Natalie and R. J.'s trusted friend. The weather that weekend was cold and windy but not dangerously so, and if anything even *almost* happened to my sister, those three men were right there to take care of her.

Granted, Natalie had been on kind of an emotional roller coaster in the last week or two. She'd called one day to discuss which turkey dressing she should have their nanny/cook Willie Mae make for Thanksgiving dinner, with some vague added comment like, "Assuming I haven't divorced R. J. by then." I honestly didn't give it a second thought. After all they'd been through together, from their first marriage, to an especially ugly

divorce, to a reconciliation and second marriage and the birth of their daughter, Courtney, not to mention work schedules that would have put a strain on any couple's relationship, Natalie's being exasperated with R. J. was hardly headline news. I didn't pursue it, and neither did she.

The more I thought about it, though, there *had* been something odd going on with her at her and R. J.'s house on Thanksgiving. She loved socializing and entertaining, and she was brilliantly effortless at it, always making sure that everyone was comfortable, relaxed, well-fed, and made to feel at home. That night, though, while a dozen of us gathered for a traditional holiday dinner and a lot more friends stopped by to enjoy a glass of champagne, Natalie was all over the place, nervous, unnecessarily tending to candles and the fire in the fireplace, unable to focus on anyone for more than a minute or two before darting off to check on something or someone else. R. J., in the meantime, was wearing his usual "affable host" mask as he tended bar and greeted guests, but there was also a subtle undercurrent of sullenness about him, an occasional flicker of tension, especially when Christopher Walken put in a brief appearance, just long enough to say hello to Natalie and R. J., have a glass of something, and leave. The only time I saw R. J. really enjoying himself was when he was focused on the kids—his daughter, Katie, from his marriage to Marion Marshall; Natalie's daughter, Natasha, from her marriage to Richard Gregson; his and Natalie's daughter, Courtney; and my daughter, Evan, who loved spending time with her cousins. R. J. was a great dad and wonderful with children, I had to give him that.

Overall, though, there was just something uneasy in the air all evening. Maybe even eleven-year-old Natasha felt it. Maybe that was why she ran up to Natalie at one point and begged her not to go away on the boat that weekend, to go some other time instead.

Natalie reassured her that everything would be fine, of course, but there was a strain in her voice. Maybe the cold, windy weather report was giving her second thoughts, or her current frustration with R. J. . . . ?

Or maybe I was reading way too much into a simple out-of-sync Thanksgiving, as if our family had never had one of those before. Maybe I should shift my focus to a beautiful dinner the previous weekend at the Bistro Garden, with Natalie and R. J., me, and my boyfriend at the time, a brilliant stage and television actor named Alan Feinstein, who was leaving the next day for a play he was doing in Connecticut. We were all in a good mood, all happy and hungry and relaxed. The meal was perfect as always, and the conversation was light and easy. By the time dessert was served, Alan and R. J. had settled into a talk between the two of them, typical actor stuff about television and film vs. theater, smart producers vs. idiot producers, anecdotes about various directors and castmates they'd worked with, that kind of thing, which freed Natalie and me to indulge into some long-overdue girl/sister talk. We obviously couldn't follow up on the divorcing-R. J. comment she'd made a few days earlier, with his sitting right there. But they seemed great together that night, so there was probably nothing to follow up on; it was probably exactly what I thought, just one of those passing flashes of exasperation that happen all the time between married couples.

Instead, we wandered into what turned out to be a wide-open, intimate hour I'll always treasure. She'd been putting up an active fight against the ageism that creeps into the life of every actress, that cruel transition from "major star" to "who?" She was excited about *Brainstorm,* adored working with Chris Walken, and was encouraged to be playing the love interest of an actor who was five years younger than she was. When *Brainstorm* finished filming, she

was going onstage to star in *Anastasia,* a play that would open in Los Angeles. She was also forming a production company, not one of those on-paper companies to talk about at cocktail parties but a real live company that would buy, develop, and film projects she could act in, produce, maybe even direct. She was always asking me for book recommendations she could pursue, and there was a Japanese author she loved whose book rights she was checking into.

I was excited for her, and she was excited for me and my relatively new career in production and development, my trying to make a place for myself behind the scenes in an industry I'd known and loved since I was a child. We were both spreading our wings, branching out from our comfort zones, and encouraging each other every step of the way, and it felt nothing short of exhilarating.

Suddenly she put her arms around me. "I love you," she said.

"I love you too," I said as I returned the tight hug, and we cried the happiest tears.

If I'd known it would be the last time we'd ever get to say those words to each other, I would never have let go.

IT WAS AROUND FIVE A.M. ON NOVEMBER 29 WHEN MY MIND FINALLY QUIETED AND let me fall asleep.

So when the phone rang at eight something and woke me up, kind of, it didn't enter my mind to answer it; I just groaned, rolled over, silently cursed whoever was rude enough to call in the middle of the night like this, and started to doze off again. Through my haze I heard Mom say, "Lana, it's Sheri Herman." A good friend since we were in second grade together. Not a great time to catch up.

"Tell her I'll call her later," I mumbled, sound asleep before I finished the sentence.

She kept calling, with only minutes between calls. I answered once, told her I'd been up all night, and hung up. Evan answered once and said I was still in bed. On call number three I was slowly waking up, more concerned than angry now because I'd never known Sheri to psycho-call like this. Mom answered again and, after a moment, let out a long, agonized scream and collapsed on the floor.

I was out of bed like a shot, raced to Mom, and grabbed the phone.

"Sheri, what is it?"

"I'm so sorry, Lana, but I just heard about Natalie."

"What about Natalie?"

"They found her body this morning. Washed up on shore on Catalina."

It was the most ridiculous thing I'd ever heard in my life, and I was in no mood for it.

"No, they didn't. God, this stupid town and its rumors . . . Whoever told you that, it's not true."

"It was on the radio, Lana."

I wasn't having it. "I've got to go," I snapped, and I hung up the phone. Calm as could be, I helped my limp, hysterical, shrieking mom into the living room, made her some tea, sat with her, and pointed out the obvious: "If Natalie were dead, wouldn't we have heard it from R. J.? Or the police? Or even the press? But Sheri Herman? Seriously? Think about it, and stop worrying. Nothing has happened to Natalie."

I believed that, too, to the core of my soul, until I started to make coffee and turned on the news. *Breaking* news, complete with helicopter footage from Catalina Island.

"The body of actress Natalie Wood was found shortly before

eight o'clock this morning after an hours-long Coast Guard search. Pending an investigation, authorities tell us it appears to be a case of accidental drowning . . ."

At that moment, I switched off the TV, and every single part of me switched off right along with it. I couldn't think. I couldn't feel. I'd heard the words, I'd seen an aerial view of a body covered with a white sheet being lifted onto a gurney, but I couldn't begin to process it. Natalie was dead. My sister was dead. But that was impossible, she couldn't be, so how was I supposed to wrap my head around something that was too horrible to even imagine?

And why were all these people suddenly showing up at my house, looking so shocked and distraught and sympathetic? Oh, right. Natalie was dead. Accidental drowning. That must have been it. There were a lot of people! No problem. Natalie would be here any minute to take care of them, probably organize everyone into some of the parlor games she loved . . . Wait, no, she wouldn't. Apparently she was gone. Apparently I would never see her again. Which was crazy. Incomprehensible. But people kept coming, and she kept not being there.

The next several hours—even days, come to think of it—have no continuity at all. My memories of them are nothing but a series of out-of-body moments, as if I strobed my way through them going in and out of consciousness.

More hugs, kisses, and "I'm so sorry"s than I could possibly count, heartfelt and heartbroken. They were meant to be comforting. I knew that. Instead, they just felt like one reminder after another that something was horribly, horribly wrong.

Natalie's and my half sister, Olga, from Mom's first marriage, arrived from Northern California with her husband, Alexi. Evan adored her aunt Olga, but she wasn't around to greet her—she'd

become overwhelmed by this growing, deeply upset stream of visitors and locked herself in her room.

The phone rang nonstop. I had no idea who was calling or who kept answering. Someone asked if we'd heard from R. J. We hadn't. Not a word, all day.

I gave in to an inexplicable compulsion to wash my hair. Who doesn't run upstairs to wash their hair when they have a house full of people?

It was when I was coming back down that I heard Mom shriek to everyone within earshot, "The wrong one died!" Heads turned to look at me for a reaction. I didn't have one. It was an awful thing to say but no big surprise. By all accounts, as Mom was giving birth to me, she'd cried out, "I didn't want another baby!" Her daughter Natalie was already an eight-year-old movie star when I was born, so what did she need with this ordinary, gangly little inconvenience?

Guy McElwaine, a close friend of R. J.'s, was miffed that there was no bourbon in the house, only wine. He and I had a long, complicated twenty-year relationship, and he seemed like someone I could ask. "Guy, have you talked to R. J.? Do you know what happened to my sister?"

"I know exactly what happened to your sister," he snapped back, "but I don't think I can trust you." Then he walked away. My mind was such a blank that it didn't occur to me at the time what a bizarre thing that was for him to say about an accidental drowning.

Suzanne Miller, a lovely woman who watched Evan when I was working, arrived and volunteered to take care of her for as long as I needed her. She was a godsend.

Alan flew in from back east and came straight to my place from LAX. He walked in the door, made a beeline for me through the crowd, and pulled me into my bedroom. The only time I

remember crying—shattering, in fact—was when he closed the door and held me.

I WAS EXHAUSTED THAT NIGHT AND MANAGED TO FALL ASLEEP, BUT SLEEP WAS almost more exhausting than being awake. Even with Alan right there beside me, the nightmares just kept on coming, obviously my subconscious mind trying to process what my conscious mind couldn't begin to grasp: Natalie was gone.

Dream after awful dream revolved around images of my sister's trying desperately to escape dark water, her greatest terror. Natalie Wood's legendary fear of water has been discussed in more articles and interviews than I can begin to count, but very rarely have I read an accurate account of where it came from.

Our mom was born in Barnaul, Siberia, into a family who escaped to China when the Russian Civil War broke out. She was a very religious, very superstitious woman with a fascination for all things mystical. She insisted on telling Natalie's and my fortunes throughout our lives, using a deck of playing cards. I don't remember a single thing she predicted for either of us, let alone whether or not any of it ever came true. I also don't remember either of us turning Mom down when she pulled out those playing cards, not because we were into it but because we simply never said no to her—Natalie was programmed to follow her orders from the moment she was born, and I had so few rules growing up that it was easier to just go along to get along.

Mom loved nothing more than telling stories, and one of her favorites was about her visit to a Gypsy fortune-teller while she was living in China. The Gypsy, it seems, told her that someday she would give birth to an exquisite little girl, a little girl who would become a famous movie star, celebrated all over the world . . . which, by the way, is part of what drove Mom's fierce, relentless

obsession with Natalie and her career. It's a complete myth, and a really tired cliché, that Mom was an aspiring actress and/or a ballerina who never quite achieved stardom when she was growing up and pushed Natalie in order to fulfill her own shattered dreams. The truth is, Mom was just a somewhat wild kid brought up by wealthy Russians who was only following through on what the Fates had already decided were her and Natalie's destinies.

The Gypsy's other prediction, which we were told when we were children, was that the life of that same extraordinary little superstar would ultimately end in a tragic drowning in dark water.

Natalie always believed every word that came out of Mom's mouth, and she spent the rest of her life terrified of dark water and admitting to it in any number of interviews. Even pools frightened her. She would pose for photos in them or be filmed in them if she absolutely had to, but then she'd spend hours afterward recovering from the panic it caused her. At most, she could dog-paddle short distances, under duress, but she couldn't really swim. There was a scene in *Splendor in the Grass* in which she had to wade out into a pond in an attempted suicide. Elia Kazan, the director, had been told about Natalie's terror of water and promised her they'd shoot the scene quickly, with no retakes, but she was still so frightened anticipating it that she called me twice for moral support. I didn't know what to say beyond, "You'll be fine," and reminded her, "There will be plenty of people around to help you," but her fear was still so palpable, even over the phone, that I cried after we hung up. She got through the scene in one take, but she was in terrible emotional shape for days afterward.

Mom couldn't swim either, by the way, so she saw no reason not to encourage Natalie to stay as far away as possible from water, especially dark water.

MY THOUGHTS KEPT SPIRALING. IF I'D JUST BEEN ON THE *SPLENDOUR* WITH HER when she fell overboard—and she must have fallen overboard, there was no way she voluntarily jumped—I could have saved her in the blink of an eye when I heard the splash. There had to have been a splash, right? You don't fall off a boat into the ocean without a loud splash . . . So how did not even one of the three guys on board hear it and pull her out of the water? Where were they? What were they doing? Maybe they'd had too much alcohol. I didn't know about Christopher Walken or Dennis Davern, but R. J. was definitely a drinker, a heavy one sometimes. Natalie didn't drink much, although she did overindulge every once in a while. Maybe that was it, maybe it was one of those rare occasions when she got drunk, and she fell overboard . . . which still didn't explain why no one heard it and rushed to save her . . .

I couldn't make sense of any of it, and I really, really wanted to. Not that it would bring her back, but still . . .

I needed to talk to R. J., once things quieted down after we got the funeral over with. It wouldn't be easy. I figured he must have been a complete basket case, especially with three daughters to deal with who'd just lost their mom and stepmom, and on top of that, he'd never been my biggest fan. No matter how he felt about me, though, we were still family, we were both grieving an incomprehensible loss, and he was the only one I could talk to about that night on the *Splendour*.

THE FUNERAL IS AS HAZY TO ME AS THAT TERRIBLE FIRST DAY.

Ron Samuels and his wife, Lynda Carter, were kind enough to pick up Mom, Evan, Alan, and me and drive us to the chapel and cemetery in Westwood Village. We arrived very early, before the press and the crowds arrived, just as the funeral director was

opening Natalie's casket so that R. J. and the girls could see her one last time. I stayed away. I'd seen her full of life on Thanksgiving, impossibly only a week ago. I'd cling to that rather than get even a glimpse of my sister's lifeless body.

I could see the tears in R. J.'s eyes as he clung to his daughters, and my heart broke for all of them. Evan left me to go join her cousins. I held on to Mom, who was heavily medicated on her Valium prescription, and Alan held on to me as we took our seats in the front row of graveside chairs. Then the cemetery lawn began to fill with mourners, a sea of bowed heads and sunglasses, and I went into another semiconscious trance. People took turns speaking. There was Russian music that made me think of our dad and the beloved balalaika he'd sat alone and played every night after dinner. If he hadn't already died, Natalie's death would have killed him. They adored each other. A glance at Mom. She was staring off into space, her eyes dry and glassy. A glance at Evan, sitting with R. J., Katie, Natasha, and Courtney. R. J.'s face was red from crying. The girls sat very still, holding hands, looking haunted.

I'd never seen or smelled so many flowers as there were around Natalie's grave that day. I read later that Roddy McDowall, Rock Hudson, Elizabeth Taylor, and Stefanie Powers were at the funeral, and the pallbearers included Frank Sinatra, Fred Astaire, Laurence Olivier, and Gregory Peck—I hadn't noticed any of them. Someone pointed out that Natalie Wood was being buried in the same cemetery as Marilyn Monroe. I remember thinking, "No, Marilyn Monroe is buried in the same cemetery as Natalie Wood."

Then we all went to R. J.'s house—that big, beautiful house Natalie loved and had taken such joy in decorating. Willie Mae had distracted herself from her grief by making enough food to feed the state of Michigan for a year. Suzanne Miller arrived to take care of Evan. I hugged and comforted my way through the

crowd while Alan stood nearby, keeping an eye on me and taking care of me but giving me enough space to do whatever I needed to do. At one point Christopher Walken and I found ourselves face-to-face, discovered we had no idea what to say to each other, and kept moving.

I noticed Mom at the bar, having some kind of intense exchange with Dennis Davern. They were sitting in the two chairs Natalie and I had sat in a million times when we were having our most serious, confidential conversations. I'd met Dennis at the house once or twice, but I'd never been invited on the yacht—it was easier on Natalie, who knew R. J. wouldn't appreciate having me there and trusted me not to make an issue of it, which I never did. I found out later that Mom was tearing into Dennis, telling him that as far as she was concerned, it was his fault that Natalie was dead: he was in charge of that boat, and she'd trusted him to take care of her daughter. That poor man; he already looked as if he'd been through more than enough.

I hadn't seen R. J. since we got to the house. Finally I took a deep breath, headed upstairs, and found him in his bedroom, sitting on the edge of the bed, his head down, distraught and seemingly all cried out for the time being.

"R. J.?" I said quietly.

He didn't look up.

"What happened? What the hell happened?"

He raised his head and faced me. "It was an accident," he said. "You've got to believe me. Please believe me."

"But how, R. J.? What does that mean? It was an accident, but how did it happen?"

There were so many things I wanted to say: I believed him, but I needed to know how my sister died. I needed someone who had been there with her to tell me what had happened, and to walk me

through how and why Natalie ended up in the water. Despite our differences, I felt the pressing need for R. J. to describe whatever he'd seen. With the media circus and all the rumors adding confusion to my grief, I just needed to hear the truth from someone I could trust.

I was pleading with him when someone, I don't know who, grabbed my arm and pulled me away with a stern, "Come back downstairs and leave him alone."

I looked at R. J. and then turned to go as he repeated, "Lana, please. Believe me."

I did, because I really wanted to. Because I trusted that when he could tell me more, he would.

I had no idea my world was about to shatter again.

2

"Sometimes the devil you know is better than the devil you don't . . ."

T hree days later, the Monday after the funeral, I dropped Evan off at school and then headed on to the Warner Bros. office of Ron Samuels Productions, where I was his director of development.

Ron was startled to see me. "What are you doing here?"

"I work here." I forced a weak smile and he gave me a look of sympathetic concern.

"I've got to stay busy," I told him. "Between the press and everyone I've ever met in my life, the phone's ringing nonstop, I can't sleep, I can't eat, I can't even think . . . Not that I want to, because if I let myself think, I'll start crying and never be able to stop . . . I just want her back, Ron."

He walked over, hugged me, and left the office. He was a good man, and I enjoyed working with him. I was associate producer on many TV movies he produced and on some Lynda Carter specials, and I worked hard to make sure he never regretted hiring me. We didn't always have the same taste in projects. There was one script

in particular he kept tossing on my desk that I kept turning down. He was sure it had potential. I was sure it didn't. Finally he left it on my desk for about the eightieth time, with a note that read, "How can we fix this?" I returned it to him with no note, just a book of matches stapled to the cover page. But despite the "artistic differences" that ultimately caused us to amicably go our separate ways, I'll always be grateful to him for making my transition from acting to development and production so much easier than it might have been otherwise.

Even though some people might have thought it was "too soon," being back at work was important to me in so many ways. Driving through a studio gate and walking into a production office felt more normal, safe, and familiar than being at home, a much-needed reminder that one essential part of my life was intact. I was still in "the business," where I knew I could excel, where I knew I was welcome, where I fit in, where I belonged, where some of my most treasured childhood memories of Natalie and me together would always be waiting.

I MADE MY ACTING DEBUT WHEN I WAS SEVEN YEARS OLD, A SENIOR CITIZEN COMpared to Natalie, who appeared in her first film when she was four. Mom kept me out of school one day, which wasn't unusual for her—she thought school was a complete waste of time—and told me I was going to the studio for an audition, not for Natalie but for me, with some very, very important people, for a very, very important film. I wasn't into it. I liked being at school with friends, playing, being a tomboy with a dirty face and scraped knees, while Natalie was expected to be perfect every minute of every day and always on a set somewhere making movies. But I never bothered to

argue with Mom, and neither did Natalie. In the end, Mom was going to win anyway, right or wrong, so why waste the time and energy?

The audition was for a film called *The Searchers*. All I knew when I dutifully followed her into an office at Warner Bros. was that Natalie had already been cast in the film to play a fifteen-year-old named Debbie Edwards, and Mom had persuaded the casting director that I was the obvious choice to play the younger Natalie/Debbie. She'd prepared me for this meeting by making sure I was bathed and wearing a clean dress. Other than that, I was clueless.

My audition went like this:

John Wayne and director John Ford were sitting there waiting for us. They introduced themselves. John Wayne seemed nice. Mom chatted with them while I sat there not saying a word. Then John Wayne walked over to me and picked me up to make sure he could do it easily with his bad back. He said, "Yup," while he held me, gently lowered me into my chair again, and I had the job.

And they say it's a hard business to break into.

The Searchers was set in the later 1800s and was about a Civil War veteran (John Wayne) on a mission to find his niece (me), who'd been abducted seven years earlier by the Comanches. By the time he found her, she'd grown up to be Natalie. My part was actually bigger than hers. I got to wear pioneer dresses, and the only time director John Ford, who notoriously hated children, ever spoke to me was to snap, "Can't you bend over when you talk to the dog?" Thanks to Natalie, I'd grown up on movie sets, and I'd seen her do this all my life, so there was nothing to adjust to; it was familiar territory. Because I was a child, my scenes were the first to be shot every day, which meant Mom wasn't there—she was with Natalie, whose scenes were shot later in the day and who was

always outside sunbathing so she'd be tan and look appropriately "outdoorsy." I didn't mind a bit that Mom was nowhere to be seen. By the age of seven, I was used to it.

Besides, I was surrounded by adults and felt perfectly safe and perfectly comfortable. John Wayne and I never really interacted offscreen, but he'd slip black currant pastilles from his pocket to me when he passed by. Ken Curtis would pick up twigs and whittle little animals for me. And Jeffrey Hunter could not have been lovelier and more attentive, sitting with me and talking to me and really listening to me, as if what I had to say mattered to him. I'll never forget him for that.

We spent some time on location in the Monument Valley desert, where John Ford and John Wayne had filmed *Stagecoach* years earlier. We got there by train and stayed at a former trading post that was now Monument Valley's historic Goulding's Lodge. I remember Mom and Natalie and I sitting silently in our dark room at night with the window open so we could hear the mystical sound of Indian chanting nearby.

Turning on the water in the sink and waiting for the orange sand to wash through . . .

An outdoor meal blasted apart by a sudden sandstorm . . .

Panic on the set one day, with everyone yelling, "Get the kid out of here!" when Ward Bond was bitten by a scorpion . . .

Yeah, we were in it for the glamour. But it was a great adventure for a little girl, and Natalie and I had the added bonus of being around John Wayne's son Patrick and falling madly in love with him. The best moment, though, was at the premiere, when my big sister told me she was proud of me.

I kept acting regularly until I was thirteen, when I hit a wall. I was loving the structure and predictability of school—not to mention the old friends, and crushes, and dances. No pressure about

where to stand, how to look, how to say lines I'd worked hard to memorize, and then being bored for hours waiting to do my next scene. School felt right, and "mine," like a much-needed place to land.

I was in eighth grade, leaving the house one morning to walk to school, when Mom stopped me on my way out the door.

"Be very careful today. Do *not* get messed up, do *not* spill anything on yourself, do *not* go to phys ed, and be ready when I pick you up *immediately* after school. You're going on an interview for a big film."

I didn't say a word. I just left, got to school, headed straight to a pay phone, and called Natalie in tears.

"I don't want to do this. I don't want to go on an interview. I don't want to act. I want to be in school, where my friends and the life I like are."

Natalie didn't hesitate. "Stay right there. We'll pick you up."

I waited at the curb, far enough away from the school that no one would notice, and before long a familiar car pulled up and I jumped inside. The "we" who was picking me up turned out to be just R. J., who by then was Natalie's husband.

Two years earlier, on December 28, 1957, movie stars Natalie Wood and Robert Wagner had been married. It was a simple ceremony held in Scottsdale, Arizona, which enchanted their countless fans and, maybe most of all, our mother. She'd been swooning over R. J. and his blue eyes since Natalie started dating him on her eighteenth birthday, and it was her dream come true that these two beautiful Hollywood A-listers would end up together.

I'd kind of known other boyfriends of Natalie's. Nicky Hilton used to spend some time at the house with Mom and Dad and me. James Dean came to pick Natalie up once, and he seemed sweet and kind of shy. Tab Hunter, Sal Mineo, and Dennis Hopper would

come over to swim and hang out, especially when there happened to be a teen magazine photographer around, and they were all fun and very nice to me. But I have no memory of even a "hello" between me and R. J. when he and Natalie were dating. I just remember being in my room at home and looking up from time to time to see him on his way to Natalie's suite, walking by without even glancing in for a quick wave.

It seems unbelievable as I think back on it, but I didn't catch on that Natalie was getting married until we were actually at the wedding. Neither my mother nor Natalie had said as much to me, and at the time our family was so wrapped up in "the business" that everything else sort of took a backseat.

Still, I might have guessed! Natalie and Mom had taken me to a dressmaker a few months earlier to have a tea-length eggshell-white peau de soie dress made for me, with little pearls around the neckline. Sure. Fine. Very pretty. Thank you. But no one ever mentioned the word "bridesmaid."

One day Dad, Mom, Mom's dog Touché, and I headed off to Scottsdale, Arizona, where R. J.'s parents lived, and checked into a hotel room. Natalie was already at the hotel and had her own room. My peau de soie dress had been carefully packed in my suitcase, so I had a feeling this trip had something to do with a wedding.

The next morning Dad got dressed in a suit and tie and left the hotel, and I sat quietly watching Mom flit around Natalie like a gnat, helping her into a white lacy dress and headpiece. She looked like the most beautiful princess bride in the world, but the significance of what was happening hadn't hit me quite yet.

Then Natalie said, "Get Lana done!" Mom got me into my peau de soie dress and suddenly realized that nobody had remembered to bring shoes to go with it. The only ones I had with me

were sneakers. Mom and I dashed off to some little nearby souvenir store and bought the only pair of white shoes they had in my size, which happened to be the ugliest flats I've ever seen.

We went straight from there to the church, where a handful of people had gathered in the stark sanctuary for the ceremony—R. J.'s parents, a few of Natalie's friends, and a few people I didn't know. I was in a panic because I couldn't find Natalie. I remember running past R. J. searching for her and neither of us looking at each other.

I finally saw her when it was time to walk up the aisle. I watched as Dad escorted her to the altar, where R. J. was waiting, and then sat down in a pew beside Mom.

The ceremony started, the reality of what happened at weddings finally dawned on me, and I burst into tears. I was standing beside Natalie and cried my eyes out during the whole thing.

After Natalie and R. J. had been pronounced man and wife and kissed, she turned, put her arms around me, and asked why I was crying.

"Because I just lost you!" I told her.

She held me and reassured me that no, I hadn't lost her at all. "We won't be living in the same house anymore, but we'll see each other all the time, we'll be together and do things together and have fun together, I promise."

I hugged her back and tried to believe her. I have photos to prove that everyone posed for pictures and that Natalie and R. J. cut the cake at the reception. But I was too distraught to remember anything except seeing her leave and the overwhelming feeling of despair that my sister was gone from me. Even revisiting the memory is painful; I truly felt in that moment like Natalie and I—the duo we'd always been—were no more.

Mom and Dad gave the Laurel Canyon house we'd been living in to Natalie and R. J. as a wedding gift, and we moved a few miles

away into a smaller house in Van Nuys, yet another suburb of Los Angeles.

A strange new house, with no Natalie in it. It was all too sudden and too different. I felt like a displaced person. Whether I was at home or working on a project at the studio, life seemed . . . lifeless. Empty. Hollow. Like I was going through the motions. Disconnected. Except when I was with my friends and in that safe, familiar, stimulating world at school, which by then seemed as essential to me as oxygen.

So when I called Natalie in tears after Mom announced that she was taking me to another "important" meeting for yet another "important" film, it almost literally felt as if Mom had announced that she wanted me to come straight home from school because she'd decided to cut off my air supply.

In the meantime, Natalie and R. J. had been living happy newlywed movie-star lives, surrounded by celebrities, never missing A-list parties, never missing work, separately and together. The press couldn't get enough of this gorgeous, popular, perfect young couple.

Shortly before I made that call, Natalie and R. J. had sold the Laurel Canyon house and moved to Beverly Hills, and that was the house R. J. took me to when he picked me up at school that morning. By the time we got there, Natalie had called Mom and told her I'd be staying with her and R. J. for a while, and why. I'm sure Mom was furious, and I'm sure Natalie handled her perfectly—Natalie and I didn't really talk about what Mom had to say, because at that point I didn't really care. All that mattered to me was that Natalie welcomed me with open arms, she never tried to convince me to go back to acting, and she understood better than anyone else possibly could how empty life could feel if Mom was the one calling all the shots.

Now, at the risk of sounding like a diva, I have to admit that the one thing that terrified me (and still does) is mosquitoes. I've always been very allergic to them and swell up like a Macy's parade balloon if I get bitten. So when a mosquito showed up in the guest room Natalie gave me, across the hall from her and R. J.'s suite, I flew out of there, slammed the door behind me, and refused to set foot in that room again until the mosquito was gone.

I wasn't exaggerating when I said that Natalie and R. J. had just moved in, and at the time they were still sleeping on a mattress on the floor. It took a week for a bed for me to arrive and for the guest room to be treated and confirmed to be completely free of that vicious mosquito. I'm sure R. J. was as relieved as I was when I stopped sharing their bed and moved back across the hall where I belonged.

Other than that, staying with Natalie in the Beverly Hills house was great. She and I spent a lot of time together just talking and being sisters, which significantly assuaged my fear of losing her. A friend of hers who lived a couple of blocks away had a son my age, and I'd borrow Natalie's clothes and go to parties at their house and hang out with a lot of kids from Beverly Hills High. School friends of mine came to visit from "the other side of the hill," Natalie handled ongoing phone negotiations with our very pissed-off mom without my ever having to speak to her, and I tested for and was admitted to a couple of L.A.'s most prestigious private boarding schools.

The more I thought about changing schools, though, the more I realized how much I missed my school in the Valley. Then, somehow, at around the three- or four-week mark, when the thought of being "the new kid" at some school full of strangers really started to sink in and put a knot in my stomach, Natalie, my hero, finally convinced Mom to relent—if I felt that strongly about not wanting

to be an actress anymore, she'd drop the subject and never bring it up again. I moved back to the Valley, and Natalie and R. J. went back to living their lives without a thirteen-year-old in the house.

Even after moving back home, I still felt close to Natalie; we were able to see each other and talk, and I'd found an equilibrium with school. I was happy not to be working and grateful that my big sister—my protector, really—had made it possible for me to have a normal life.

It was five years later, in 1962, when Natalie suddenly showed up at our house in Van Nuys, totally distraught, her hand bleeding. It seems she'd come home early from somewhere, poured herself a glass of something, and walked into her and R. J.'s bedroom to find him in a very compromising position with his butler. She was so shocked and so enraged that she squeezed the glass she was holding until it shattered and cut her, ran to her car, and floored it over the hill to Mom and Dad and me, bloody hand and all.

That was the end of her first marriage to R. J., and my heart ached for her. She locked herself away in the big two-story Colonial house in Beverly Hills she came to hate, lost friends, and began her addictions to daily therapy and a sleeping pill called Seconal. And she came to the rescue of her little sister . . . again.

It was also in 1962 that I decided it would be a great idea to get married. I was sixteen, teetering on the brink of spinsterhood, and very involved with an eighteen-year-old named Jack Wrather III. Older man, a regular on the Hollywood party circuit, handsome, and he wanted to marry me. What could possibly go wrong?

To avoid the pesky detail that I happened to be underage, we made the impulsive decision one night to drive to Juárez, Mexico, and have a simple ceremony there—no family, no attendants, just the two of us, which can sound very romantic if you say it quietly over dinner and lit candles. Natalie was on a long flight back to

L.A. from Europe, so she was unreachable, but I remember making the announcement to Mom and Dad as I stood by the front door with my packed suitcase.

"Jack and I are going to Mexico to get married," I said.

"Okay, bye," they essentially said.

They'd met Jack, of course. Dad didn't seem to dislike him, and Mom thought he was a great catch—his father was a well-known entrepreneur, businessman, and television producer, and Jack had a Roman numeral after his name. It didn't seem to bother her in the least that I was too young to have a clue what I was doing. In fact, I thought she almost looked relieved that I was being whisked away to be taken care of by such a desirable young man.

So off we went to Juárez, where I quickly and unceremoniously became Mrs. Jack Wrather III, sentimentally wearing the same green and gold dress I'd worn on the night he and I met.

Then it was time to address the question, "Now what?" We had the Jaguar XKE convertible Jack had bought on his very successful father's credit. Other than that, we had nothing—no jobs, no money, and no place to stay, since his relationship with his divorced parents was strained at best.

But Natalie, I realized, should have been home from Europe by now, so I called her. She was predictably shocked by the wedding news but sounded tentatively happy for us and urged us to come home and move into her guest room, because she was newly divorced and alone and loved the idea of having me around again.

Within days of arriving at Natalie's house, I discovered that I had married a deeply troubled man. Jack turned dark, erratic, and violent, throwing our suitcases around the room one night and finally hitting me, which was an instant deal-breaker for me—I kicked him out, and a few months later Mom and Dad had the marriage annulled.

And as usual, Natalie was my rock. I was devastated. I was humiliated. I was horrified that I'd brought this awful person into her house, and I felt like a complete failure, especially in front of her. But she wasn't having it. If marrying the wrong man made you a failure, she pointed out, then that made her a failure too, and she didn't even have the excuse of being only sixteen years old. There was no way I could ever think of her as a failure, I told her, to which she simply replied, "Same to you." Then she held me, and in her arms, I knew that I was unconditionally loved and accepted and protected and never, ever judged by her.

A COUPLE OF WEEKS AFTER NATALIE DIED, I RECEIVED A PACKAGE FROM A BRILLIANT wardrobe designer named Donfeld, who'd designed my costumes for *Diamonds Are Forever* and Natalie's wardrobe for *Brainstorm*. I opened it to discover a sketch of one of Natalie's *Brainstorm* costumes with a swatch of fabric and a note that read, "Natalie thought you hung the moon."

Just as she had the day she comforted me in the wake of my colossally idiotic first marriage, she managed to make me feel as if maybe I *had* hung the moon. How blessed was I to have been on the receiving end of her magic?

Hard as I tried, though, I'm afraid I wasn't always able to do the same for her . . .

Natalie kept right on working after her divorce from R. J., of course, and she moved on personally as well, including her live-in relationship with Warren Beatty, a three-year marriage to Richard Gregson, and the birth of their daughter, Natasha. When she caught Richard cheating on her with a female co-worker, she lost her mind, threw out every article of his clothing, set up a No Trespassing sign against a sawhorse in the driveway, and hired

a security guard to keep him from coming anywhere near the house.

So when, in 1972, ten years after she and R. J. had divorced, she told me that they had reconciled and were getting married again, it completely blindsided me, and I admit it, I hit the roof. As if she hadn't been through more than enough drama, she was remarrying a guy who had cheated on her with another man? I'd been through something similar when I walked in on one of my ex-husbands trying on my favorite peignoir. I was out of there that same day. (Natalie was never comfortable with intimate conversations. She was the only person I ever told about that, and she immediately put her hands over her ears and started singing, "La-la-la-la-la . . . ," to block me out.) It has nothing to do with being judgmental; it has to do with thinking major disclosures about things like that should happen *before* the wedding, not after.

I've never forgotten Mom's response, by the way, when I told her how uncomfortable I was about Natalie's remarrying R. J., for the obvious reason. Her only comment: "He's been cured." As far as Mom was concerned—and presumably Dad, although he never voiced his opinion about it—the past was the past, R. J. was a wonderful man who'd simply made a mistake and deserved to be forgiven like everyone else, and it was great to have him back in the family again, especially since he and Natalie so clearly belonged together.

Of far more importance was Natalie's response: "Sometimes the devil you know is better than the devil you don't." She'd known R. J. since she was seventeen years old. She knew him and his issues now. He knew her and her issues. There was no more pretense between them, no more danger of being blindsided, which made her feel secure, and what Natalie had always wanted more than anything else in this world was the security of a husband, children, and a home she could count on.

"Besides," she added, "he's a great father." She was going into this second marriage to R. J. with a two-year-old daughter she adored, and he had eight-year-old Katie, whom she also adored, from his marriage to Marion Marshall. The thought of providing those little girls with a wonderful, attentive dad to grow up with would almost have been enough all by itself.

In the end, all things considered, the fact that R. J. and I had never especially liked each other seemed too trivial to even mention. Even after the second wedding, I held on to my suspicions— but I figured if Natalie was happy, I should be too. And while I didn't know if R. J. and I could get along, or if I could trust him to look after my sister, I was going to make an effort for Natalie.

AFTER NATALIE DIED, I HAD THE SAME FEELING: THE PAST WAS THE PAST, AND IT was time to move forward. I felt strongly that he and I should have been grieving together, that something so tragic ought to be enough to mend broken fences. The way I saw it, we'd *both* lost the person we loved most—couldn't we get past our old childish grudges?

That wasn't a shared feeling, apparently. Mom and Evan would be invited to the house for dinner with R. J. and the girls, while I would pointedly be left out. It was deeply painful. R. J. and I had been family, not once but twice. I hadn't been expecting that we would suddenly become inseparable, or that we'd even exchange a warm hug while quietly singing "Kumbaya" together. But avoiding and excluding me? Really?

I started reaching out to him, by phone and in God knows how many long, heartfelt letters, asking why he was shutting me out and what I could do to fix whatever it was. He never returned a single call or responded to a single letter. It hurt. A lot.

There was a limit to what I could do. I certainly didn't ask Mom to intervene on my behalf. She would never have jeopardized her relationship with R. J. and run the risk of being cut off from her granddaughters, and I would never have expected her to. I guess I kept hoping that it would smooth itself out somehow. Maybe when we'd both had a little more time to process our grief. Maybe, after Natalie's will had been published, when I made my obligatory trip to the house to pick up my share of the inheritance, then we would have a chance to have just one conversation.

The will was straightforward. Mom was given continued residency in the West L.A. condominium Natalie owned and enough money to keep her comfortable for the rest of her life. Our half sister, Olga, received fifteen thousand dollars. Everything else went to R. J. and the girls, as it should have, except for one thing: "I give to my sister, Lana Wood, all of my furs and clothing."

"All of my furs and clothing" took my breath away. Her impeccable closet was massive, and it meant the world to me that she wanted me to have everything in it. The fact that we were both clothes junkies was one of our strongest connections. We spent countless hours shopping for them together, trying them on, trading them, critiquing them, calling each other about our latest "finds," exploring new boutiques, always explaining away this mutual addiction by concluding that it was genetic—our mom paid exhaustive attention to what she and everyone else on the planet were wearing and whether or not she approved. Besides, Natalie and I were the same size, and God knows my wardrobe was starved for the kind of boost only Natalie's exquisite taste and exquisite designers could give it.

I arranged a day and time through Willie Mae to retrieve Natalie's clothes. Alan rounded up a couple of his friends, a rented box truck, and a dozen commercial clothes racks, and we headed off to

Beverly Hills. Willie Mae let us into the house, and for the next eight hours we hauled clothing, shoes, handbags, and hats from Natalie's warehouse-sized closet to the truck, which had to make more than one trip to my apartment in the Valley and back.

At one point in the middle of all that busy-ness I was taking a break, standing by myself in R. J. and Natalie's bedroom. It was still filled with her, every pretty, carefully selected object exactly where she'd left it, as if she might come walking back in at any moment. That she wouldn't, that she was really gone, that I was there to take away all that clothing because she'd never need or even touch it again, crashed into me, and I burst into tears.

I was trying to catch my breath when I heard R. J. behind me. "Lana?"

I turned to see him leaning against the doorjamb.

I said hello and rhetorically asked how he was. He just shrugged a silent "How do you think?" and then got to the point: "These belong to the girls, and they thought you and Evan might like to have them."

He reached into the hallway and retrieved a publicity poster of Natalie for *Anastasia,* the play she died too soon to do, and a portrait of her in character that had been used as a prop in a TV movie called *The Memory of Eva Ryker.* I took them, gratefully, and said, "Please thank them and tell them Evan and I will love having them."

"And if you don't mind, I'd like to keep the dress Natalie wore to our second wedding."

I'd lived my life through a perpetual subconscious filter of whether or not Natalie would approve. That filter hadn't automatically vanished when she passed away. She would definitely have disapproved of my being petty enough to refuse R. J. one dress, a

dress that understandably meant a lot to him, out of literally truck-loads of clothes.

"Of course," I told him. "I'll find it and make sure you get it back."

He nodded a thank-you, and a sudden impulse surged up in me—I wanted to reach through that invisible wall between us and hug him, and have him hug me. We'd both lost the same precious, irreplaceable woman. His wife. His daughters' mother. My sister, my most intimate friend, the voice I counted on all my life for advice and love. The woman who understood us better than anyone else on earth ever would or could. Only he and I shared that rare, exquisite gift. History didn't matter anymore, and distance made no sense. We hadn't asked for this, but it was where we were. Like it or not, we were in it together, and I still had so many unanswered questions that only he could answer.

But before I could take a step toward him or say another word, he disappeared down the hall. It felt like he'd slammed yet another door in my face. Then again, with the chaos of Alan and his friends parading in and out of the bedroom with Natalie's clothes, it was hardly the time for a quiet, private, personal conversation—my team and I had a huge, exhausting job to do.

Still, I took that moment as a possible first step. The ice might have been melting a little, I thought, and maybe when I returned the wedding dress, we could finally talk, just the two of us, and even start reconnecting.

THAT NIGHT, WHEN WE WERE FINALLY FINISHED HAULING CLOTHES FROM BEVERLY Hills to the Valley, Alan and I stood gaping at what used to be my spacious, orderly apartment but now looked like the world's largest

clothing donation center. Every square inch of every piece of furniture and every floor in every room was covered with at least two feet of the contents of Natalie's closet, not counting the additional racks of clothes the building manager had allowed us to store in the hallway when we simply had no place else to put them.

"Overwhelmed" isn't a big enough word, and suddenly, with no warning at all, I collapsed. I sank to the floor, onto a mountain of sweaters, and lost it. I couldn't move, couldn't think, could barely speak beyond a choked, helpless, "I can't live like this."

Alan, as always, was a rock. He knew I was talking about a lot more than all this clothing, that the profound tragedy that caused it to be here in the first place had hit me and knocked me down. He sat down beside me and pulled me into his arms.

"You're not going to live like this," he assured me. "What you are going to do is take your time, go through these things and decide what you'd like to keep, and then leave the rest to me. I promise, I'll take care of everything."

That's exactly what he did. It took several days and a lot of trying on, but once I'd set aside the several items I knew I'd wear that fit perfectly, Alan called a resale shop Natalie had used many times. He made an appointment for the owner, whom Natalie knew and liked, to come look at everything I couldn't use and had no room for. She was thrilled and wanted it all, so Alan, with the help of his same two friends and the rental truck, hauled everything to the shop, and came back many hours later with a check made out to me for fifteen thousand dollars.

I'll never be able to thank him enough for helping me do exactly what Natalie would have wanted. She used to worry about my being a single mom with a little girl in private school and a career in the world's most fickle business. I could hear her now: "Which do you need more, Lana? Money in the bank, or more clothes than

you could possibly wear in three lifetimes?" She would have approved, and as always, it felt so good to know that. I had a feeling that Natalie might have known that's what I would do all along.

A few days later I got a call from Paul Ziffren, R. J.'s attorney, "regarding Natalie's estate." I'd managed to come down with the flu and was in no mood for yet another piece of business about her death, but sure, okay. "What about it?" I said.

"As you're aware, the will stipulates that you inherit your sister's furs, but R. J. would like to buy them from you to keep for the girls."

The furs. Natalie had built a special storage unit for them in her closet, lined with cedar and hidden behind locked doors, and our clothes-hauling team had been so busy clearing out everything in sight that I hadn't given a single thought to what we hadn't seen. Natalie had a whole wardrobe of mink and sable she'd worn to the Oscars and other spectacular events all over the world. They were beautiful. They were also something the girls would probably treasure and might actually wear, while my days of glittering Hollywood galas and premieres were pretty much behind me.

I finally told him I had no problem with R. J.'s buying the furs.

"Good," Ziffren said. "Come by my office today and pick up the check, and I also have some paperwork ready for you to sign."

"Today won't work, I'm sorry. I'm sick as a dog."

"It has to be today, Lana. See you when you get here." Abrupt, all business, end of discussion.

He hung up. I cursed at the phone, steamed and fumed and sulked for a few minutes, and then decided I was going to have the flu no matter where I was, so I might as well have it while dragging myself to Ziffren's office. Then at least I'd have it over with. But I was not a happy camper when my fever and I arrived at the office and Ziffren greeted me with the paperwork he'd mentioned on the

phone. I'd guessed it was some kind of confirmation that R. J. was buying Natalie's furs from me.

I was wrong. It was a release, stating that on receipt of R. J.'s check for the furs, I was relinquishing any and all further claims against Natalie's estate.

I was offended by it. R. J. really thought that he and the girls had to be legally protected from me, as if I'd ever go after anything of Natalie's I wasn't entitled to? But sure. Fine. Whatever. I signed it, Ziffren handed me a twenty-thousand-dollar check from R. J., and I headed home to bed with a terrible taste in my mouth. This was all so cold and impersonal and soulless, Natalie's forty-three loving, amazing years on earth reduced to signed pieces of paper and dividing up "stuff."

Now that my part of the business of her death was over with, and I'd committed in writing to never even try to touch another dime of her estate, though, maybe this icy distance between R. J. and me could begin to thaw a little. Maybe I could come along sometimes when Mom and Evan went over to visit. Maybe I could spend time with my nieces again. And maybe he and I could finally have that long-overdue conversation . . .

I had my hopes, of course, but I figured that the ball was in his court. Then word got back to me through mutual friends that the distance had only widened—R. J., it seems, was livid with me for selling most of Natalie's clothes. According to him, I was an opportunistic money grubber, profiting off my dead sister. Now *I* was livid, and deeply insulted. He hadn't even made the effort to say anything to *me*, and it was just another thing that had become fodder for gossip.

But I kept my mouth shut and never defended myself or con- fronted him about it—it didn't seem worth it, and doing so would have kept us from reconnecting. I didn't say anything, not even

decades later, in December 2015, when Natalie's estate held a standing-room-only Bonhams auction. Among the items for sale was a dazzling collection of jewelry, screenplays, awards, letters, and other items from the estate. By all accounts, the Natalie Wood estate made a fortune.

I remember writing him another letter back then, a few weeks into the icy silence that followed my trip to Paul Ziffren's office. I didn't keep a copy of it or commit it to memory, but it went something like this:

"You can keep your check for the furs, R. J. You can have every dime I got for selling Natalie's clothes. You can even have the clothes of hers I kept, and everything else she ever gave me. Just please let me back in, or at least tell me why you won't. If I've done something to create your hostility toward me, let's sit down together and talk it out. Losing Natalie, and now you and the girls, feels like a huge part of my family and my whole life have been ripped away, and I don't understand any of it. I don't understand how, or why . . .

"I've tried, unsuccessfully, to imagine Natalie suddenly dying while she and I were off somewhere for a weekend together and expecting you to leave it at a simple 'It was an accident.' That's all I keep hearing, from you, from the press, from our friends—'It was an accident.' That's all I know, and it's not enough. If you could just tell me the story of that accident, maybe I could finally start to heal a little. Whatever it is, it will be easier to deal with than the thousand different scenarios that keep me awake night after night after night. Please, R. J., I need to know what happened to my sister. Can't you at least just tell me that?"

Still nothing.

The stakes were too high for me to give up on my relationship with R. J. that easily. Natalie had connected us and loved us, and

now we were grieving the same loss, of that love, of the same irre-
placeable woman who'd been the force that made us a family and
kept us together. If there was ever a time when we should have been
connecting, it was then. For her, for ourselves, and for each other.
If not then, when?

So along came R. J.'s birthday. February 10, 1982, his first
birthday without her in more than a decade. Maybe by reaching
out to him and acknowledging it, I could bridge this strange, pain-
ful gap between us that Natalie would have hated.

R. J. loved obscure antiques, and I was proud of myself when,
after Alan and I did a lot of browsing in a lot of odd little shops, I
managed to snap up a pair of antique ivory glove stretchers. Who
can have too many of those, right?

Then I called Katie to make arrangements.

"Alan and I want to take your dad out for his birthday," I an-
nounced.

After a brief, awkward pause, she replied, "Um, actually, we're
giving him a party."

"Great!" I said. "Where, and what time?"

An even longer awkward pause, then, "It's really going to be
just R. J.'s friends . . ."

I pressed right on, choosing to believe the hesitation was some
issue of Katie's, not R. J.'s. "Of course. And most of R. J.'s friends
were Natalie's friends as well, people I've known my entire life. So
where, and what time?"

She reluctantly gave me the information—R. J. and Natalie's
house, seven thirty P.M.

"We'll be there," I said, silently adding to myself, "whether you
like it or not."

And there we were, February 10, at R. J.'s door, unfashionably

prompt, in our best party wear, Alan with a bottle of champagne, me with the gift-wrapped glove stretchers.

I handed him his birthday present. He didn't say a word, just took it, along with Alan's champagne, and headed off to busy himself behind the bar, entertaining his friends, many of whom I considered my friends as well thanks to Natalie, and many of whom didn't seem any happier to see me than R. J. was.

Katie and I nodded at each other from across the room. If Natasha and Courtney were there, I never saw them. After twenty minutes or so of feeling like two elephants in the room that no one wanted to address, Alan and I were so uncomfortable that we made our excuses and left.

I was shattered. But maybe it was still too soon. Maybe I was too glaring a reminder of Natalie for R. J., the girls, and our friends to deal with yet. Maybe when more time had passed . . .

In the meantime, I still had a lot of questions about the last night of Natalie's life. Maybe, if I put my mind to it, I could come up with someplace other than R. J. to look for answers.

3

"You've been blacklisted."

could obviously rule out R. J. as a source of information, and I worried that reaching out to Christopher Walken or Dennis Davern would only incite more of his wrath. Given the fallout I was already dealing with, that didn't seem like a great idea. I finally thought of a possible alternative and managed to get my hands on a copy of the autopsy report. Unfortunately, that actually raised more questions than it answered.

The autopsy was performed by "coroner to the stars" Dr. Thomas Noguchi. His track record included autopsies on Marilyn Monroe, Robert Kennedy, Janis Joplin, and Sharon Tate. He was Los Angeles County's chief medical examiner, and he was trusted. When his report on Natalie was published, no one questioned it, including me.

"Case #81–15167. Reported as: Accident. Probable drowning in ocean."

Sure enough, accidental drowning, just as R. J. said.

"Blood alcohol level: .14 percent."

The approximate equivalent of seven or eight glasses of wine. Okay. She was intoxicated, she lost her footing on the boat somehow, and she fell overboard. She wasn't much of a drinker. That could happen.

The time of death was shortly after midnight, and her body was pulled from the ocean at 0744 hours, or 7:44 A.M.

My head didn't start spinning until I read excerpts from Dr. Noguchi's narrative:

"When it was determined that indeed the dinghy and Natalie Wood were missing, a search was begun with Harbor Patrol, Bay Watch, private searchers, L.A. County Sheriff, and U.S. Coast Guard all participating." Natalie was found in a cove about a mile away from the *Splendour*. The dinghy had been found "a couple hours earlier" in the same cove near the shoreline. "Key was in the ignition, which was in the off position. The gear was in neutral and the oars tied down, and it appeared as if the boat had not even been used." But according to Dr. Noguchi, both Natalie's body and the dinghy were where the current and wind would have swept them.

Because "decedent ha[d] numerous bruises to legs and arms," Dr. Noguchi concluded that Natalie had untied the dinghy and tried to step into it but tripped and fell into the water. "No other trauma noted and foul play is not suspected at this time."

In other words, Natalie, in the middle of a cold winter November night, climbed down from the yacht toward the dark water that terrified her to board a lightweight dinghy and, instead of trying to row it or turn on the engine, let it just float away.

I couldn't begin to imagine it. And if that didn't sound impossible enough, there was also Dr. Noguchi's description of Natalie's body:

"Decedent is wrapped in plastic sheet, she herself is dressed in flannel nightgown and socks. The jacket that she was wearing

when floating is no longer on the body, having come off when she was pulled from the water."

So she didn't just leave the *Splendour* that night to float away in a dinghy, she did it in a nightgown, socks, and what was later described as a red down jacket. According to the police, "the main salon was in disarray and showed evidence of broken glass on the floor," which R. J. explained was likely the result of a bottle toppling off the bar in "rough seas." He, Christopher Walken, and skipper Dennis Davern all gave essentially the same account of the evening leading up to Natalie's disappearance—dinner on Catalina at Doug's Harbor Reef, back to the boat between ten o'clock and ten thirty for more drinking, and R. J.'s discovering Natalie and the dinghy missing at around midnight.

All of which was very interesting and none of which sounded at all like Natalie, or brought me any closer to knowing *what the hell had happened.*

I lost countless hours of sleep reviewing that autopsy report in my mind and trying to make sense of what made no sense at all—what could possibly have propelled Natalie into that dinghy in her nightgown and socks in the middle of that freezing night? And I wasn't the only one speculating—the Hollywood gossip mill couldn't stop talking about it, more and more articles flooded the press every week, and with every new article came new theories about the hottest topic in town, the death of Natalie Wood. For the most part, I'd steered clear of the never-ending stream of articles, but after reading the official autopsy report, I found myself *wanting* to know what other people were saying. Had anyone else found themselves questioning the circumstances of Natalie's death?

There was the rumor that maybe she'd intended to take off in the dinghy to go boat-hopping. Really? Boat-hopping in her nightgown and socks? A woman who'd been trained since she was a

toddler not to even step out the front door to get the mail without looking absolutely perfect?

The "boat-hopping" rumor was only one of the unbelievable possibilities floating around. There was also the very popular but similarly ridiculous "Natalie walked in on R. J. having sex with Christopher Walken and fled the *Splendour* in some combination of shock and rage" theory. I didn't believe that for one second, and I don't believe it now. I know—the indiscretion that ended R. J. and Natalie's first marriage. And I don't have a clue about Christopher Walken's sexuality, nor do I care, nor do I consider it to be any of my business. But there were four people on that sixty-foot yacht. I don't think there's enough alcohol in the world for two of those four people—one of them Natalie's husband and the other her costar and friend—to get the bright idea to sneak off for a tryst as if no one would notice. Besides, it later became clear that R. J. had grown jealous of Chris's friendship with Natalie and the two of them argued. This pretty much destroyed the outlandish gay affair theory.

Last but not least, there was the "Natalie committed suicide" story, usually backed up with an authoritative, "It wouldn't be the first time."

No, it wouldn't. Natalie did make a highly publicized suicide attempt in 1966. It was typically attributed to the end of her marriage to R. J. and/or the breakup of her tumultuous live-in relationship with Warren Beatty. The truth is, it had nothing to do with R. J. or Warren at all.

In October of 1965, Natalie started shooting a movie called *This Property Is Condemned*. Her costar was Robert Redford, and the director was Sydney Pollack. By the time they finished filming, Natalie and Sydney Pollack were involved in a very passionate affair.

Sydney was a fascinating man—brilliant, charismatic, sensitive, and intensely talented—and Natalie fell deeply in love with him. She was joyful when she was with him, desolate when she wasn't, and conflicted by the fact that he was married and gave her no indication that he was planning to leave his wife. She yearned for a future with him but couldn't let herself indulge in fantasizing about something that probably wouldn't happen.

When Sydney ended the affair with Natalie, it devastated her. As she always did after a difficult breakup, even though she was one of those people who hated being alone, she shut herself away from everyone except me, her therapist, and one or two of her closest friends. It was one of those friends, her assistant Mart Crowley, who found Natalie unconscious in her bedroom after she'd swallowed a handful of sleeping pills; rushed her to the hospital, where they pumped her stomach; and saved her life.

To even try to make a connection between Natalie's suicide attempt in 1966 and her death on the night of November 29, 1981, was preposterous. She only had two weeks of shooting left on *Brainstorm*, a film she was excited about. She was looking forward to starting rehearsals for her starring role onstage in *Anastasia*. She was enjoying pursuing projects for her new production company. Most of all, she had the home and family and children she'd wanted all her life. Her love for her daughters was more than enough to sustain her—she would never, ever have deliberately left them.

THEORY AFTER THEORY ABOUT WHAT HAPPENED ON THE *SPLENDOUR* THAT NIGHT, BUT still there were no answers, and the noise from the media was deafening. It became impossible to ignore the rumors, the tidal wave of books and articles and documentaries, and the constant requests

from reporters in breathless search of a sensational headline. I was still grieving and emotionally fragile, and that frenzied attention made an overwhelming situation all the more so. I wanted to close my eyes, put my hands over my ears, and make it all go away, but there was no escaping—over and over, I saw my poor, beautiful sister, obviously planning on just going to bed, when something happened, something I couldn't begin to imagine, and she found herself helpless in the cold, churning ocean instead.

After the autopsy report was released, along with photos of her in the nightgown, the media became newly obsessed with Natalie. As hard as this renewed feeding frenzy was for me to deal with, I knew it had to be even more insane for R. J. Natalie's husband. Star of the current hit TV series *Hart to Hart*. Last but certainly not least, aboard the yacht on the night she died. I was still worried about him, and about my nieces, who'd been through more than enough with the loss of their mother.

We could and should have been in this together, supporting each other through it. Evan could spend time with the cousins she loved so much, and R. J. and I could have our long-overdue private conversation. I still felt that hearing him describe what had happened that night on the *Splendour* would help me to put that part of the nightmare to rest. I couldn't trust the media, but I could trust R. J., and by hearing someone who was there tell me about the events that night, maybe I could focus on just grieving and starting to heal. I felt R. J. could even help me with what I should say to the press that might calm things down a little, take some attention away from our families—especially the children.

I kept reaching out to him. He never responded. Not once. It hurt, a lot, and it confused me, to the point where sometimes, after hours of lying awake and exhausted, awful thoughts would creep in that I fiercely tried to push away—thoughts that transformed

"What happened, R. J.?" into "What are you keeping from me, R. J.?" It was unthinkable that one of the three men on the *Splendour,* all of whom loved her, had actually caused this "accidental drowning," or that R. J. would have protected them if they had. But then I thought, "Well, what if . . . ?"

But then I'd get furious with myself for letting my imagination take me to a dark, impossible place that would just compound this tragedy and split apart what little was left of my family and what little was left of my broken heart . . .

And finally, maybe inevitably, after weeks of stress headaches, no appetite, and no sleep, I crashed.

AT FIRST IT SEEMED LIKE AN ORDINARY DAY. EVAN WAS AT SCHOOL. ALAN WAS downstairs waiting to drive me to my umpteenth press interview, and I was in the upstairs bathroom putting on lipstick and adjusting my hair one more time.

Then, in an instant, out of nowhere, an immobilizing pain slammed into me and took me to the floor. I started frothing at the mouth, screaming for help. Alan called 911, and I was rushed to the hospital, where I was in Integrated Comprehensive Care for ten days with what was ultimately diagnosed as a coronary artery spasm. I was put on a ton of medication, finally released, and still recuperating when I headed back to my associate producer position on a TV movie called *Murder Me, Murder You* for Jay Bernstein at Columbia Studios, a job I loved and desperately needed. Production work was sporadic, as were the paychecks, and between my monthly, unavoidably high L.A. rent checks and Evan's expensive tuition, money was *always* one of the issues on my mind.

I was blessed at the time with a couple of wonderful producing agents, Shelley Wile and Sam Adams, and it was about a week

after I'd returned to work that Shelley took me to lunch to check up on me and make sure I was okay. It was purely social until I started telling him some stories about Natalie and me growing up together and the special sister/best friend relationship we had. All of a sudden he interrupted me and announced, excitedly, "Lana, this would make a great book."

My immediate response was, "No, it wouldn't." I hadn't thought of writing a book, and I had no intention of writing one. The stories didn't seem all that fascinating to me, they were just what happened, no more or less extraordinary than any other two sisters' lives. Comforting and cherished to me, but why would anyone else care?

As Shelley pointed out, though, no one had been closer to Natalie than I had, or could tell those stories from a more personal, intimate perspective. With my permission, he said, he'd like to at least run the idea past a few publishers and see what happened.

The more I thought about writing a book, it occurred to me that doing so could be a good way to cut through all the gossip and drama and outright fiction. It would give me an opportunity to share the Natalie Wood I'd known all my life—the *real* Natalie. I knew she would trust me to honor her memory, and it was something to do during a time when I felt so hopeless about what had happened to her.

I ended up giving Shelley the go-ahead, and less than twenty-four hours later he presented me with an offer from G. P. Putnam's Sons that included a generous advance check and my choice of three ghostwriters they recommended. I'd never written anything but some poetry, short stories, and script revisions, so no way would I even pretend to know how to write a book. I chose a terrific au-

thor named Wayne Warga, who was a gifted, patient, experienced lifesaver. Without him there would never have been a book called *Natalie: A Memoir by Her Sister.*

I'm afraid I didn't make it easy for him. It hadn't been a year yet since Natalie died, and I was still in the throes of processing it—or, I realize, looking back, trying *not* to process it. It should have been cathartic, but it wasn't, because I wouldn't let it be. "Cathartic" would have meant putting what I was feeling on paper, when the truth was, I didn't want to think about what I was feeling. I didn't want to call anybody out, or expose anybody, or psychoanalyze anybody, including myself. All I wanted to do was talk about me and Natalie growing up and not let it interfere with my life. I literally couldn't afford the luxury of stopping to take a long, hard look at where I was, how I had gotten there, and what it meant.

When the book—a.k.a. my exhausting exercise in avoidance— was finally behind me and the Jay Bernstein movie wrapped, I took occasional acting jobs, kept looking for other projects to pitch around town, and spent a lot of time on the phone calling everyone I knew who might be in a position to make them happen. By then I had a strong three-year track record of working hard, getting films and specials made, and being an honest, opinionated, but supportive team player.

As it happened, a prolific producer/director/actor named David Hemmings had cofounded a company called the Hemdale Film Corporation with a British producer named John Daly. David and I were introduced by our mutual friend Leslie Bricusse, who thought I'd be perfect for a permanent position in David's new company. After our initial talk, David and I went to dinner and a screening, during which we discussed everything from my interest

in producing, to projects and books I wanted to option and bring to the company, to a salary we agreed on and my office at Hemdale. I was so excited!

Shortly after that dinner, David left for London. When weeks of silence from him went by, I decided to take the initiative and call Hemdale's acting chairman and president John Daly to introduce myself and go into more detail about what he and David had in mind for me.

It was a brief call—he had no idea what I was talking about.

I was mortified. I stammered something that included the words "misunderstanding" and "my apologies" and hung up as quickly as possible.

End of story between Hemdale and me. There was no doubt about it, I'd breached protocol by going over David's head and contacting the president of the company. But there were no further calls from David, or even an explanation, and I was too embarrassed to reach out to him, so I quickly put Hemdale behind me and moved on.

I'd found a wonderful treatment for a TV comedy/drama (we called them "dramedies" at the time) that I had intended to take to Hemdale. When that door slammed shut, I submitted it to Embassy Television, Norman Lear's company. One of the development executives got back to me just a few days later—he was very interested in the treatment and made an appointment with me for the next day to discuss it. The meeting went beautifully, including my making it clear that I wanted a permanent position producing that and other Embassy projects.

"We'll get back to you very soon," he said, smiling, as he enthusiastically shook my hand on my way out the door.

And he did. My phone rang the next day. It was the man I'd met with, calling to say that the position we'd discussed wasn't ac-

tually going to come through. No explanation, just, "It's not going to work out," click.

I was stunned. I shouldn't have been. I knew the business too well to believe in "sure things," but I still felt as if a rug had been pulled out from under me for no apparent reason. And I still had a little girl to support and rent to pay.

Back to making phone calls in search of a job, including one call in particular I was not looking forward to—Mr. "I know exactly what happened to your sister, but I don't think I can trust you" himself, Guy McElwaine.

I'd known Guy since I was a teenager. Back then, he was Natalie's press agent, and so he was at her and R. J.'s house all the time. He and I had spent hours and hours just talking and laughing and getting to know each other. He was smart. He was funny. He was attentive. Before he became a big-deal press agent, he'd been a professional baseball player, and at least in those days he managed to exude self-confidence without a hint of arrogance.

He and I had quietly started seeing each other. I was sixteen, and he was twenty-six. We became inseparable—dinner together five or six times a week, I was the scorekeeper at his weekend celebrity softball games, and most nights I'd hop in my Chevy Monza and drive over to Westwood to stay with him rather than sleep at home. As always, I never explained to Mom and Dad where I was going, and they never asked. And just to keep things from getting awkward or messy, we never told Natalie we were anything more than friends.

It was all very exciting, until the inevitable happened: I got pregnant. I was terrified, and Guy wasn't exactly turning cartwheels over it either. He was the only person I told, and all he said was, "I'll make the arrangements for an abortion as soon as possible."

He'd already changed from a loving, attentive boyfriend to a cold, hostile stranger when he picked me up three days later for the four-hour drive to a Mexican clinic. We barely said a word all the way there, except for his telling me that I was to use an alias with the doctors—Mary something, I think—and never mention my real name. When we finally arrived at the clinic, he pulled up to the back door, I got out, and he drove away.

Hours later, when I exited into the parking lot, I saw Guy sitting in his car in the alley about a block away; I waved at him, and he picked me up and floored it out of there. There was nothing but silence all the way back to L.A. while I slept off and on from the anesthesia, and when we finally got home, he just pulled up to the curb and left me there.

I was sobbing when I crawled into bed that night, heartbroken and confused and alone. I desperately needed someone to love me, comfort me, and assure me that, as hopeless as I felt, the day would come when everything would be okay again. So I called Natalie, who did all that and more—bright and early the next morning, she fired Guy as her press agent.

Guy was furious with me for costing him his biggest client, his logic apparently being that I had single-handedly gotten myself pregnant and randomly chosen him to suffer the consequences. We inevitably ran into each other from time to time over the years and managed to be civil, and none of this ever interfered with his and R. J.'s close friendship. I have no idea if Natalie ever told R. J. what happened between me and Guy, but I seriously doubt she did—not once in her life did I ever hear her betray a confidence.

Guy and I had long since moved on with our lives, both personally and professionally, when Natalie died. He'd done very well for himself, leaving his press agent days behind him to become a studio executive, and by the time I steeled myself to pick up the

phone and call him to ask for an appointment, he'd become head of production at Columbia Pictures.

He seemed cautious when I walked into his office, but he seemed to relax a little when, instead of asking him again what he knew about Natalie's death, I told him I was looking for a production position. It was a brief conversation.

"You've built a good behind-the-scenes reputation for yourself in the last few years," he allowed. "And I hear you've also written a book."

I nodded.

"Send me a copy. If I like it, I'll give you a job."

That was pretty much it. I thanked him, said I'd look forward to hearing from him, and left. I messengered a copy of my book to his office that same afternoon.

I never heard from or spoke to Guy McElwaine again.

BUT BUSINESS IS WHAT I HAD TO FOCUS ON, SO I RETURNED TO THE REAL TASK AT hand: finding production work—of any kind, really—that would keep my family afloat. But after months and months of trying, I was met with unreturned calls and an increasing panic about money. I needed to support Evan and myself, and there was only so far my limited savings could go. Everyone in this business goes through occasional dry spells, but I couldn't begin to imagine why this one was going on for so long and what I should do about it.

Then, one afternoon, while I was going through my address book for the thousandth time in search of someone, anyone, I hadn't contacted yet, my phone finally rang. I felt a surge of hope when I answered and heard the voice of an old, trusted acquaintance on the line, Mr. Rowland Perkins, cofounder and president of the Creative Artists Agency.

He got right down to business, while I took an instant nosedive from hopeful to hopeless.

"Lana," he said, sounding very grim, "I'm only calling to tell you this because I like you, and I think you're a decent person and a good actress—I'm afraid you're not going to get work in this business anymore, because you've been blacklisted."

It literally knocked the wind out of me. The only words I could manage were, "Blacklisted? Who would—?"

He cut me off with a simple, "It was R. J."

4

"My heart hit the floor."

My heart hit the floor.

Blacklisted. Shut out of the business I'd known all my life. The business that had always provided me with yet another connection to my sister. The business that was making it possible for me to support myself and my daughter. The business in which I'd worked so hard to earn a good reputation onscreen and off.

And R. J. was allegedly behind it.

I couldn't wrap my head around it.

Rowland Perkins was highly respected in the business. He was someone I liked and trusted, certainly not a man to believe, let alone repeat, every rumor he heard in a town that thrives on gossip; and he must have heard it from at least one reliable source if not more, or he would never have gone out of his way to call and pass it along to me.

The thought of losing my behind-the-scenes career was devastating. It hadn't escaped my notice that as I'd waded into my

thirties, I began to get fewer and fewer acting roles. Whether or not it was ageism I had no idea, and frankly, I didn't spend a lot of time analyzing it. I had a child to take care of, by myself, only occasional child support, no alimony, and diminishing income, so what possible difference did "why?" make? That's what had inspired me to start looking for off-camera work in the late 1970s, and heave a sigh of relief when I landed a job as a talent coordinator with Alan Landsburg Productions. My revised definition of a show business career kind of took off from there, thank God.

I thought back to that last long, quiet conversation I had with Natalie at the Bistro Garden the weekend before she died. I was Ron Samuels's director of development by then, she was in the process of starting her own production company, and we were so excited for ourselves and each other. On top of all the other benefits behind-the-scenes work had to offer, when you weren't on camera, it only mattered how smart and capable you were and what good instincts you had, not how young you could still manage to look. We both loved acting, no doubt about it, but it was a whole new and different adrenaline rush to see a project through from inception to filming.

And now, after several successful, exhilarating years on the production end of the industry, and a fairly reliable income, one door after another was slamming shut in my face. It seemed too sudden and too consistent to be just another one of those career slumps that happen in this fickle business. Then again, maybe it was . . .

Or maybe Rowland Perkins was right . . .

I CERTAINLY COULDN'T CONFRONT R. J. AND ASK HIM FACE-TO-FACE IF HE'D DONE this, since he'd frozen me out of his life after Natalie's death. Mom still saw him occasionally, when Willie Mae would call to extend

an invitation for her and Evan to visit the girls, but discussing it with her was out of the question. Been there, done that, way too many times—R. J. walked on water as far as she was concerned, and there wouldn't have been a doubt in her mind that if he'd had me blacklisted, he must have had a good reason. I was in no mood to listen to it.

Then, out of nowhere, I got a call from Natalie's dear friend and assistant Mart Crowley, the man she kept on her payroll so he could support himself while writing the play *The Boys in the Band*, the man who saved Natalie's life after her suicide attempt. He'd been like family since they met on the set of *Splendor in the Grass*, and he and R. J. had remained close after Natalie's death. In fact, Mart was a producer on R. J.'s TV series *Hart to Hart*. He was a wonderful man and someone I trusted to help me get to the bottom of this, as long as it didn't mean betraying R. J.

We met for lunch, and I quickly brought up the subject at hand. Mart claimed not to know anything about R. J.'s blacklisting me, and he said he was sorry, but he didn't seem all that surprised. I found myself wondering if R. J. had put him up to calling me to find out if I suspected he was behind it. At that point I didn't care. Mart was someone who could answer the question that had been haunting me, and I wasn't leaving that restaurant without digging deeper after his almost offhanded, "I'm sorry to hear that."

"You know him very well, Mart. Do you think he would do something so cruel and destroy my career like this? And if so, why?"

He simply replied, "I don't know what he did or didn't do, Lana. But I do know he thinks you're a loose cannon."

A loose cannon? What the hell did that mean? What trouble could I possibly cause R. J.? I didn't know anything, let alone anything that could do him harm in any way. If I was a loose cannon, I was a loose cannon with no ammunition.

Rather than even try to defend myself when there was nothing to defend, though, I just let that go, took a deep breath, and brought up another subject he and I had never discussed.

"Mart, has R. J. told you anything about what happened the night Natalie died?"

"Just that it was an accident."

I wasn't sure I believed him, so I pressed my luck a little. "I don't understand that. If it was just an accident, why all the secrecy? You were one of Natalie's closest friends, I was her sister, for God's sake . . ."

He stopped me with a quiet, emphatic, "He doesn't want to talk about it, Lana."

In other words, "Leave it alone."

I did, and a few minutes later I left that lunch even more confused and more hurt than I'd been when I got there.

I never heard from Mart Crowley again.

I racked my brain for the next several days, still reeling from the reality of a whole industry's turning its back on me for no tangible reason and wondering whether I could have done something to R. J. that would make him hate me enough to upend my career. The only possibility I could come up with, and it seemed remote, was the egregious offense I'd supposedly committed against him and Natalie more than a decade earlier. R. J. had been like ice to me for years over it, and it had caused the longest, most painful estrangement Natalie and I ever went through—all over of a bunch of wedding photos.

I was married to Richard Smedley at the time. Natalie had hosted our wedding at her home, and it was perfect—warm, understated, simple. A week later I asked to have a look at the wedding photos her photographer had taken.

"Oh," she said, "I didn't like them, so I had all the negatives destroyed. I'll never use that photographer again, that's for sure."

For about two seconds, I was tempted to blow up. Then again, she'd been trained all her life by our mom that, in person, on film, or in photos, image was *everything*. Even if the pictures were just for a private wedding album, if she didn't like the way she looked in them, they weren't to be seen. I'm also not big on throwing a fit about things that can't be changed, an overall "what's done is done" attitude. If the negatives had been destroyed, what was the point of yelling about them? So I swallowed my impulse to bark back an irate, "You did what?!"; simply replied, "Okay"; and never said another word about them.

RICHARD HAPPENED TO BE A GIFTED AMATEUR PHOTOGRAPHER, AND HE WAS HAPPILY surprised when Natalie and R. J. asked him to photograph their second wedding on July 16, 1972—a small, intimate ceremony, just family and a few friends, on a fifty-five-foot yacht called the *Ramblin' Rose*, anchored near Malibu off Paradise Cove. After the ceremony, we guests were dropped off at the dock, and Natalie and R. J. sailed off to Catalina for their honeymoon.

The next day a film industry journalist and longtime friend of Natalie's named Marcia Borie contacted Richard and asked for copies of the wedding photos to print in fan magazines. Richard hadn't worked since *A Place Called Today* wrapped in 1971 and needed money, so he and Marcia arrived at some minuscule fee, and the fan magazines had some gorgeous pictures of the remarriage of Natalie Wood and Robert Wagner to feature in their next editions. None of which had anything to do with me. It was strictly between Marcia and Richard. In fact, I went out of my way to stay

out of it. Natalie wouldn't be upset, I figured, since she knew Richard needed the money.

But when Natalie and R. J. saw those photos splashed all over the media, they hit the roof. As far as they were concerned, it was an appalling betrayal and an obscene invasion of their privacy. And the target of their considerable wrath wasn't Richard, who took the pictures, or Marcia, who'd paid him for them and sold them to the press. Somehow, for reasons I never did understand, it was me. Somehow, it was all my fault. No confrontation, not even a discussion, no questions asked, I was just immediately cut off and shut out of their lives. It was agonizing. I wasn't just persona non grata for a few days or a few weeks; it went on for years. It even kept going when Natalie and I were pregnant at the same time. We should have shared that amazing experience together, but we didn't, and it still breaks my heart to think back on it.

I don't remember how or exactly when we started easing our way toward each other again, I just remember my profound relief when we finally talked about it and worked it out.

ADMITTEDLY, IT WAS A STRETCH TO THINK THAT MAYBE R. J.'S OBVIOUS DISLIKE FOR me extended so far into the past. Surely he hadn't been seething about it for all these years . . .

No matter how much I obsessed about whether R. J. played some role in my work troubles, I kept coming back to the same crushing bottom line: I was no longer welcome backstage in the TV and film industry, there was nothing I could do to fight it, and I had bills to pay.

Time to move on, tighten our belts, and reach for the classified ads.

I THINK I FILLED OUT AN APPLICATION FOR EVERY COMPANY IN THE GREATER LOS Angeles area that was hiring. I was hired for brief stints at a doll shop, a furniture store, and the women's department at Barney's in Beverly Hills, and I was also pleasantly surprised to discover that I wasn't completely unwelcome *onstage* in the industry I knew and would always miss. I got a few acting jobs here and there, just guest spots on a few prime-time series and a stint on the CBS soap opera *Capitol*. All of them were enjoyable, fleeting, and reminders of how much I appreciated Natalie's lifelong refusal to *ever* pull a few strings, throw her figurative weight around, or use her considerable influence in any way to get me work as an actress. She actually took pride in telling anyone who asked that there was no nepotism involved in my acting career. She never offered me a role or even a formal introduction to the "right people," not once, for a couple of reasons—she never wanted anyone to make the mistake of giving her credit for my success, and she always wanted me to know that she had enough faith in me to stand back and let me succeed, or not, on my own. If she'd handled it differently, if I'd been dependent on her "clout" to get hired as an actress, what on earth would I have done now that she was gone?

Ultimately, with acting work teetering somewhere between sporadic and nonexistent, I was relieved and grateful to land a full-time job at Sprint. Not very glamorous, but I'll take a steady paycheck and supporting my daughter over glamour any day of the week.

For even more belt-tightening, I also gave up our apartment in the Valley, and Evan and I temporarily moved with Mom to the condo Natalie had provided for her. I could almost hear Natalie as I hauled the last of the boxes through Mom's door: "Good luck with that, Lana."

Natalie had learned the hard way that no good could come

from living with Mom for any length of time. She would have understood not leaving Mom alone to grieve in the wake of her death, but now she would have reminded me of a conversation we had one night when it was just the two of us, sitting side by side at the bar in her house, a long, private conversation I'll never forget.

It started with our reminiscing about a family drama many years earlier, one that began with a frantic call I got from Mom, who was at a pay phone in a Beverly Hills park.

"You have to come pick me up," she sobbed. "Natalie told me to go home to your father where I belong and never come back!"

Natalie had asked Mom to stay with her and Richard Gregson for a few weeks to help with baby Natasha while Natalie was working on *The Candidate* with Robert Redford. Mom was euphoric, of course, and all seemed to be going well until one afternoon when Mom was in the nursery putting Natasha down for her nap. Natalie happened to overhear her through what Mom called "one of those listening things," which the rest of us call a baby monitor.

"There she was, whispering to my baby girl," Natalie told me, "telling her how she was going to become a big star, and Mom would take care of her, because she does more for her and loves her more than anyone else in the whole world ever will. It sounded like she was planning to give Natasha the same childhood she gave me, and I wasn't having it, so I kicked her out."

It was classic Mom behavior—her world was about her, and she had an astonishing sense of entitlement and need for control. The rest of us were here to provide access to whatever she felt entitled to, whether or not it was in our best interest, and the more control she had, the less interference she had to deal with.

We'd both long since figured out that Mom hadn't had her heart set on our becoming actresses because she thought it would make us happy. She wanted it because of the status it would give

her in Hollywood if we were successful at it. And if we were successful at it, the credit would belong to her. As she used to tell the press, "God created Natalie, but I invented her."

We'd also figured out Mom's efforts to use the old "divide and conquer" approach for maximum control. Telling Natasha that she loved her more than Natalie, or anyone else in the whole world, ever would was ridiculous. She'd tell Natalie terrible things I supposedly said about her, and tell me terrible things Natalie supposedly said about me, to try to keep us closer to her than we were to each other. Then she'd swear each of us to secrecy and tell us to just suck it up.

One day Natalie and I were venting about our mother, when, out of nowhere, she asked, "Have I ever told you how glad I am that you called me instead of Mom about the Maximilian Schell incident?"

The Maximilian Schell incident. It had been forever since I'd thought about that. It seemed like a lifetime ago.

I was playing a girl named Mary in a movie called *Five Finger Exercise* with Maximilian Schell and Rosalind Russell. I had a sweet pearl ring I loved, with three little diamonds on the side. I wore it to work every day, until we shot a scene in which I had to go into the ocean. I was afraid of losing my ring in the water and was trying to figure out what to do when Mr. Schell happened to step up and ask if I was okay.

I explained my dilemma, and he graciously replied, "I'll take care of it for you."

What a relief, and how nice of him. I thanked him, handed it to him, spent the next several hours shooting the ocean scenes, and then tracked down Mr. Schell and asked for my ring.

Instead of giving it back to me, he said, "Only if you come to dinner with me when we're finished shooting today."

I was so shocked and embarrassed and clueless about what to say or do that I started crying, walked away, and called Natalie. I told her the whole story. She listened, she sympathized, and she told me not to worry, everything would be okay.

I'd never known what she said or did; all I knew was that the next day my ring was delivered to me at home, hastily wrapped in brown paper and string, and Maximilian Schell never came near me again.

Finally, that night, sitting with Natalie at her bar, I asked her, "What *did* you say to him?"

"I told him to return your ring and leave you alone or I'd ruin him." She smiled a little and added, "Thank God he didn't call my bluff. Like I could have ruined Maximilian Schell if I'd tried. Mom, on the other hand, would have told you to suck it up and go to dinner."

"Natalie," I reminded her, "he must have been about thirty years old. I was fourteen."

"That wouldn't have mattered to Mom. He was a big deal movie star with a lot of very important friends in the business. Imagine the career possibilities."

Mom or no Mom, it was hard to take in. I finally had to ask, "Do you really believe that?"

She looked into my eyes, deadly serious. "Lana, I know that."

There was a long silence between us while she poured herself a second glass of wine. I could tell she was trying to decide whether or not to say more, and I didn't want to push her. She didn't break the silence until she'd taken a sip of wine and a deep breath.

"There's no reason you'd remember this. You were only seven or eight years old. I was fifteen. But one night you and Mom drove me to a 'very important meeting' with a 'very important movie star'

at the Chateau Marmont. Mom sent me in by myself while the two of you stayed in the car . . ."

To my surprise, hazy memories of that night that came rushing back to me when Natalie mentioned the Chateau Marmont, and Mom and me staying in the car to wait for her. Versions of this story, some of them inaccurate and some of them simply incomplete, have appeared in print before, but I've always refused to tell the whole story about it until now. I promised Natalie I would keep it to myself. Forty-five or so years later, with no one still around to protect, I'm sure she'll forgive me for finally breaking that promise.

The night she was referring to was in the summer of 1955, while we were filming that part of *The Searchers* that shot at the RKO-Pathé Studios in L.A. Mom had been a nervous wreck all day, fussing over Natalie to get her ready for a meeting she'd arranged at the legendary Chateau Marmont between Natalie and a *huge* movie star. As huge movie stars went, this man was one of the hugest, and one of the most influential. There was no telling how far Natalie's career might go, and how many doors might be thrown open for her, with just a nod of his famous, handsome head on her behalf. All the way there, Mom kept telling her over and over to be very nice to this man because he could make or break her career.

I remember that Natalie looked especially beautiful when Mom and I dropped her off that night at the Chateau Marmont entrance. Rather than using valet parking, Mom parked on a narrow tree-lined street near the hotel. I was in the backseat. Mom wasn't speaking to me because who knows? It was dark and silent in the car, I got bored with nothing to look at but the back of Mom's head, and finally just curled up and went to sleep.

It seemed like a long time passed before Natalie got back into

the car and woke me up when she slammed her door shut. She looked awful. She was very disheveled and very upset, and she and Mom started urgently whispering to each other. I couldn't really hear them or make out what they were saying. Something bad had obviously happened to my sister, but whatever it was, I was apparently too young to be told about it.

I remember being frightened for Natalie and starting to cry. She reached back and patted my hand and said, "I'm okay, Lana, I promise, please don't worry." She kept holding my hand while Mom pulled away from the curb, and the three of us headed home with a thick, troubling tension in the air but not another word.

Natalie seemed anxious for weeks afterward, Mom seemed preoccupied, and the two of them would stop talking when I walked into the room. I'm sure it was my usual don't-ask/don't-cause-trouble approach that kept me from ever bringing it up. It wasn't until that intimate conversation with Natalie at the bar in her house when we were both all grown up that she finally confided what happened after she got out of the car that night so many years ago . . .

"I walked into the Chateau Marmont as if I'd actually been there before and knew my way around, I found my way to the elevator, I knocked on the door Mom told me to go to, and next thing I knew, Kirk Douglas was ushering me into his suite."

I asked her if anyone else was there. She shook her head. Then she got very quiet, and her eyes filled with tears. I could barely hear her when she added, "And, uh . . . he hurt me, Lana."

It literally turned my stomach. She never used the word "raped" or "molested," and I knew better than to push her for any more than she was willing to say—Natalie loathed conversations that even hinted at being sexually explicit.

Finally she added, "It was like an out-of-body experience. I was terrified, I was confused . . ."

By now we were both crying. "Of course you were," I said as I put my arms around her. "I'm so sorry. I can't imagine . . . What did you do?"

"Nothing. When it was over, he just walked me to his hotel room door and said good night, I left and found you and Mom, and that was the end of it. I mean, what else *could* I do? Who would have believed me? And even if someone had believed me, who was more expendable—fifteen-year-old Natalie Wood, or Kirk Douglas?"

"What did Mom do?" I asked her.

She answered me with a simple look.

I was almost afraid to hear it. "Let me guess: she told you to suck it up."

"Mom was sure it would have meant the end of my career if I'd caused trouble for Kirk Douglas. So of course, suck it up."

She took another sip of wine while I tried to process the horror story she'd just told me. Whether or not it made sense, I was much more enraged at Mom than I was at Kirk Douglas. She'd sent her fifteen-year-old daughter into a hotel room alone with an incredibly powerful man who was old enough to be her father and then done absolutely nothing about it when he violated her. I couldn't imagine it. It was even more unimaginable now that Natalie and I were both mothers with young daughters of our own. Send Evan or Courtney into a meeting alone with a V.I.P., no matter who he was? Uh, no. Arranging for that meeting to take place in the V.I.P.'s hotel room? *Hell* no! And if that V.I.P. made even one inappropriate move toward one of our underage daughters? They wouldn't spend the rest of their life in prison, they'd spend the rest of their life *under* it.

But not our mom. Not with her out-of-control ambition that blinded her to pretty much everything else but her child's stardom. I was repulsed, but sadly not all that surprised.

Natalie put her hand on my shoulder. "Lana, I didn't tell you this to upset you. I just wanted you to know why I've always watched Mom like a hawk when she's around my daughters, and I hope to God you'll do the same with Evan."

I promised I would, and I kept that promise, especially after Evan and I moved into the condo with Mom. We had a strict rule—Mom was never to take Evan anywhere without leaving me the phone number where they were going and what time they'd be back. I used the excuse that it had to do with Mom's medical issues, but the truth was, it had everything to do with that unforgettable conversation with my sister and her protective love for her niece.

Mom respected that rule until late one afternoon when Natasha came to pick up her and Evan. They'd been invited to dinner at R. J.'s new house in Pacific Palisades. I pretended not to mind that I wasn't included in the invitation and continued the endless process of unpacking. I happened to walk past the phone at some point and noticed a piece of paper lying there, with Natasha's name and new phone number at R. J.'s written on it. I made a quick mental note of it and went on about my business.

Natasha and Evan were already in the car waiting for Mom, who always needed a few extra minutes to primp when she was about to see R. J. A few moments later Mom went breezing past my open bedroom door, where I was trying to make sense of my new closet; told me she and Evan would be home by eight o'clock, since she knew it was a school night; and left.

When eight forty-five came and went with no Evan and no Mom, I got frustrated enough that I decided to call R. J.'s house, whether he liked it or not, and remind my mother that it was long

past time to bring my daughter home. I went to retrieve the phone number Natasha had left beside the phone. It was gone.

Mom and Evan arrived a few minutes later. I sent Evan to bed and then asked Mom what happened to that piece of paper with the phone number on it. She couldn't blame Natasha or Evan for taking it—they'd already left when I saw it beside the phone. So . . . ?

She didn't say a word. She didn't have to. She looked guilty as hell.

Clearly, I wasn't supposed to have the phone number at R. J.'s new house in the Palisades, although I had no idea whether that was Mom's decision or R. J.'s, nor did it matter at that particular moment. Rather than confronting her about it, I reminded her that there were no exceptions to the "no leaving with Evan without a phone number" rule. She could abide by that rule, or she could forget about ever going anywhere with Evan again. The choice was hers.

She resented it, but she grabbed a piece of paper and a pen and wrote down the number.

"Don't tell R. J.," she said as she handed it to me.

"I'll try to restrain myself next time he and I get together for lunch," I said as I turned away to go hide it in my bedroom so it wouldn't disappear again.

I had stuck to the promise I'd made to Natalie about Evan, and it felt great.

OVERALL, THE MORE STRESSFUL MY LIFE WAS BECOMING, THE MORE DETERMINED I was to get it together, stop acting like a passenger, and climb back behind the wheel where I belonged, and where Evan needed me to be. And no doubt about it, Evan wasn't easy. On one hand, she was the kindest, most empathetic girl in the world, unable to see any

person or animal in need without wanting to reach out and help them. On the other hand, she could be extremely moody and defiant. I blamed myself for that, for not having provided her with the stable, secure, peaceful home she deserved. Her father had started a whole new family in Texas, fifteen hundred miles away. She'd spent several years watching me stumble my way through the grief of losing Natalie, the loss of my career, and my emotional turbulence in general. She was well aware of the estrangement between me and her uncle R. J. and his refusal to have anything to do with me, which I could hardly explain to her when I didn't understand it either. And living with her histrionic, high-maintenance grandmother wasn't easy, no matter how much she loved her. It was time for me to do something about it.

I started by having a long, honest talk with Alan. He and Evan had never gotten along. My theory was that because we'd never lived together, she'd never known whether or not it was safe for her to let herself get attached to him. He and I finally agreed that as much as we cherished each other, we were at different places in our lives, and we came to a sweet, gentle, mutual parting of the ways that's allowed us to remain friends ever since.

Next on the priority list for giving my daughter an overdue sense of stability, now that Mom was settled back into her condo and doing fine on her own, was finding a place for just Evan and me. It wasn't going to be easy on my Sprint salary, so after a lot more searching and a lot more applications, I managed to land a better-paying sales job with American National Telecom. I'd never missed a payment for Evan's $6,500-per-semester tuition at Campbell Hall, and now I could also start saving money toward a decent rental house where she and I could make a home for ourselves.

But life never got too busy to obscure the "elephant in the room," that oppressive combination of grieving the loss of my sister

and still not knowing exactly what happened to her. Friends urged me to take R. J.'s and Dr. Noguchi's word for it and let it go. "It was an accident. Please believe me." "Cause of death: accidental drowning." "That's what happened. The end," friends said. "Leave it alone. Even if it turns out there's more to Natalie's death, nothing you or anyone else can do will bring her back. Stay focused on Evan and moving on with your life, which is exactly what Natalie would want you to do."

All true. And frankly, I would have loved nothing more. Unfortunately, it had become impossible to ignore.

I still couldn't bring myself to imagine that R. J. had done anything to intentionally harm Natalie. But between his open, inexplicable hostility toward me and his ongoing refusal to talk to the press about that night on the *Splendour,* he almost seemed as if he had his heart set on making himself look suspicious. The less he talked, the more every newspaper and tabloid in the world seemed to fixate on him, from unearthing the dalliance with his butler that Natalie had walked in on to breathlessly reporting on the relationship he'd started with Jill St. John just months after Natalie died. Jill and I had worked together once, on the James Bond movie *Diamonds Are Forever.* We hadn't exactly—pardon the expression—bonded, and I felt safe in saying she probably wasn't encouraging R. J. to mend fences with me and start inviting me to family dinners and holiday parties again.

Dr. Thomas Noguchi also managed to make headlines, just a year after he'd performed Natalie's autopsy, when he was suspended by the Los Angeles County Board of Supervisors. He was accused of releasing details of celebrity deaths he'd investigated to the press in order to generate publicity for himself; damaging, losing, and contaminating evidence; and general mismanagement of the coroner's office. He was demoted from chief medical

examiner to a staff position but blamed it on "backroom politics." It wasn't exactly confidence-inspiring about Natalie's autopsy report, but I read every article I could get my hands on and saw no indication that Noguchi's "accidental drowning" conclusion was being disputed.

The press wasn't about to leave me alone either, as if I might have a different answer if they asked the same questions a hundred times. How was I doing? How were Natalie's daughters doing? How did I feel about Natalie's death's being ruled an accident? Did I believe that? You name it, they asked it, and they weren't shy about it. I was even ambushed in the parking lot of a strip mall by a news crew that unapologetically stuck a camera and microphone in my face to ask some urgent in-depth question like, "Do you miss your sister?" or, "What do you think of R. J. moving on from your sister so soon with Jill St. John? Weren't you and she 'Bond girls' together?" I just kept walking, as if I couldn't hear a single word.

Then there was the almost daily barrage of mail and phone calls from total strangers all over the world, many of them crackpots claiming to have "important information" about Natalie's death and some of them trying to cash in on it.

A man introducing himself as an FBI agent was "conducting an investigation" but quickly hung up when I offered to get back to him after I called the Los Angeles FBI field office to verify his identity.

A "lawyer" I'd never heard of was supposedly writing a book on Natalie and offered me money and a share of the profits in exchange for Natalie's autopsy photos.

The father of one of Evan's classmates was a private detective named Milo Speriglio. He was a notorious publicity seeker who was so obsessed with the death of Marilyn Monroe that he wrote three books about it. According to Speriglio, she was murdered by

the mob, but the murder was covered up by someone in the L.A. coroner's office. He wanted to get together with me to share some "inside intel" about what really happened to Natalie. After spending a few minutes with him on the phone, I got the impression, right or wrong, that I was talking to a "celebrity ambulance chaser" and that was that. I hung up.

It was relentless. It was exhausting. It was disheartening. And at some point, I hit a wall and decided my friends were right—it was time to put all this behind me, leave it alone, and move on. I'd given up on speaking to R. J., and I'd stopped reading any and all articles about "the enduring mystery of Natalie Wood." I needed to come to terms with the fact that nothing I could do would bring my sister back. I'd be carrying the grief for the rest of my life, I knew that, but I had to stop running through scenarios of what could have happened that fateful night. It had been ten years since Natalie had died, and I was still thinking about it nonstop.

WHICH WAS EXACTLY MY INTENTION UNTIL THE EVENING I CAME BACK TO MY OFFICE at American National Telecom after a day of appointments and our receptionist, Sheryl Quarmine, handed me my stack of phone messages.

I sank down at my desk and started flipping through them. Business call, business call, crackpot, business call, friend, crackpot . . . what?!

I must have stared at the next message slip for a good two minutes, convinced that I couldn't possibly be reading it right.

"Please call. Needs to talk to you ASAP," it said in Sheryl's handwriting, followed by a phone number, and the name Dennis Davern. Skipper of the *Splendour*.

5

"I saw a lot of things."

Dennis Davern called. My heart was pounding.

I'd only met Dennis in passing a handful of times at R. J. and Natalie's house, and I hadn't seen him since the reception after Natalie's funeral. It was 1992 now. More than a decade had passed. According to all the reputable articles I'd read about her death, both he and Christopher Walken completely backed up R. J.'s account of what happened on the *Splendour* the night she died. I knew that R. J. and Natalie considered him not just the skipper of their yacht but a friend as well, and at this point I was wary of anyone in R. J.'s camp. Then again, Dennis Davern was the only eyewitness from the *Splendour* who'd reached out to me in all these years. Whatever he had to say, I was ready to hear it. I had to hear it.

I picked up the message slip and left the office for the day. That night, after Mom and Evan went to bed, I settled into a chair in the den and dialed the number Dennis had left. He answered instantly, as if he'd been waiting by the phone for me to call.

"Dennis," I said, "it's Lana Wood."

After a brief, heavy silence, he replied, "I wasn't sure you'd call me back." His voice was quiet and a little shaky. "I should have made this call a long time ago, I just couldn't. But now . . . I have to talk to you. It's going to hurt you. It's been hurting me for all these years . . ."

He started to cry. This was obviously very hard for him, and it was creating a knot in my stomach.

"Okay. What is it?" I tried to sound as calm as I could manage.

"I don't even know where to start . . . What has R. J. told you?"

"That it was an accident."

"That's it?"

"That's it," I said. "That's what you told the cops, too, right?"

He answered my question with a question of his own. "Do you still see R. J.?"

"He doesn't want anything to do with me, Dennis."

"Me either," he responded. Then, after a deep breath, he blurted out, "I held out on the cops, Lana."

"What does that mean?"

"I didn't tell the cops everything," he almost yelled. "Not even close."

That caught me completely off guard. "What are you saying? Are you saying it wasn't an accident?" Silence. "Was she pushed?" More silence. I was getting upset. "Dennis, did R. J. do something to Natalie? Did you see him push her . . . ?"

"I saw a lot of things."

"Did he hit her?"

"I think he did more than that."

I was stunned. In all their years together, I had never seen R. J. raise a hand to Natalie. I couldn't imagine his doing anything to intentionally hurt her.

Dennis was crying harder now and beginning to ramble, about how they'd all been drinking; about how R. J. kept pouring him drinks; about how this had been torturing him; about how his childhood friend Marti Rulli had convinced him that if he didn't open up about it, it would eat him alive; about how much he loved Natalie, how good she'd always been to him, and how he owed her the truth; about how he'd prayed a thousand times that he could have that night to live over again so he could do it differently . . .

Finally he was so exhausted and emotionally spent that he just said, "I can't do this anymore right now. I'll talk to you some other time," and hung up.

I felt as if my head was going to explode. I don't think I moved, or even blinked, for about half an hour, trying to process it. Dennis sounded like a good guy, an earnest, down-to-earth man with a conscience, and if what he'd told me was true, it was explosive. If it wasn't, if he'd become delusional in the last ten years or his memory had become distorted, how would I know? He didn't tell the whole story to the cops? Had he left out parts that would have changed their minds about Natalie's death being an accident? So why call me, why not call the cops? What was I supposed to do about it? Call them myself? To say what, exactly? I didn't have nearly enough information to come off like anything but a nut job. And if he'd kept important facts from the investigators, what reason did I have to believe he was telling me the truth now'?

Once my mind had worn itself out from spinning around, I decided the best way to preserve my sanity was to put that call out of my mind as best I could until I heard from Dennis again, which might never happen, for all I knew. He was clearly feeling the guilt in an intense way, and I worried that calling would only spook him. He'd have to come to me in his own time.

Thanks to suddenly getting blindsided by R. J. again a couple

of days later, putting it out of my mind turned out to be not so hard after all.

THE CALL CAME FROM R. J.'S ATTORNEY'S OFFICE, AT HIS REQUEST.

As the attorney dispassionately explained, Natalie's will stipulated that Mom was to be allowed to continue staying in the condo where she and Evan and I were currently living. However, R. J. was the beneficiary of all of Natalie's real estate properties, which included the condo, and there was no stipulation that Evan and I could live there too. So, as the rightful owner, R. J. was exercising his legal authority. Effective *immediately*, Evan and I were to vacate, and in the very near future, he'd be relocating Mom to a smaller apartment in a Wilshire Boulevard complex called Barrington Plaza, and fixing up the condo as a nice new home for his daughter Katie.

I couldn't imagine what difference it made to R. J. where Evan and I were living. And Katie could pretty much live anywhere she wanted, so was it really fair to uproot Mom, who was well into her seventies by then? But when I started venting about it to Mom, her response was so predictable that I could have recited it along with her: "It's R. J.'s condo, Lana. If that's what he wants, that's what we need to do."

Of course, I'd been planning and saving for to move with my daughter anyway, I just hadn't factored in the "immediately" part. With the help of a Realtor, I quickly found a small, available, affordable rental house in the Valley, paid the deposit, and started packing. Somehow the move was so fascinating to a few of the tabloids that photos were printed of Evan and me hauling boxes from the back steps of the condo to our rented U-Haul truck. It must have been a very slow news week.

With a lot of help from some close friends, four days after we started—"immediately" as far as I was concerned—Evan and I, and everything we owned, were out of the condo and into what I hoped would be our home for a very long time.

Once we'd slogged in with the last of the boxes and collapsed on the floor, a few of those friends took me up on my offer of pizza and whatever we could find around the house to drink. While we sat around eating and not moving, I told them about Dennis Davern's phone call. They were as intrigued as I was, and a little skeptical.

"Why now, after all these years?"

"You don't even know this guy. What makes you think you can believe him?"

"He says he saw a lot of things? Like what?"

I kept explaining that Dennis was having a hard time talking to me, which seemed understandable, and I had really only gotten fragments of information, prompting one of them to ask how those fragments matched up with the police report.

I'd never seen the police report. I'd never even thought to ask to see the police report, and I had no idea how to go about getting a copy of it.

"Give me a couple of weeks. I think I can take care of that for you," he said.

Less than two weeks later I came home from work to find a plain, unmarked manila envelope in my mailbox. The police report was inside, and my heart started pounding again. Finally, an official account of what happened to my sister! I couldn't wait to read it, and I was afraid to read it. Part of me wanted to know everything about that night. Another part of me was braced for the possibility that "everything" might be more than I could handle. But here it was, right here in my hands. Setting it aside wasn't an option.

The report was dated December 11, 1981. Some of it I skimmed, when it got too bogged down in logistical details that didn't seem to matter. What I'm including here are just the segments that *did* seem to matter as far as I was concerned, along with the notes I jotted down as I read it, starting with the fact that the report was dated thirteen days after Natalie's body was found. I knew nothing about standard police procedure, but that seemed like an awfully brief death investigation to me, especially when the victim and two of the witnesses were high-profile celebrities.

According to the twenty-two single-spaced pages, a helicopter from the L.A. Sheriff's Department Aero Bureau transported R. J., Christopher Walken, and Dennis Davern from Catalina to Aero Bureau headquarters in Long Beach. They were interviewed in the captain's office.

At 9:54 A.M., R. J. was asked to explain the events leading up to Natalie's disappearance from the *Splendour*. He said that he, Natalie, Christopher, and Dennis had had dinner and drinks at the Isthmus on Catalina and then returned to the *Splendour* in the dinghy named the *Valiant*, referred to as the Zodiac. The four of them were in the salon when Natalie went below to her bedroom, and shortly after that they noticed that she and the Zodiac were missing. R. J. called to see if she'd gone back to the restaurant, and "the next thing he recalled they were unable to find her and people were searching. Mr. Wagner was in an emotional state at the time of this interview, so it was terminated at this time."

At 10:00 A.M., Christopher Walken was interviewed. He described the foursome going to the bar at the Isthmus and having some drinks. He was asked if Natalie had much to drink, and his response was, "No, she wasn't much of a drinker."

(True enough. She rarely drank, and when she did, she didn't hold it well—she was definitely a "lightweight" when it came to alcohol.)

He then said that once they were back aboard the *Splendour*, he and R. J. got into a "small beef." He left the cabin and went outside on deck for a few minutes. When he returned, Natalie was sitting there and "seemed to be disturbed." She went to her room, and he thought she'd gone to bed. He next remembered Dennis mentioning that the dinghy was gone, and it was around that time when they noticed that Natalie was missing.

He thought this was shortly after midnight, and "he did not hear a motor or a small boat." Then he remembered that a shore boat came along, which R. J. boarded and proceeded to go ashore to look for Natalie. He came back to report that neither Natalie nor the dinghy had been found. "This interview was terminated at this time."

(I was sure I was misreading it. One of the four people on the boat, his friend, was missing, but where was Chris while all this was going on? Did he just retire to his room and go to sleep or something, since he only seemed to remember bits and pieces of what happened the rest of the night? It didn't make me suspicious of Chris, it made me suspicious of whoever was questioning him. How and why would a trained detective leave it at that and simply terminate the interview "at this time"? I wouldn't have, and I was an amateur.)

The investigators were then taken by sheriff's helicopter to the Isthmus on Catalina to meet with Deputy R. W. Kroll of the Avalon Station, the responding deputy to this incident. Deputy Kroll informed them that he'd been dispatched based on a notification that the Baywatch Isthmus lifeguards and the U.S. Coast Guard cutter *Point*

Camden were searching for a missing woman, "Victim Wagner," who was probably in a thirteen-foot Zodiac boat.

Deputy Kroll was later advised that the Zodiac boat had been found against the rocks at an area called Blue Cavern Point. He requested the help of the sheriff's helicopter, which located Natalie's body, floating approximately 250 yards north of Blue Cavern Point. The body had been transported to the USC marine laboratory.

At 8:30 A.M. Dennis Davern positively identified Natalie's body.

(I stared at that sentence for a good five minutes. Dennis Davern identified Natalie's body. How, and why, did that happen? Why wasn't it R. J. who identified her? The last time he saw her was on the *Splendour*. He didn't demand an opportunity to spend a few final moments with Natalie to say good-bye? The idea of leaving that final act to someone else was beyond me.)

At 11:30 A.M. Dennis was interviewed in the Isthmus harbor sheriff's station. He stated that he'd been employed as captain of the *Splendour* since 1974. He said that on November 28, 1981, they had eaten dinner and drunk some wine ashore, then returned to the *Splendour*. At some later time he noticed that the Zodiac, usually tied to the stern, was gone. They called for the Harbor Patrol Bay Watch. They'd initially decided not to call the Coast Guard station at Long Beach but later did notify them.

The next thing Dennis remembered was riding with a deputy, making a ground search for Natalie, and hearing that the Zodiac had been found. Sometime later he was transported to the marine laboratory, where he "made a positive identification of the victim."

Dennis was questioned further to clarify the events leading up to Natalie's disappearance. He said that at around noon on Friday, he, Natalie, R. J., and Christopher

left Marina del Rey on the *Splendour* and sailed to Avalon
on Catalina Island. He stayed on the *Splendour* while the
other three took the Zodiac ashore and, he thought, went
shopping. They returned to the *Splendour* in the evening,
where the four of them spent the night.

Early Saturday afternoon they sailed to the Isthmus and
obtained a mooring. They had a few drinks at the bar, had
dinner, and then returned to the *Splendour*. He thought
Natalie had gone down to her room to put on her pajamas,
and sometime after that he noticed that the Zodiac was
gone. He also mentioned that the trip to the island was very
rough and that several wine bottles had been knocked over
and broken due to rough seas.

Investigators had received prior knowledge that the
above victim [Natalie] had spent Friday night (11/27/81)
at a hotel in Avalon. Mr. Davern was questioned about
this, and "he stated before answering he would rather
talk to R. J. and possibly an attorney." This interview was
terminated at this time, and as Mr. Davern was leaving he
stated to investigators, "If you check the hotel you'll find
that there were two rooms rented."

(My mind was racing all over the place when I read and
reread that paragraph. Natalie, who'd spent thousands
of comfortable nights in her and R. J.'s stateroom on the
Splendour, had a sudden urge to, what, check out the
hospitality at a hotel on Catalina? Why on earth would
she leave the boat to spend the night somewhere else?
And the implication was that Dennis was with her—
okay, maybe he needed to take her there in the dinghy,
but if that's all it was, I'd think he could just say that
without needing to discuss it with R. J. "and possibly
an attorney." Not for one second did I believe something
might be going on between Natalie and Dennis; she was
fiercely loyal, and protective of her family above all

else. If Dennis had spent the night at that hotel too, it would have been so that he could take her back to the *Splendour* in the morning rather than make two round trips; they of course would have had two hotel rooms. But, details aside, what was Natalie doing leaving the boat at night in the first place, and why was Dennis suggesting he wanted to talk with R. J. and maybe an attorney rather than simply answering the question? In my eyes, it should have been extremely straightforward.)

At noon on 11/29, investigators interviewed two employees of Doug's Harbor Reef Restaurant at the Isthmus—the manager, Don Whiting, and a cook, Bill Coleman. Mr. Whiting stated that he noticed "the Wagner party" at the bar when he arrived, and that they came in for dinner shortly after the restaurant opened at 6:00 P.M. They had brought their own wine, and during dinner other customers ordered bottles of champagne for them. "He thought at the time there were some possible problems between Robert Wagner and his wife . . ."

As the party was leaving, Mr. Whiting saw R. J. put a heavy coat over his wife's shoulders and thought he was telling her something privately. Because he felt they'd been drinking heavily, he contacted the harbormaster and suggested that he watch the Wagner party while they were en route to the pier.

Mr. Whiting closed the bar at around midnight and went home to his boat. He kept his radio tuned to the emergency wavelength and thought it was around 1:30 A.M. when he heard the call saying, "This is the *Splendour* asking for help, needs help." He recognized R. J.'s voice and thought it sounded as if he'd been drinking. He called back on his radio, and R. J. said he thought Natalie had gone ashore and asked Mr. Whiting if he would check. A second person, Paul Wintler, had heard the call as well. Mr. Wintler, at

Mr. Whiting's request, checked the Isthmus area and the pier and didn't see the Zodiac. Mr. Wintler promptly took a harbor patrol boat and sailed to the *Splendour.*

R. J. told Mr. Wintler he thought Natalie had gone into the bar. After an unsuccessful search of the area, Mr. Wintler contacted Mr. Whiting and cook Bill Coleman, who arrived at the Isthmus somewhere between 2:30 and 2:45 A.M. and couldn't locate the Zodiac. They then notified the harbormaster of the incident.

Various boats began searching, while Mr. Whiting sailed to the *Splendour* and talked to R. J. and Dennis. They both "appeared a little dazed that she was gone and could give no reason why she would have left." He also overheard Dennis ask R. J., "Boss, do you think she could have gone to the mainland?," to which R. J. replied, "Yes, that's a possibility."

Mr. Whiting continued the search of the sea and found the Zodiac washed up on the rocks at Blue Cavern Point shortly before dawn. The oars were in a locked position. The key was in the ignition in the "off" position. The gearshift was in neutral, and the bowline was hanging in the water. Mr. Coleman boarded the Zodiac, which started immediately, and used it to continue searching, while the team radioed that the Zodiac had been found. The helicopter arrived at dawn and began hovering. Mr. Coleman traveled in the Zodiac to the helicopter's location and saw a body being lifted aboard lifeguard boats.

Mr. Whiting was asked again about his impressions of the Wagner party at dinner the previous evening. It was his belief that they were all under the influence, and he added that he and Mr. Coleman had found an unopened bottle of wine in the Zodiac when they came across it. As an experienced boatsman, it was his opinion that while the seas were "a little heavy," they weren't strong enough to propel a person out of the dinghy, and that the Zodiac had

never been started but instead had drifted on its own to the rocks of Blue Cavern Point.

At 12:45 P.M. on November 29, 1981, investigators boarded and began their search of the *Splendour*, observing the Zodiac tied up on the starboard side en route. The double bed in the master stateroom was in disarray, as if it had been used, and the stateroom itself contained clothing and other articles that indicated it had been occupied by a woman. The main salon, also in disarray, had broken glass on the floor but no substantial indication of a disturbance.

The Zodiac, after initially being collected for safekeeping by investigators, was transported to the Isthmus into the custody of Deputy Kroll.

Once the investigation of the *Splendour* had concluded, a harbor patrol boat transported the investigators to the marine laboratory, where Deputy Coroner Pam Eaker, who'd been with the homicide investigators at the Isthmus, was conducting an examination of Natalie's body. Natalie was observed to be wearing a blue and red plaid nightgown, dark heavy socks, no underwear, and jewelry that was removed by Deputy Eaker.

Other than light bruising on the lower portions of Natalie's legs, there were no signs of heavy trauma. The body was then transported via sheriff's helicopter to the office of the chief medical examiner/coroner for a postmortem examination.

(I was finally able to exhale when I read about the bruising. Somehow it gave me a little comfort knowing that there were no signs of heavy trauma on Natalie's body. However she ended up in the water, the thought of her being badly hurt before she died had been making this accident even more unbearable every time I involuntarily imagined it over and over

and over again. To know there wasn't severe bruising or other injuries at least left me with the dim hope that maybe she didn't suffer.)

At 2:50 P.M. on November 29, 1981, investigators questioned Mr. Curt Craig in the harbor patrol office at the Isthmus Pier. He told them that just prior to going off duty the night before, he'd been called by the restaurant manager, alerting him that the Wagner party was on their way to the pier, he thought they were drunk, and he wanted Mr. Craig to keep an eye out for their safety.

Mr. Craig advised that occupants of the *Capricorn*, a vessel near the *Splendour*, reported to the shore boat operator that they'd heard a female screaming for help at around midnight.

At 3:15 P.M., investigators spoke to a waitress at Doug's Harbor Reef Restaurant, Michelle Mileski, who'd assisted in serving the Wagner party at dinner the night before. She'd seen R. J. and Dennis sitting at the bar when she first arrived for her shift. She also recalled seeing Natalie driving the Zodiac to the Isthmus Pier, with Christopher accompanying her, and seeing Natalie secure the Zodiac to the pier. She saw Natalie and Christopher go into the restaurant and join R. J. and Dennis. Sometime later R. J. asked to see a wine list and wasn't pleased with the selection, and she heard Natalie state, "We can go shopping on the *Splendour* and get our own wine." That concluded her observations of the party for the rest of the evening.

(I paused for a moment to roll my eyes at that typical exchange between R. J. and Natalie—his finding the wine selection not up to his high standards, and Natalie's immediately coming up with a solution to keep the peace, especially when there were other people around. I'd seen her do it a thousand times when he was on the verge of trying to turn something petty,

like what was probably a perfectly good wine list, into
a major issue.)

Investigators then interviewed Christina Quinn, the
waitress who served the Wagner party their dinner. She
recalled that one of them brought two bottles of wine from
the *Splendour*, both of which were consumed during the
meal, and that other people in the bar sent champagne
to the Wagner table. She said Natalie didn't eat much and
"was doing a lot of complaining about small things such as
there was too much light on the table, the table was too big,
the fish was not fresh, and it appeared to the witness that
the victim [Natalie] was not in the best of moods . . ."

**(On the other hand, that behavior wasn't typical of Nat-
alie at all; she really didn't like to make a fuss in public
places. She must have been having a rough weekend
for some reason to be complaining her way through
dinner like that. Maybe she was still as exasperated
with R. J. as she had been when she talked to me about
him earlier that week, and a few drinks wouldn't have
helped.)**

". . . As they were standing to leave, she recalled Robert
Wagner lifting a large dark-colored jacket, and she felt it
was being used as a shield because the victim appeared to
be stumbling slightly. She then recalled all of the Wagner
party leaving together, and it was her opinion they were
not in the best of moods. She clarified this statement by
saying that throughout the evening the victim appeared to
be in changing moods, sometimes laughing and sometimes
solemn."

Shore boat operator William Peterson recalled that at
approximately 12:45 A.M. he'd been asked by members of
the Long Beach coast guard to make a harbor search for a
boat that was overdue, but he'd observed nothing unusual.

Mr. Paul Wintler, a maintenance employee of the Isthmus campgrounds, had assisted in the original search. He stated that at approximately 1:00 A.M., he'd been awakened by loud music. He turned on his radio monitor and heard what he thought was a drunken voice, and "to him it sounded like an emergency." After contacting Don Whiting, he boarded a harbor patrol boat and went to the *Splendour*, where he talked to R. J. His first impression was that R. J. appeared to be drunk and "not real shook up but a bit nervous. He thought Mr. Wagner had possibly made a statement that he and his wife had had a fight and he thought she had gone back to the bar." Mr. Wintler took R. J. ashore to look for Natalie.

The investigators moved on to the city of Avalon, where they spoke to Ann Laughton, night receptionist at the Pavilion Lodge. She told them that at approximately 11:15 P.M. on the night of November 27, 1981, Natalie and "a slim man wearing a beard" came into the lodge to check into the two single rooms she'd reserved. Ms. Laughton escorted them to room 126 and then asked if they wanted to see the second room, 219. She was told, "No, not at this time, we'll see it later." She added that they both appeared "very intoxicated."

The maid service records from the morning of November 28, 1981, reflected that room 219 was vacant and appeared undisturbed, while room 126 had been disturbed and was routinely cleaned.

(I was shocked that it appeared as if Natalie and Dennis had shared a hotel room the night before she died. It still never entered my mind that the two of them were romantically involved in any way, but he and I definitely had a lot to talk about if he ever called again.)

Ms. Linda Winkler, the day shift receptionist at the Pavilion Lodge, stated that at about 8:00 A.M. on Saturday,

November 28, 1981, Natalie entered the hotel office. She "looked fine but seemed somewhat disoriented." She showed Ms. Winkler the key to room 219 and asked for help finding "her room." Ms. Winkler directed her to that room, and Natalie returned about twenty minutes later and pulled out her American Express card to pay for the two rooms. She was surprised to hear that she'd paid for them when she checked in the night before. Natalie then asked where she could catch boat transportation back to the mainland. Ms. Winkler directed her to the proper location and was "amazed at the fact that a movie star like Ms. Wood would be taking public transportation to the mainland." About twenty minutes later Dennis walked in asking for Natalie, Ms. Winkler directed him toward the boat dock and observed him joining Natalie as they walked past the lodge in the direction of the main pier.

On Monday, November 30, 1981, a postmortem examination was conducted on Natalie's body by Dr. Choi, assisted by Dr. Thomas Noguchi. Dr. Choi indicated that all contusions and abrasions appeared to be from twelve to twenty-four hours old. He noted that there was a "scraping type abrasion" on her left cheek that appeared to have an upward direction, an injury that could happen if "one would fall down, one's head striking an object and the person going down over the object."

Once the original investigation of the *Splendour* was completed, it was secured by the Los Angeles County Sheriff's Department, to be released "pending information received from the post-mortem examination." It was released on December 1, 1981, and Dennis, along with a Mr. Frank Westmore, returned the *Splendour* to Marina del Rey.

At 1:30 P.M. on December 3, 1981, investigators met with Christopher Walken and his attorney, Bob Talcott, at the Beverly Wilshire Hotel. Christopher stated that

he, R. J., Natalie, and Dennis had left Marina del Rey at
around 11:30 A.M. on November 27, 1981, and that shortly
after they left he became ill and slept through most of the
cruise. When he woke up, the *Splendour* was anchored at
Avalon. He, R. J., and Natalie went ashore at approximately
5:00 P.M. and shopped at a jewelry store and an art gallery,
then had dinner at a Mexican restaurant. They went on
to a second restaurant and had a few more drinks on the
veranda. There was a steady drizzle.

Natalie wanted to take the shore boat back to the
Splendour, thinking she'd get too wet aboard the Zodiac,
but they finally convinced her to return in the Zodiac. It
was getting dark as they boarded the *Splendour*, where
Dennis was preparing a barbecue dinner. Christopher
was still ill, and he was lying down when they actually ate
dinner. He remembered that there was more drinking, and
he finally returned to his cabin.

He became aware of some kind of "hubbub" upstairs.
About twenty minutes later he thought he heard an anchor
chain, and Natalie came to his door and said, "He wants
to cross during the night," after which she left. Then
Dennis asked him to "come up and get involved," to which
Christopher replied, "Never get involved in an argument
between a man and wife."

He remembered waking up during the night, looking out
the porthole, seeing that the *Splendour* had moved closer
to Avalon, and going back to sleep. Natalie woke him up
the next morning and said something about taking the
seaplane back. She asked if he was staying, and he told her,
"I'm not in this."

By the time he came up, everyone seemed happy, and
Natalie was making breakfast. They left for the Isthmus
shortly after that, and later they all went ashore for
dinner.

After dinner they returned to the *Splendour* and were

in the salon, talking. They'd all been drinking and were having one of those conversations "where you kind of put your cards on the table. R. J. was making statements and complaining that she was away from home too much and she was away from the kids and it was hurting their home life." Christopher supported Natalie's position. Then he caught himself violating his own rule and getting involved in an argument between a married couple, and he stepped outside for some air. When he returned, everyone was apologetic, and everything seemed fine.

He thought it was at about this time that Natalie retired to her bedroom. Before long Dennis noticed that the dinghy was missing. R. J. checked the bedroom and discovered that Natalie was missing. They all believed that she'd probably taken the Zodiac back to the restaurant. He didn't think much about it, since she'd gone to the restaurant the night before and stayed at the lodge in Avalon, so he went to his stateroom and went to bed.

When he woke up the next morning and saw R. J. and Dennis, R. J. said, "She may have drowned." "He appeared to be very worried," Christopher told the investigators. Christopher was monitoring the radio in the wheelhouse when he overheard that someone had "found somebody in red," and he joined R. J. but was afraid to repeat what he'd just heard. Several minutes later a boat arrived beside the *Splendour*, and the person inside said to R. J., "It's not good." Shortly after that, Christopher was taken ashore and helicoptered to the mainland.

"As Mr. Walken could add no further information, the interview was terminated at this time."

R. J.'s second interview took place on December 4, 1981, at 1:00 P.M. in his bedroom. He was in bed. His attorney Paul Ziffren was present.

R. J.'s answers to the investigators' questions were consistent with Christopher's account of the Friday

activities, although he said that once they were back
aboard the *Splendour* after shopping, dinner, and drinks,
he, Dennis, Christopher, and Natalie discussed the
possibility of returning to the mainland because of the
rough seas. He said he did move the *Splendour* closer to
shore for that reason, which Natalie objected to. R. J. told
her to take Dennis, go ashore, and stay in a hotel that
night, while he and Christopher stayed on the *Splendour*.

**(Oh, so it was R. J.'s idea for Natalie and Dennis to stay
at a hotel the night before, because the sea was rough
and Natalie was opposed to moving the *Splendour* clos-
er to shore. Good for him, if he was being protective of
her.)**

On Saturday morning Natalie and Dennis returned to
the *Splendour* and they all left for the Isthmus. Everything
was peaceful en route. After they moored there, R. J.,
Dennis, and Christopher all took a nap.

R. J. awoke to find a note from Natalie saying that she
and Christopher had gone ashore to the Isthmus in the
Zodiac. He and Dennis proceeded to go ashore on the shore
boat and joined Natalie and Christopher in the restaurant
bar. They had a few drinks and an early dinner, during
which Dennis and Christopher went back to the *Splendour*
to retrieve some wine. After dinner they all returned to
the *Splendour*, and a while later Natalie went down to bed.
He remembered that Christopher stepped out on deck, and
when he returned to the salon they continued talking.
About fifteen minutes later he went to check on Natalie.
That's when he noticed that both she and the dinghy
were missing. They first assumed that she'd gone back
ashore. He radioed some people on shore to ask if they'd
seen her, and he then took the shore boat to go ashore
and look for her.

He told the investigators that when they'd returned to

the *Splendour* after dinner and drinks, Natalie had been wearing blue jeans, a yellow turtleneck sweater, and a jacket. He was sure they would have heard the Zodiac if Natalie had started it. By then he'd heard what she was wearing when her body was found and said, "She would not have gone out in the dinghy dressed that way." He added that "she was familiar with boats and their operation."

R. J. was asked about the discussion he and Natalie had had before she retired to her bedroom. He said it was about her being away from home and their daughters so much.

When asked about the broken glass in the salon of the *Splendour*, R. J. said it was probably from the rough seas—bottles falling and breaking happened quite often when they traveled. "The interview was terminated at this time."

Dennis met with investigators on December 10, 1981, at 11:00 A.M. in the law office of Stephen D. Miller. His attorneys Stephen Miller and Mark Beck were present with Dennis while he was interviewed.

His account of the weekend was consistent with R. J.'s and Christopher's, with a few additions:

He drove the Zodiac to the *Splendour* after dinner and drinks and pulled to the rear, where R. J. secured the dinghy to the stern. There were three tie-down areas, one on each side and one in the middle. R. J. secured the Zodiac to the tie-down in the middle.

Once it was determined that Natalie and the Zodiac were missing, Dennis used the radio and contacted the Avalon harbormaster "due to a mistake." Then he contacted the coast guard and the Isthmus Baywatch and asked for a helicopter.

"He stated that she [Natalie] could swim, but she really didn't care to because the water was usually too cold." Once they'd been advised that the dinghy had been found, Dennis assisted in a ground search "in case she had swum ashore. After the body had been recovered, he

was transported to the U.S.C. Marine Laboratory to make identification. The interview was terminated at this time."

With the help of the harbormaster's list of moored boats in the Isthmus Bay area at the time of the incident, Homicide Bureau investigators interviewed various boat owners:

Marilyn Wayne was aboard the *Capricorn* with her boyfriend, the vessel's owner, John Payne. She said that around midnight she opened a hatch and thought she could hear a woman yelling, "Someone please help me, please help me." She advised Mr. Payne to call the coast guard, but he was hesitant because he thought the woman was involved in a drunken party on a boat at their one o'clock position. Mr. Payne thought the woman sounded drunk. Ms. Wayne thought the woman sounded hysterical.

Ms. Laurel Page spent the weekend on the vessel *Kestral* with her boyfriend Dennis Bowen and his family. Their boat was moored about eighty-five to ninety-five yards from the *Splendour.* They went to bed at approximately 11:30 P.M. Ms. Page said she heard rock and roll music coming from a cabin on the shore. Mr. Page heard a male voice yell, "Shut up!," which he assumed was directed toward the music from another boat.

"This file is to be made inactive as to any further action by the Sheriff's Homicide Bureau, pending receipt of any further workable information."

The report is signed by Sergeant Duane P. Rasure and three investigators who worked the case.

I must have read that report fifty times. It made me sad. It made me angry. I admit, I'd gone out of my way to avoid any and all articles and interviews about Natalie's death—I couldn't stomach reporters and "experts" speculating about it and tossing around

their "informed opinions." I wanted facts or nothing at all, and the facts were what I hoped for many years I might get from R. J.

So now I at least had some of them, and this was definitely more complicated than "an accident." And in seeing the report for the first time, I kept thinking that if *only* Dennis had told the police a fraction of what he had told me during our phone call . . .

But no. "This file is to be made inactive . . ." In other words, case closed? That's it?

I kept thinking of more and more questions.

Did Natalie scream and yell for help, or didn't she? If she did, how could people on other nearby boats hear her, but none of the three men on the *Splendour* could? If she didn't scream, what was done about clearing up the conflicting accounts? I knew absolutely nothing about police work or how to conduct an investigation, but that would have bothered me; it certainly seemed like an oversight. And what about that loud rock and roll music those "ear-witnesses" kept talking about? Important? No connection? Was that ever looked into?

Beyond those discrepancies, though, some other things just defied logic.

R. J. would know better than anyone—except maybe for me and Mom—that Natalie wouldn't climb down into a dinghy by herself with a gun to her head, not even on a bright, sunny day, let alone in the middle of a cold, stormy night, with nothing but dark water all around her. And she wouldn't have gone anywhere that could have been considered "public" without being fully dressed and made up.

And since when did the police stop questioning an eyewitness, especially the husband of the victim, because he seemed upset? Oh, no, not the old "He's a celebrity" excuse . . .

Dennis said he'd failed to tell the whole story to the cops,

and yes, he most certainly had. Just for starters, "Natalie could swim, she just didn't like to because the water was usually cold"? Yeah, right. R. J. could have, or should have, straightened it out that, no, she definitely couldn't swim in the true sense of the word. At best, she could manage a dog paddle for a few feet. As far as Natalie was concerned, the words "swimming" and "pleasure" didn't even belong in the same sentence. Or if they'd taken the time to ask me about Natalie and swimming, I would have made sure they knew that there wasn't a chance in hell, period.

And when Dennis was questioned about his and Natalie's spending the night before she died at a hotel in Avalon, he wanted to talk to R. J., "and possibly an attorney," before answering? Why not just attorney? For what possible reason did he want to talk to R. J. before telling the cops about the Avalon hotel, unless he wanted to make sure they got their stories straight?

A LIST OF QUESTIONS A MILE LONG, AND AGAIN, WHAT WAS I SUPPOSED TO DO WITH them? The cops were apparently satisfied with their investigation, so they weren't going to be interested in anything I had to say.

That left no one but Dennis. I wanted so badly to call him. But it had been so obvious in that one phone call from him that he was really uncomfortable talking to me. The last thing I wanted to do was push him and run the risk of having him shut down on me completely. If I spooked Dennis, there was going to be no other way for me to find out what had really happened on the *Splendour*.

Hard as it was, I realized I was going to have to wait and hope to hear from him again.

In the meantime, between work, Evan, and yet another surprise from R. J., my hands and head were already too full to deal with anything else.

6

"Sorry
it's
been a
while . . ."

etween getting Evan and me settled into our rental house and getting Mom moved and settled into her small apartment in Barrington Plaza, life was already hectic enough. But then, shortly after Mom's move, I picked her up to take her grocery shopping one afternoon, and from the moment I got to her apartment I noticed that she was acting weird and nervous. Instead of heading to the front entrance of the building we always used, she made a beeline for the rear entrance and started walking across the parking lot in the opposite direction from where I'd parked, looking around every step of the way as if she were on a secret mission. It was like she thought we were being chased. She'd been kind of forgetful lately, and occasionally a little confused, and I thought maybe this was just another manifestation of whatever was going on with her. Maybe she thought we *were* being followed? I just kept walking along behind her, waiting for her to start going toward my car.

Finally, as she wandered farther and farther away in the parking lot, I asked, "Mom, where are you going?"

Her eyes shifted around a little as she stopped walking and almost whispered, "R. J. said I'm not supposed to see you or talk to you ever again."

I had no idea what to do with that.

While Mom hadn't been diagnosed yet, I'd been wondering if she might be in the early stages of dementia. If I was right, this might have been some kind of dementia-related paranoia creeping in. Or, all things considered, it might have been something she'd actually discussed with R. J., in which case, *hell* no. I was generally pretty compliant, not someone who would rock the boat unless I absolutely had to—and admittedly, the last thing I wanted to do was cause even *more* resentment toward me from R. J.

But no way, not ever, was R. J. going to dictate the relationship rules between me and my mother. God knows it had never been a perfect relationship, or even a healthy one, but it was ours, hers and mine, and he wasn't even entitled to an opinion, let alone a vote. This was my *mom*. She was living alone, with no help, not at her sharpest anymore, and despite everything that had happened between us, by then it looked like she was the only family Evan and I had left.

Not to mention that even in her prime, my mom was one of the worst drivers in the history of the automotive industry. With her seeming increasingly confused and out of sorts, I was terrified that she might accidentally harm herself—or someone else—while on the road. I knew that I would do my best to keep her from getting behind the wheel of a car again, and take care of her in general for the rest of her life, and dare R. J. or anyone else to try to stop me.

All I said to her at that moment was, "It's okay, I'll work it out." It seemed to ease her mind a little—she stopped looking around

and let me lead her to my car, and off we went to shop for groceries while I worked on trying to get my head to stop spinning.

To be fair, I had to admit that it was impossible to guess what Mom might have been telling R. J. about me. Dementia, or whatever was happening to her mind, seemed to be exacerbating her patented "divide and conquer" approach to the people in her life, as I discovered thanks to a call at around that same time from my half sister. Olga didn't even say hello, she just launched into an irate scolding about my having stolen our mother's washer and dryer so that she couldn't do laundry anymore. I agreed that that would have been a terrible thing for me to do, if it had happened. But since Mom still had her own washer and dryer and I had mine, I said, we should be okay. For all I knew, Mom might have told R. J. I'd taken up knife-throwing as a hobby and was using her as a practice dummy, and he was trying to protect her by telling her to stay away from me. Considering my history with him since Natalie had died, though, I still wondered.

But whatever the truth was, and whatever was going on between Mom and R. J., the bottom line was that she needed me. She'd started forgetting to eat, so every day I took her to lunch. Evan and I took her grocery shopping a couple of times a week and ran errands with her, which gave us a front-row seat to her gradual, alarming mental decline.

One day I arrived to find holes in her wall. She had "no idea how they got there," but in an apparent effort to make them blend in with the rest of the decor, she had filled them with artificial flowers.

Artist Margaret Keane had painted a beautiful portrait of Natalie. Mom loved that portrait and hung it in a place of honor in her living room. She also decided that it wasn't quite as authentic as it should be, so she cut the canvas in the area of the portrait's

left wrist and installed a bracelet where Natalie always wore one to cover the protruding bone from a childhood accident while she was shooting the movie *The Green Promise*. (Mom didn't trust doctors or hospitals, so Natalie's broken wrist was never treated or set. In fact, at Mom's insistence, Natalie didn't cry when her wrist was broken, or even mention the injury to anyone at the studio, because complaining might have shortened her career.)

One night Mom didn't care for what she was watching on television, so instead of changing channels or turning it off, she poured her drink down the back of the TV.

The more I observed, the more frightened I was. Despite my having hoped that whatever confusion was occurring might even itself out, obviously the time was coming—and sooner rather than later—when Mom couldn't be trusted to live alone. The answer turned out to be a resounding "sooner."

I got a panicked call at work one afternoon from Barrington Plaza, telling me to get there ASAP. It seems that Mom had dropped an earring that rolled underneath her bed. She got down on the floor to look for it, but it was too dark for her to see. With no flashlight on hand, she lit a candle instead, reached under the bed with it, set the bed on fire, and then sat in the living room watching the rest of her place ignite. Fortunately, a neighbor smelled smoke, broke down Mom's door when she didn't answer his knocking, rushed in, and dragged her out of the apartment. Mom wasn't injured, but by the time the fire was extinguished, she'd lost everything she owned.

I came flying into the lobby, rushed up to her, and asked if she was okay.

She was fine but a little exasperated with me, and snapped, "I've been sitting here waiting for you for two days."

I put her in the car, took her home to my little house in the

Valley, and alerted R. J., through his attorney, that Mom had set fire to her Barrington Plaza apartment and would be living with Evan and me from then on, and that she wasn't mentally capable of living alone anymore.

Mom set up camp on a futon in the living room, which was the only space available. One tiny bedroom was mine, just big enough for me and my bed. The other, slightly larger bedroom belonged to Evan and her shiny new husband, Eddie.

EVAN AND I HAD BEEN ON A VERY BUMPY RIDE TOGETHER FOR THE PREVIOUS FEW years. By the time she reached high school, her behavior had become very erratic, swinging back and forth in a heartbeat from angrily combative to quietly desperate. She was also bigger and stronger than I was by then, and trying to get her to do anything she didn't want to do seemed impossible and left me feeling helpless, powerless, and completely inept.

What Evan most adamantly refused to do was go to school. As far back as second grade, she'd hated it and fought against going every step of the way. We tried a public school, a private school, a Catholic school, a Montessori school, the prestigious and very expensive Campbell Hall, even a half-day school, all of which she loathed and snuck out of after I'd driven her there and watched her disappear through the front door, and she ultimately dropped out completely. It still pains me to admit that I was exhausted from our daily fights about it and that I had no idea how to stop her.

Rather than let her sit around the house doing nothing, I suggested she start coming to my daily four or five American National Telecom appointments with me, meeting people in their offices to analyze their phone costs and convince them that we could save them money. To my surprise, she agreed, and even seemed to kind

of enjoy it. She'd call me "Lana" rather than "Mom" so our potential clients wouldn't think we were honoring Take Your Daughter to Work Day, and we were a pretty successful team.

It was while Evan was working there with me that my friend and colleague Kelly Hunter informed me that one of our wiring technicians, Eddie Maldonado, wanted to know if it would be okay for him to ask my daughter for a date. That was up to Evan as far as I was concerned (as if my input would have made a bit of difference one way or another).

Long story short: They dated, they fell in love, and shortly after Evan's eighteenth birthday, they were married in a small ceremony at the Holy Virgin Mary Russian Orthodox cathedral in the Silver Lake area of Los Angeles. After a brief honeymoon in exotic Burbank, the newlyweds came home to Woodman Avenue in Sherman Oaks, ten miles away, where Evan and I had been living.

And so, with Mom's arrival, there were four of us, crammed together in a sweet house that was perfect for two people. It became apparent very quickly that the only way we could live together without losing what was left of our sanity was to move to a bigger place. I was relieved and excited to find an affordable three-bedroom house, a lease with an option to buy, about half an hour away in Thousand Oaks, and before long, Mom, Evan, Eddie, and I were settling into yet another "permanent home."

ALL OF WHICH IS TO EXPLAIN WHY IT ACTUALLY STARTLED ME TO ANSWER THE PHONE one day at work and hear, "Lana, it's Dennis Davern. Sorry it's been a while. How are you?"

It had been many, many months since Dennis's first call. In that time I'd allowed my focus to shift to my mother and Evan for two reasons. The first was that they were there and immediately in

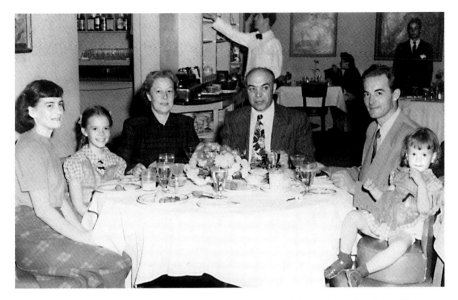

At dinner in a Russian restaurant. LEFT TO RIGHT: Mom; Natalie; Natalie's godmother, Helen Loy, and her husband; Dad; and me. We used to visit Helen and her husband at their home in Santa Barbara—a gorgeous, huge mansion up a private driveway that was so long it took ten or more minutes to reach the house. They had a ballroom with an electronic floor that would uncover an indoor pool. I used to get lost there until I gave up looking around.

Our mom, visiting me at the Shoreham Towers.

Playing with
Natalie in our yard
in Burbank. I was
so young I can't
remember those times
at all, but I'm so glad
I have the photos
now.

Natalie and me on our way to another New York trip – glamorous Natalie, tailored me. I was very excited to go!

Our backyard in our Laurel Canyon home, which was gifted to Natalie and
R. J. as a wedding present.
Photo by Earl Leaf/Michael Ochs Archives, via Getty Images

Sisters in Natalie and R. J.'s backyard, where we gathered to hang out for a barbecue.

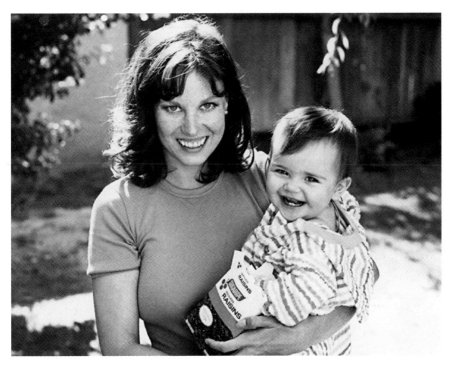

With Evan, my pride and joy, in the backyard of the house where we lived with my then husband, Richard Smedley, Evan's dad.

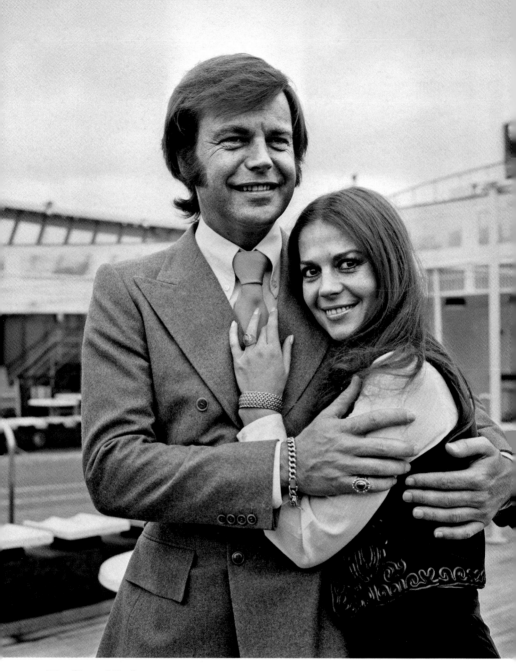

Natalie and R. J.
Photo by Chris Wood/*Daily Express*/Hulton Archive, via Getty Images

In my mom's apartment in Los Angeles with R. J. and his mother, "Chat" Wagner.

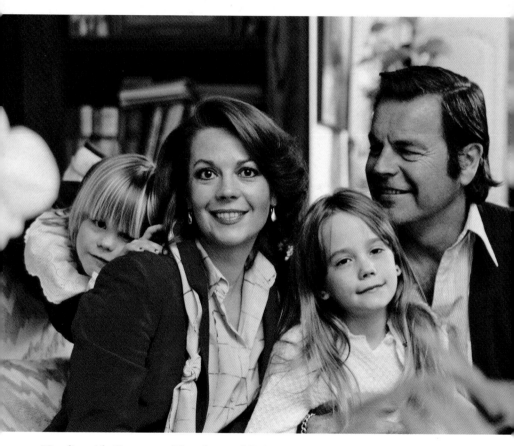

Natalie with Courtney, Natasha, and R. J.
Photo by Douglas Kirkland/Corbis, via Getty Images

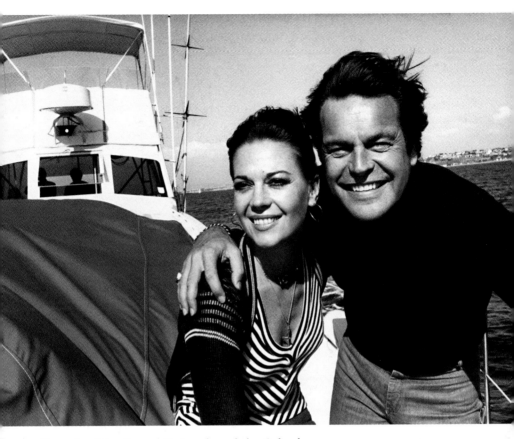

Stunning Natalie and R. J. onboard the *Splendour*.
Photo by Steve Schapiro/Corbis, via Getty Images

Our dad with Natalie on the *Splendour*. They were just sailing around for my dad's first and last time on the boat. He died not too long after this photo was taken.

Dad (who was loving being called "Fahd" by Natalie). Here he is visiting while *Splendour* was docked, with Dennis Davern next to him.

Natalie's body bag being brought to a sheriff's helicopter on Catalina Island.
Photo by Paul Harris/Getty Images

Press conference given by Lieutenant John Corina announcing new evidence in Natalie's death, plus announcing Robert Wagner as a person of interest.
Photo by Kevork Djansezian/Getty Images

Catalina, where Natalie and R. J. were sailing on the night she died. Photo of the dinghy *Valiant*.

Photo by Paul Harris/Getty Images

C. PERSON DEAD, ACCIDENTAL DROWNING Action Taken

V.

D.

S.

On 11-29-81 at 0830 hours, investigators were detailed to investigate the circumstances surrounding the death of Victim Natalie Wood Wagner.

Investigators responded to the Los Angeles County Sheriff's Department Aero Bureau Headquarters, where investigators were advised that witnesses involved in this incident were being transported from the Isthmus of Catalina Island via Sheriff's helicopter to the Aero Bureau Headquarters.

At 0954 hours on 11-29-81, investigators interviewed ROBERT J. WAGNER, MW/51, husband of the abovenamed victim. This interview was conducted in the Captain's Office of the Aero Bureau. Mr. Wagner was asked to explain the circumstances up to the point his wife was missing. He stated they had been ashore at the Isthmus, had had a few drinks and dinner. There were four (4) people in his party, he, his wife, CHRIS WALKEN and the boat captain DENNIS DAVERN. They had all returned aboard their boat named The Splendour, in their Zodiac dinghy. He said they were in the salon, when Victim Wagner went below to her bedroom. Shortly thereafter they noticed she and the Zodiac missing. He first called to see if she had gone back to the restaurant, and the next thing he recalled they were unable to find her and people were searching.

Mr. Wagner was in an emotional state at the time of this interview, so it was terminated at this time.

At 1000 hours on 11-29-81, Mr. CHRISTOPHER WALKEN, MW/38, ▮▮▮ ▮▮▮▮▮▮▮▮▮▮▮▮▮▮▮▮▮▮▮▮▮▮▮▮▮ was interviewed. Mr. Walken is an actor and personal friend of both Robert Wagner and Victim Natalie Wood Wagner.

Mr. Walken stated he had been invited to go on a cruise by the Wagners. They left Marina Del Rey at approximately 11:30 a.m. on Friday, 11-27-81. He recalled they went into Avalon, spent some time ashore Friday night and they had dinner aboard the boat, then went to bed. Saturday morning they left for the Isthmus and

From the original homicide detectives' report.

party and rock and roll music coming from a cabin which was on the shore. She did not hear or see anything after that time.

On 12-3-81 at 1630 hours, investigators contacted Mr. DENNIS BOWEN, ▮▮▮▮▮▮▮▮▮ related substantially the same as his girlfriend ▮▮▮▮▮▮▮▮▮ adding that his boat was tied up to a mooring approximately 85 to 95 yards from the Splendour. He said he went to bed at approximately 11:30 p.m. and he had his porthole open, which faced the vessel Splendour. He stated approximately one hour later he heard rock and roll music coming from the shore, and he heard a male voice yell, "Shut up", which was apparently coming from another boat and directed toward the music. He stated he is a light sleeper and if someone had been yelling for help he would have heard it. He also contacted the other members of his family who were on his boat that evening, and ascertained that none of them had heard anyone yelling for help.

Investigators contacted Mr. BURT SPIRA, ▮▮▮▮▮▮▮▮▮ is the owner of the vessel Sweet Bippy, which was moored three boats away from the Splendour, toward the beach. He called hearing some loud music during the early morning hours. He described this sound as "blasting" from a powerful set. Later in the morning, while in a restaurant he overheard other people complaining about this noise, and he heard them estimate the time as approximately 1:30 a.m. He further added that it was a very cold night and most of his doors and ports were closed.

The only thing he knew of this incident was that just after daylight he had bailed some water out of his dinghy, took it for a little run around the harbor and at one point a sailboat owner had called to him and asked him if he was looking for Natalie Wood.

Investigators also contacted JANET MAY, ▮▮▮▮▮▮▮▮▮ were aboard the vessel Jan Cat, which was moored at the Isthmus at the time of this incident. ▮▮▮▮▮ stated she and her husband had heard or observed anything unusual. Neither she nor her husband was sometime Sunday morning they had observed a dinghy being towed back to the Splendour. She could add nothing further.

This file is to be made inactive as to any further action by the Sheriff's Homicide Bureau, pending receipt of any further workable information.

DUANE P. RASURE, SERGEANT #074379

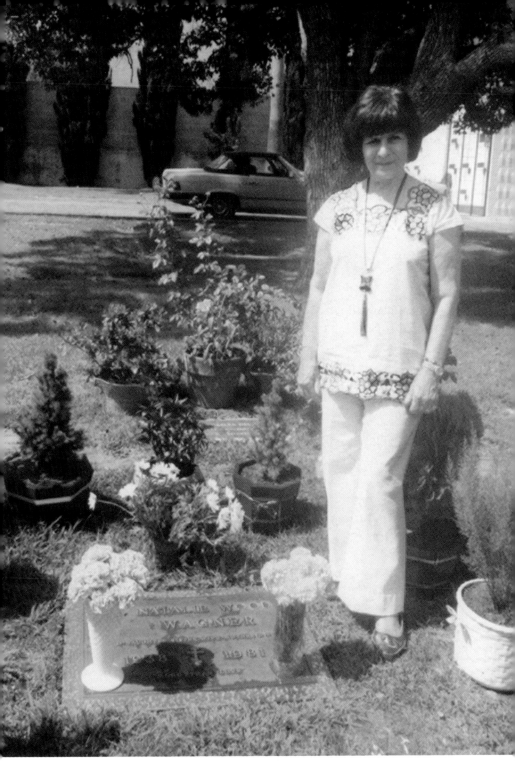

Our mom visiting Natalie's gravesite in Westwood, Natalie's yellow Benz at curbside behind her. Whenever we visited I always told her Natalie is not there . . .

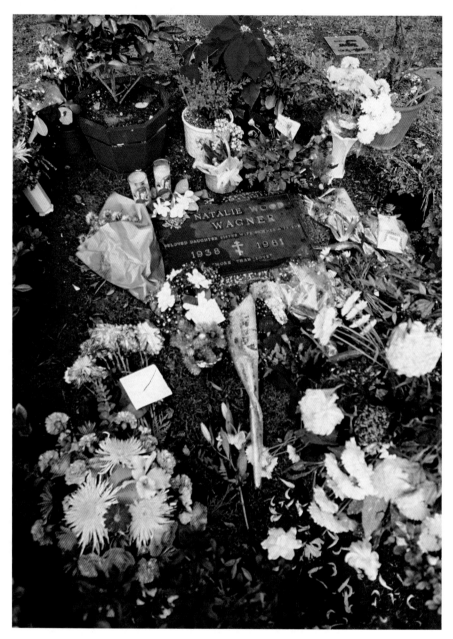

Natalie's gravesite at Pierce Brothers Westwood Village Memorial Park.
Photo by Paul Harris/Getty Images

need of my help, and the second was that, frankly, the prospect of digging deeper into Natalie's death was too daunting. All I wanted to do at that point was get by. Week by week, I was trying to figure out how to keep close enough tabs on my mother so that she wouldn't hurt herself and keep Evan pacified so that we wouldn't have any serious blowout fights.

I'd obviously been a little busy, but just hearing Dennis's voice snapped me right back to that other part of my life, that huge hole in my heart that hadn't begun to heal, that I didn't know how to begin to address.

Rather than spend three or four days trying to answer Dennis's question, I replied with a simple, "I'm okay, Dennis. How are you?"

He didn't sound completely sober and snorted out a sad laugh. "Hey, don't you read the tabloids? I'm the 'death-yacht captain.' You know, I'm just an ordinary guy, just a working stiff trying to earn a living. You celebrities are used to all this attention. I'm not. I never wanted it, never asked for it . . ."

He'd obviously called to talk, not listen. I'm not even sure he heard me when I softly, sincerely said, "I'm sorry. I know it's hard."

He kept right on going. "All these articles and interviews keep stirring everything up all over again, Lana. My friend Marti Rulli is writing a book about it with me so I can finally get the truth out there and put all these lies to rest . . . like this bullshit about the dinghy . . ."

The dinghy issue sent him into a rapid-fire monologue I could barely keep up with. From what I could gather, it seemed R. J.'s latest interview theory about how Natalie ended up in the water was that the dinghy was banging against the side of the boat, and she got out of bed to secure it and slipped on the swim step.

Ridiculous, Dennis said. For one thing, Natalie would have

asked Dennis to take care of it, as she'd done many times before. For another thing, Dennis had already tied the dinghy behind the stern with two lines, which meant that both lines had to be untied for the dinghy to go missing, and those lines were always retied from the deck without going anywhere near the swim step. For yet another thing, terrified as she was of dark water, Natalie would never have climbed down to the swim step, *ever,* let alone in her nightgown and socks in the middle of a cold, stormy night. And then there was the fact that not once in her life had Natalie even been in the dinghy by herself, and she would have had no idea how to operate it . . .

I pointed out that the waitress at the restaurant had told the police she saw Natalie driving the Zodiac to the pier.

"Then she was either mistaken or misquoted. Or at most, maybe Natalie steered it for a minute or two to show off for Chris or something. But she didn't have the first clue how to start the Zodiac, stop it, turn it off . . . I'm telling you, no way. No fucking way."

I couldn't resist asking about his and Natalie's spending that Friday night at a Catalina hotel rather than on the boat.

"Oh, come on, Lana, you can't possibly think—"

I stopped him and assured him that I knew nothing had happened, I just wondered why they'd bailed out on the *Splendour* and gone onshore.

Natalie was upset with R. J., he told me, because he kept insisting on moving the boat to the Isthmus for what she thought was no good reason. She was really furious with him and wanted to get away from him. She booked two rooms when they first got to the hotel. "You know how she was," Dennis said. "She didn't want to be alone."

Exactly right. Exactly Natalie. It made perfect sense.

Then he launched into something about turning on loud music so the other boaters wouldn't hear R. J. and Natalie's arguing, which explained the rock and roll music ear-witnesses reported to the police, and how R. J. poured more drinks for himself and Dennis, when I found myself getting too agitated to keep my mouth shut. It was like every feeling bottled up inside me was finally surfacing, all of those months spent wishing he'd call me back, after *years* of hoping someone could finally tell me what exactly had happened to Natalie.

"Dennis," I almost pleaded, "don't tell me, tell the authorities!"

I could hear that he was on the verge of tears. "Don't you think I want to? But I'm scared."

"Of what?"

"I didn't tell the cops everything. I only told them what I was supposed to tell them and helped cover for R. J. And if R. J. found out I was talking to the cops . . . I'm scared of the cops, and I'm scared of him too. But it's eating me up inside. That's why I started talking to Marti about it, and that's why she convinced me to call you. I loved Natalie, and Natalie loved you. You're her sister. No one has more of a right to know what happened than you do. I'm so sorry, Lana."

And he hung up.

So there I was again, all upset and nowhere to go. Only now, for the first time since Natalie had died, I felt like I was on the brink of something. I was so agitated and so conflicted I felt as if I might explode. I was still far from getting a cohesive story from Dennis, but I liked him, and I believed him. I also couldn't bring myself to believe that R. J. would ever intentionally hurt Natalie, because I didn't *want* to believe it.

Why all of the conflicting stories, though? And why weren't those stories bothering the cops as much as they were bothering me?

"She probably put on her nightgown and socks and went boat-hopping in the dinghy . . ."

"She was probably trying to tie up the dinghy and slipped on the swim step . . ."

And the explanation that kept ringing in my ears: "It was an accident, Lana."

It didn't make sense that the case could be closed, not know-ing what I knew. Not after reading the police report. Simply put: some things didn't make sense. There were the ways in which the behavior didn't square with the Natalie I had known, the ways in which R. J.'s story didn't align, the heavily edited story Dennis had told . . . and then there were the facts.

I was furious with R. J. again. It felt like he was parceling out pieces of the story. Why couldn't he just tell the whole story for once and let the rest of us finally understand how Natalie had died so we could start to heal and get on with our lives?

Then I could wrap myself in the comfort of remembering how she lived and all the memories that belonged to just the two of us . . .

How I would drop everything on a moment's notice and be there when she'd call to say, "Come stay with me," whether it was at her summer rental house in Malibu or in her hotel room in New York after she'd finished shooting *Splendor in the Grass* . . .

Our quiet, hardworking dad, disappearing after dinner every night to be alone with his glass of vodka, his balalaika, and his beloved historical books, and how the sweet, gentle sound of bala-laika music drifting in from the living room was such a special part of our childhood soundtrack . . .

Quoting Mom's advice to each other behind her back, such deep words of wisdom as, "Don't have girlfriends who are prettier than you" . . .

Natalie's nervousness over an appearance on *The Merv Griffin*

Show because she was so uncomfortable being on camera without a script, and her calling me afterward to tell me it went well and she'd actually had a great time because she" just pretended to be me." And what I'll always remember as a compliment that literally brought me to tears, when I saw that Natalie had written above a line in the script of a movie she was working on, "Say this like Lana would" . . .

The two of us stealing wine off the vacated dinner tables at Natalie's favorite restaurant, La Scala, in our younger days, thinking we were being very cunning, only to find out years later that the staff at La Scala knew all about it and were charging the bottles to our tab . . .

The smooth, charming British agent we were appalled to discover was dating us both at the same time, and the look on his face when he walked into a restaurant for a date with Natalie and found the two of us sitting there together, waiting for him with big "Surprise!" smiles on our faces. The coward did an immediate U-turn and rushed right back out the door, never to be heard from by either of us again . . .

Our many private conversations about how Mom had taught her everything about image and success but forgotten to teach her anything about being happy . . .

My playing along with the drama when Natalie pretended to be too sick to work one day while she was shooting *West Side Story* as her way of protesting Jerome Robbins's being fired . . .

Natalie's disapproval when I posed for *Playboy*, after which her press agent contacted *Playboy* about her posing as well, but they couldn't come to terms with her wardrobe specifications and refusal to pose completely nude . . .

Our never-ending futile attempts, at one piano bar after another, to sing like Barbra Streisand . . .

There was even some comfort in remembering our arguments and that, no matter how serious they were, we always found our way back to one another in the end. Even at our worst, we couldn't stay too angry for too long.

There was so much joy and so much pain in all those memories and many, many more, and no matter how hard I tried to avoid it, they all inevitably led to the same excruciating question: *Why isn't she here?*

Of course, I wasn't the only one asking that question. The death of Natalie Wood continued to be "one of Hollywood's most enduring mysteries," which meant that constant reminders of her were inescapable. There were nonstop magazine and tabloid articles, television specials, documentaries, and requests for interviews. Most of them I turned down when it became obvious that they were more interested in exploitation than they were in facts, even if they had to make things up to create a sensational headline. A favorite among the few I agreed to started with a call from R. J.'s daughter Katie, who was working for MTV. She was producing an episode of the Lifetime series *Intimate Portrait* about Natalie and asked me to talk about some of my recollections of her. I agreed with great pleasure.

Included in all that attention was a call from a woman named Suzanne Finstad, who wanted to interview me for a biography she was writing about Natalie. I have to admit, my initial silent reaction was, "You and everybody's grandmother are writing a biography about Natalie." But I checked her out, and her credentials were impressive: journalist, lawyer, and author of some thoroughly researched biographies about everyone from Warren Beatty to Priscilla Presley to Jordan's Queen Noor. From the first time we talked, I appreciated how respectful she was of Natalie and of me. Suzanne didn't want to write a Natalie Wood biography to jump on the

moneymaking bandwagon that books about her had become. She wanted to write a book with heart and integrity. She wanted it to be thorough, and accurate, and compassionately objective. After all the opportunistic vultures who'd approached me over the years, she was a refreshing change of pace.

I felt exactly the same way about Dennis Davern's good friend Marti Rulli, who also began contacting me about the book she and Dennis were working on. Marti wasn't just another Natalie Wood groupie or a Dennis loyalist who was blindly trying to protect him and assuage his guilt. She was an experienced journalist who'd dug in hard for years to investigate the whole story of Natalie's last days on earth, wherever it led, and actually do something about it.

These two women opened up to me, and I opened up to them in return, more than I had to anyone else who'd reached out to me. I wasn't just a "story" to them. I was a human being in pain, and they cared. I was so grateful. I knew exactly as much about investigative journalism as I knew about nuclear physics, but finally here were a couple of people who had those kinds of brains and experience and were putting them to good use on Natalie's behalf. For the first time in a long time, I had some hope that, thanks to them, I might be on the way to finding out what the hell happened to my sister.

Suzanne even accompanied me on one of the more unique adventures of my life.

A woman I'd never heard of contacted me with a bizarre story: She'd worked for a doctor for many years, and when he retired and emptied his office, he told her to do whatever she wanted with his mountains of files, paperwork, and medical journals. "Whatever she wanted" translated to stacking it in huge piles in a storage facility and avoiding it for years, until her husband understandably begged her to sort through it and get rid of as much as she possibly could.

She was weeks into that process when she came across several handwritten pages she didn't recognize. It was only as she read through them that she realized, to her utter amazement, that she was looking at the unfinished memoir of one of her former employer's patients, Natalie Wood.

She contacted me to ask if I'd like a copy of it. Uh, yes, I most certainly would! Natalie's life, in her own writing, in her own words? What an unbelievable, unexpected treasure! I invited Suzanne to join me, and the two of us drove a long way to the trailer where the woman lived. She seemed very nice and very sincere, and I remember her asking me shortly after we arrived if I happened to know a man named Gavin Lambert.

I did. Gavin Lambert wrote the book and the screenplay of *Inside Daisy Clover,* a movie Natalie made with Robert Redford in the 1960s. Natalie, Gavin, and Mart Crowley had become close friends, and R. J. had kind of "inherited" Gavin after Natalie's death.

"Why do you ask?"

She explained that as soon as she realized she was in possession of Natalie Wood's original, unfinished autobiography, she'd contacted "Mr. Wagner's people," assuming he'd love to have it. "Mr. Wagner" immediately sent "Mr. Lambert" to see the manuscript. "Mr. Lambert" read it right then and there; called "Mr. Wagner" from the woman's trailer; told him, "I don't see anything in it that should be a problem for you"; and left without it.

She was surprised that "Mr. Wagner" wouldn't want to keep something so personal of his late wife's—if not for himself, at least for their daughters.

I wasn't necessarily surprised, but it did make me sad. R. J. had long since moved on—he was remarried, his life was moving forward—but still, those were Natalie's words. They were an

amazing way of keeping Natalie's memory alive—a way, weirdly, of hearing from Natalie.

And then she handed me a copy of Natalie's unfinished memoir. Up until that moment I'd held this fear that the document wouldn't actually be Natalie's at all, but any skepticism I was still holding on to vanished the instant I saw the pages.

It wasn't just the fact that I knew Natalie's handwriting as well as I knew my own, and this was most definitely hers. It was also the fact that the content was indisputably her "voice," her phrasing, her heart.

It was kind. It was discreet. And it was as fiercely protective as she was.

For example, she'd started writing it in 1966. She'd moved on from R. J. after their divorce in 1962, but it was understandably still a pivotal event in her life and one she needed to write about.

She could so easily have gone into detail and told the true, sensational story of walking in on an intimate encounter between R. J. and his butler. She didn't.

Instead, she gently let Warren Beatty off the hook, after years of whispers that he was the cause of Natalie and R. J.'s divorce, and focused on the emotional impact of R. J.'s unnamed betrayal of her:

"I have suffered in silence from gossip of my walking away from my marriage to go with Warren . . . but Warren had nothing to do with it. We began our relationship after, not before, my marriage ended . . . It is too painful for me to recall in print the incident that led to the final break-up . . . so shattering, it destroyed the relationship . . . It was more than a final straw, it was reality crushing the fragile web of romantic fantasies with sledgehammer force."

I shed many, many tears over passages about me—how close

we were, as sisters and friends and companions, and how much she loved me. At some point as I was reading it for the very first time, it hit me yet again, this time with total clarity: If the situation were reversed, if I had suddenly died without her knowing how or why, she would have moved heaven and earth to get to the bottom of it and see to it that she got justice for me. I would never forgive myself if I didn't do the same for her, no matter how long it took. And now that I had Marti, Dennis, and Suzanne in my corner, I was starting to feel as if there might be a distant light at the end of this very dark, twisted tunnel after all.

In the meantime, though, life had to go on, and it wasn't getting easier.

7

"It was the
last time
we ever spoke."

Our move to Thousand Oaks was working out well.

The house was perfect. It was comfortable. We each had our own bedroom where we could disappear for some much-needed, long-overdue privacy. It was big enough that we weren't bumping into each other every time we turned around anymore. And instead of vanishing into thin air every month, our rent checks were going toward the down payment. The thought of being a homeowner seemed almost too good to be true, particularly with Evan's expecting her and Eddie's first child.

Eddie and I both had full-time jobs, so it was a big help that Evan, at her own insistence, was in charge of running the household, from bookkeeping to chores to errands.

Mom liked having a bedroom of her own again, but in general she was getting more unpredictable and harder to manage by the day. It was exasperating, and it was heartbreaking. She'd draw all over the furniture with lipstick. She'd flush her diapers down the toilet and clog up the plumbing. She'd have irrational

delusions, like she did the afternoon Evan and I decided to go to Marie Callender's to pick up a pie for dinner. Mom still loved going places, and we thought she'd leap at the invitation to go with us. But no, not this time. She didn't just not want to go, she said she couldn't go.

The reason?

"Because the dead children are in the bathroom."

By then I'd learned the hard way not to argue with her or try to reason with her and convince her that she was mistaken, there were no dead children in the bathroom. It only frustrated both of us and got us nowhere. It saved a lot of time and emotional energy to just play along.

"The dead children will be fine," I promised her, never having dreamed that sentence would ever come out of my mouth. "We'll just close the bathroom door on our way out."

That satisfied her. She picked up her purse, and off we went. She seemed to be enjoying herself until we parked in front of Marie Callender's, when she stubbornly refused to get out of the car and come inside with us. Evan and I weren't going to be gone long, so we left her there, went in without her, picked up our pie, and came back out maybe twenty minutes later to find a strange, very upset woman standing beside my car, accompanied by a police cruiser and a couple of uniformed cops.

It seems that while we were inside, Mom had started yelling for help. The woman heard her and hurried over to check on her, and Mom grabbed her through her open window and cried, "Please help me! I've been here for two days!"

The woman, understandably concerned, called 911, and the cops were there in no time. It wasn't quick or easy, and I was picturing myself being hauled away in handcuffs for elder abuse, but we finally got things straightened out, I thanked the woman and

the cops, and we all left, with Mom wondering what the fuss was about.

We never left her alone again, at home or anywhere else. She was too much for Evan to handle, and I certainly couldn't afford a five-day-a-week caregiver, so I quit my job and devoted myself to my declining mom and my pregnant daughter.

It was shortly after the Marie Callender's incident that Mom had her first stroke and was rushed to the hospital.

She was a very religious, spiritual, superstitious woman, and Evan and I never came to sit with her in her hospital room without bringing an amulet of some kind to remind her of a story she'd told Natalie and me a thousand times, a story Dad had confirmed was absolutely true:

It was about a year before Natalie was born. Mom and Dad had met and married when Dad was working as a manual laborer, unloading sugar boats in San Francisco. Mom was out somewhere one day, just walking along on the city streets, when, with no warning, she suddenly collapsed. She was rushed to the nearest hospital, where it was discovered that an undiagnosed tubal pregnancy had burst and ruptured her fallopian tube. They performed emergency surgery to stop her massive internal bleeding, but she took a terrible turn for the worse, and they lost her. She was pronounced dead.

There were no cell phones in those days, of course, so they'd been unable to reach Dad until he got home from his carpentry job and received a call that his wife had passed away and was now lying in the hospital morgue.

As fate would have it, a letter had arrived that morning from Mom's mother in China, telling the story of the brown, withered flower petals she'd enclosed in the envelope. She'd been in church, she said, and the congregation had watched in awe during the service as sunlight streamed through the stained-glass windows and

brought the sanctuary's wilted flowers back to life. Everyone there that day was given a magically renewed flower to take home, and Mom's mother had decided to send hers to Mom.

Dad, in shock that his wife hadn't lived long enough to receive the letter, and in a hurry to get to her, picked up a locket he'd been keeping as a special-occasion gift for Mom, slipped a few wilted petals into it, and raced off to the hospital.

The doctors respectfully gave Dad a few minutes alone with Mom's body when he arrived at the morgue, during which he sadly fastened the locket around her neck . . . and moments later, everyone in the morgue area came running as Mom let out a very-much-alive, ear-shattering scream.

It was a miracle. She came back from the dead, with lots of utterly amazed witnesses, and the doctors were the first to admit they had no idea how or why it happened. Mom said later that she remembered collapsing in the street and then nothing, until she suddenly felt a warmth in her chest that began to spread throughout her body. She opened her eyes, not knowing where she was or why she was there, and she was as mystified as everyone else until Dad showed her the flower petals in the locket and told her the story behind them. Then, because she was Mom, her return from the dead made perfect sense.

So when Evan and I would sit down beside her in her hospital bed and close her hand around a healing stone or fasten a cross on a chain around her neck, I'd tell her, "Mom, if you can come back from death, coming back from a stroke will be a piece of cake."

I called Natasha to tell her what was happening with her grandmother, her "Baba," and she and Courtney came to visit her. They spent time alone with her in her room, we hugged when they left, and I never saw my nieces again.

Mom did make it home from the hospital, but she was bedrid-

den and in bad shape from then on. It was obvious that we didn't have much time left with her, and less than four weeks later she was back in the hospital on life support. She lingered for a day or two, but then, on January 6, 1998, her doctor quietly announced, "We've got to let her go. She's not alive in there."

I couldn't bring myself to be in the room when they pulled the plug. I couldn't watch her take her last breath. "The wrong one died" and all of our many years of differences aside, she was my mother. Her flaws led her to a lot of terrible behavior and a lot of terrible mistakes with Natalie and me, but the bottom line never changed—we both loved her. When her doctor told me a few hours later that she was gone, I fell completely apart.

It took some time for me to be able to talk again, but Evan helped me pull myself together enough to pick up the phone.

I called R. J.

I was too distraught to care that a call from me would be unwelcome, to put it mildly. He was the only link to family I had left.

Willie Mae answered. I asked to speak to R. J., and she panicked. "I can't put you on the phone with him," she whispered. "I'd get in so much trouble."

I managed to get out the words, "My mom died, Willie Mae."

There was a long silence. The next voice I heard was R. J.'s. He answered with a curt, "What is it, Lana?"

"Baba is dead. I thought you and the girls should know."

After a beat he said, "I'm sorry," and hung up.

No more or less than I expected.

LATER THAT DAY I WAS AT HOME, ALONE IN MY ROOM, LYING DOWN, EXHAUSTED. THE phone rang. To my surprise, it was R. J.

"I really am sorry, Lana. Are you okay?"

I told him that no, I wasn't, but said, "I will be."

I heard him take a breath before he added, a little awkwardly, "I just wanted to say that," and then he hung up again.

It was a totally unexpected flicker of empathy and humanity. For that moment, nothing else between us existed. It mattered to me, and I appreciated it.

It was the last time we ever spoke.

THE OPEN-CASKET FUNERAL WAS AT MOM AND DAD'S RUSSIAN ORTHODOX CHURCH in San Francisco. It was me, Evan, Eddie, Olga, her sons and their spouses, and around a hundred others. I gave the details of the service to R. J. and the girls through R. J.'s attorney ahead of time, but they didn't come. A hard rain fell on us at the cemetery, so we showed up that night at a sit-down Chinese-restaurant dinner for forty looking like a family of wet rats. Mom would have had a fit.

Mom missed the birth of Evan and Eddie's first baby by a matter of weeks.

They named him Nicholas. He came out of the womb insisting on being held and coddled and paid attention to, and he was loudly opposed to sleeping. Evan gradually started struggling emotionally after Nick was born, from some combination of her already existing issues, postpartum depression, and exhaustion, so let's just say I was a very actively involved grandmother.

I'd gone back to work at a furniture store close to the house a couple of months after Mom passed away, which allowed me to go home for lunch every day and also allowed Evan to bring Nick to "visit" me at the store when she was feeling overwhelmed. She felt overwhelmed a lot.

I was holding Nick one night, giving him his bottle, when I suddenly remembered one of Natalie's reactions to my inane first marriage: "If you have a baby before I do, I'll just die." She was serious about it when she said it, but we laughed about it years later, when she had her first baby, Natasha, in 1970, four years before Evan came along, and said, shortly after Natasha was born, "Thank you for waiting."

Of course, Natalie was never far from my mind, ever, but even the tabloids seemed to be taking what turned out to be a temporary break from their hobby of manufacturing headlines about her death to focus on the Bill Clinton/Monica Lewinsky scandal instead. From time to time I would find myself preoccupied with what seemed to be gaping holes in the police report on Natalie's death and my frustration that nothing could be done about it—after almost twenty years, it was still "case closed," no further investigating, no nothing. I hated it, but then again, I already had my hands full with personal current events, and they were about to get even fuller.

When Evan and Eddie told me two years later that a second baby was on the way, I somehow managed not to scream, "Are you out of your minds?!" But newborn Daphne essentially announced with her first breath that she was really quite independent, thank you, and had no interest in all that attention Nick demanded. She was as quiet as Nick was noisy. If she'd been taller, she probably would have prepared her own meals, and almost as soon as she could walk, she insisted on putting herself to bed every night.

We were at a routine appointment with Nick and Daphne's pediatrician one morning when, out of nowhere, the pediatrician's focus suddenly shifted from Daphne to Evan. He studied her for a long moment and then said, "There's a lump on your throat I don't like. You need to see your doctor ASAP."

She did, and the results were devastating: Evan was diagnosed with Hodgkin's lymphoma.

I'll spare you, and myself, the details, and the pages of adjectives trying to describe how awful the next few years were . . .

. . . the surgery on Evan's neck to remove some lymph nodes . . .

. . . the chemo and radiation . . .

. . . the damage to one of her lungs from radiation . . .

. . . the COPD, and her being put on oxygen . . .

. . . Nick, Daphne, and me sitting in the car in an underground parking lot for hours on end, week after week, while Evan got her treatments, so the kids wouldn't see what was happening to their mother inside the hospital . . .

. . . and Evan's emerging from the seemingly endless marathon of treatments and procedures with a serious addiction to pain pills.

She became mean and violent, and I hate to say that I didn't have the slightest idea what to do about it. She would threaten me if I didn't do what she wanted, and one thing she wanted, even expected, was that I help keep her pain pill supply well stocked.

That was *not* going to happen, but I would trick her into believing I was trying. We'd go to an urgent care clinic, and she'd say, "Go in there and show them your hands." (I'd developed arthritis by then, which was very visible in my hands.) "Tell them you're in terrible pain, and you desperately need some oxycodone, hydrocodone, whatever they'll give you." She'd wait in the car while I went inside. Then I'd sit in the waiting room for about twenty minutes, read a few out-of-date magazines, and come back out pretending to be disappointed and tell her they refused to help me no matter how much I begged. But it didn't matter. Somewhere, somehow, she was maintaining her own supply without me, leaving the rest of us in the household to pretty much live our lives trying not to upset Evan.

She'd been told by her doctors that because of her chemotherapy, she wouldn't be able to have more children. Her doctors were wrong. Baby number three, Max, was born in 2004, sweet, gentle, loving, and something of a miracle. During Evan's pregnancy, her ob-gyn broke the news that her fetus had Down's syndrome. We researched and worried and cried and did our best to prepare ourselves until shortly before Evan went into labor, when Max's prognosis was changed from "Down's syndrome" to, "Oops, our mistake, the fetus is perfectly healthy." He was, and is, and we were so grateful and so relieved. We had one more mouth to feed in a family that was already struggling, financially and emotionally, but we were grateful and relieved nonetheless.

I have more regrets in my life than I can count. I try not to dwell on them, but they still have a way of creeping into my thoughts. And at the top of the list is being so inept and uneducated when it came to helping my daughter. I just tried to keep the peace as best I could because I didn't know what else to do, and I look back now and realize I did it at her expense.

AND WHILE ALL THAT WAS GOING ON, THE "ENDURING MYSTERY" OF NATALIE'S death had begun heating up again. Suzanne Finstad's book *Natasha: The Biography of Natalie Wood* was released in 2001, followed by R. J.'s friend Gavin Lambert's *Natalie Wood: A Life* in 2004. The books sparked a fresh new wave of TV movies, documentaries, magazine and tabloid articles, and, inevitably, more requests for interviews with me.

I had two criteria for saying yes to those requests. They had to be coming from reputable, credible journalists, and those journalists had to be willing to pay for the interview. That, of course, triggered a new round of accusations from R. J. to anyone who would

listen that I was trying to profit from Natalie's death. Dennis Dav-
ern had been giving interviews as well, and R. J. accused him of
the same thing. It was a repulsive thing for him to say. I was still in
touch with Dennis and Marti, and I knew Dennis wasn't exactly
shopping for chateaus in the south of France in his spare time. As
for me, between the children, Evan, and my full-time job, I barely
had a spare moment to breathe, let alone set aside hours every week
for doing interviews, and I was in desperate shape financially. I
needed money—everything I had, and then some, had gone to
Evan's medical bills, since she had no insurance. Maybe most of all,
Dennis and I would have happily given up every dime we were ever
paid for interviews to still have Natalie around and for none of this
ever to have happened in the first place.

It was all I could do not to call R. J. when his book came out
in 2008 and ask him if he was trying to profit off Natalie's death.
It didn't make sense that he would accuse me the way he did and
then turn around and basically do the same. But confronting him
didn't have any foreseeable upside, besides taking a stand against
him, and anyway, I was too busy dealing with the foreclosure and
eviction we were going through at home to add another battle with
R. J. to my plate.

Ah, yes, 2008. That magical year of the mortgage and banking
crises and the stock market crash. And because, I'm sorry to say,
I was afraid of Evan, who never thought twice about chasing me
around the house and pushing me against walls if I tried to make
a decision she didn't like, I'd continued to let her manage the fi-
nances at home.

So I guess I shouldn't have been too surprised when we got
a notice one day that our mortgage payments were two months
behind. We frantically sent them a check, which they refused, and
next thing we knew, we were being evicted, with one day's notice to

vacate the house. We packed up what we could in a few hours, lost the rest, and moved to a nearby hotel. Me, Evan, Eddie, and three children, sharing a room in what we later discovered was one of the area's most notoriously haunted inns. We were spared any actual paranormal incidents, but the place was creepy enough that we only lasted one night before we trekked on to a more civilized hotel for three or four weeks. I still look back and thank God that our most valuable belongings, including some of my most treasured keepsakes of Natalie's, were safe in storage facilities, or we would have lost those in the eviction too.

Then a semblance of relief arrived, in the form of a house in Fillmore, owned by a former sheriff's deputy and available to be leased. Despite having an eviction on my credit history, I was approved somehow, and we were finally finished living in a single room with two queen-size beds, a rollaway, and one child sleeping on the floor. That house was a huge relief, until a little over a year later, when the former sheriff's deputy broke the news that it had been foreclosed on too. So we were off to another Fillmore rental house, and I was off to work, off to all the functions and meetings at the kids' schools, off to the inevitable chaos at home, and finally, when I faced the fact that I was really starting to emotionally unravel, off to a therapist, just like Natalie would have insisted I do years earlier.

As I told my therapist, I was feeling torn in two separate, equally important directions, and constantly afraid that when I was focused on one of them I was neglecting the other and disappointing the people I loved the most in this world.

On one hand, our latest rental house wasn't going to organize itself, and it certainly wasn't going to pay for itself, so taking time off from work wasn't an option. My grandchildren were very young and behaving exactly like kids who had a troubled, erratic mom;

a hardworking but fairly uninvolved dad; and a grandmother who always seemed to be at a dead run. They were probably wondering if they were ever going to live in a place where it felt safe to unpack, get attached, and call it "home." I was needed there, present tense, 100 percent.

On the other hand, I continued to be in touch with Marti and Dennis, getting more and more details about that night on the *Splendour,* Natalie's death, and everything that followed, and I'd feel as if I was letting my sister down, when she deserved 100 percent from me too.

Sometimes those phone calls lit a fire under me and made me determined to dive in and start asking questions . . . if I'd had a clue where and how to even begin . . .

Sometimes they made me feel inadequate, because other people, like Suzanne and Marti and a lot of television and print journalists, were working harder than I was to get to the bottom of my own sister's death . . .

My therapist was adamant that I needed to a) stop beating myself up about the possibility of disappointing everyone, since I was obviously doing all I knew how to do, and b) learn to compartmentalize, so that whatever I was doing at any given moment *could* get 100 percent of my attention.

He also believed that until I made peace with losing Natalie, I'd never find peace within myself. "Get more involved," he'd say. "Be more proactive." I'd ask, "How?" and he'd repeat a suggestion he felt strongly about—he was constantly urging me to file a wrongful death civil suit against R. J. I kept refusing. I didn't want money from R. J., and I certainly didn't want him in my head any more often than he already was, especially since his book *Pieces of My Heart: A Life* came out. I wasn't about to read it, but friends kept passing along snippets of it that contradicted things he'd said earlier,

things I'd been told by Suzanne, things that Dennis and Marti had told me that were included in their book, *Goodbye Natalie, Goodbye Splendour,* which had also come out.

Whenever I tuned into the noise of the media, or the recent pieces on Natalie, I felt worse than before. I didn't think that reading R. J.'s book would help me heal; if anything, I thought it would undo the progress I had already made.

Sometimes I'd leave my therapist's office feeling stronger, determined that if I just learned to focus and compartmentalize, I really could do justice to both life at home and my indebtedness to Natalie. Other times I'd leave with an almost paralyzing sense of hopelessness everywhere I looked, overwhelmed at home and wondering what the hell difference all this talk about Natalie's death made anyway, since as far as the police were concerned, it was an accidental drowning—almost thirty years ago.

Case closed. End of story.

OR SO I ASSUMED, UNTIL THE TIRELESS MARTI RULLI FOUND A WAY TO POSSIBLY turn that around and get the case reopened.

No guarantees, but worth a try, she said, and would I be willing to participate?

Finally, I thought, something proactive I could do, an opportunity to get involved, and finally, actually, maybe a way to *help.*

Did I want to get involved? I could have laughed with relief when she asked me.

Oh, my God, *yes!* In fact, *try to stop me.*

8

"Breathtaking news, in headlines all over the country."

t seems that a Washington, D.C., patent attorney named Vincent DeLuca was a Natalie Wood fan who had always been troubled by the way she died. He'd followed the countless media reports and interviews about it for years; and then he happened to read Marti and Dennis's 2009 book, *Goodbye Natalie, Goodbye Splendour*, which exposed what he felt were a lot of inconsistencies and a lot of holes in the original investigation. What he read bothered him so much that he decided to initiate an online petition calling for the Los Angeles County Sheriff's Department to reopen Natalie's case, and he reached out to Marti to work on it with him.

An online petition. I would never have thought of it. I didn't even know such a thing was *possible*. But I was inspired by the thought of people rallying together on behalf of Natalie, and of course when Marti reached out to me, I immediately said I would participate.

It was 2011 when Marti and DeLuca, after spending three months putting it together, posted the petition on a website called GoPetition.com in the hope of gathering signatures.

"Natalie Wood," it read, "was a Hollywood icon, beloved by millions for her performances in such classic films as *Miracle on 34th Street, West Side Story* and *Rebel Without a Cause.*

"Her bizarre death near the yacht *Splendour* on a chilly November evening in 1981 off Catalina Island has remained shrouded in mystery.

"Recent revelations, including admissions by Ms. Wood's husband, have shown that the initial investigation was seriously flawed and evidence ignored.

"We, the undersigned, call on the Los Angeles County Sheriff's Department to officially re-open the case of the death of Natalie Wood Wagner on or about November 29, 1981 and to review thoroughly and completely all available evidence."

Then, for added persuasiveness, Marti and DeLuca came up with the idea of asking a select few of us who had potentially worthwhile information about Natalie's death to write testimonials, outlining our reasons for believing the request to reopen the case was warranted, and attaching them to the signed petition as a package to submit to the Los Angeles County Sheriff's Department.

I'd also spent almost twenty years talking to Dennis and Marti. I'd given more interviews than I could begin to count. And I'd been frustrated for nearly two decades about the lack of forward movement, and the feeling that no justice was being served for Natalie.

At the moment, the case was still exactly where it had been for the last three decades: closed. If all this effort by all these people had even a slight chance of changing that, I wouldn't be able to live with myself, or face Natalie again someday, somewhere, if I didn't take a deep breath and give this assignment everything I had.

The testimonials would prove to be thorough, compelling, and, in most cases, painful for me to read. But at this point, not

reading them wasn't an option. Not writing one wasn't an option. As much as I wanted to be able to move on, to find closure, it was becoming clear that the only way to really seek justice for Natalie was to delve back into that horrible night on the *Splendour*.

Marti's testimonial consisted of several detailed pages of information, some of which hit me like a ton of bricks, even though I'd already heard most of them from her.

For example, she included the fact that R. J., in his 2008 book *Pieces of My Heart*, gave an account of Natalie's last hours on earth that was inconsistent with other versions he'd come up with since Thanksgiving weekend of 1981.

In his book, R. J. said that Natalie had already gone belowdecks when he and Christopher Walken got into an argument in the main salon of the *Splendour*. R. J. felt that Christopher was trying to interfere with Natalie's career, and out of anger, he broke the open wine bottle they'd all been sharing. He went below to look for Natalie, discovered she wasn't there, then went back up on deck and discovered the dinghy was gone. At first he wondered if maybe Natalie had taken the dinghy to get away from the arguing between him and Chris. But not a chance, he thought, because of her fear of water. And besides, he, Chris, and Dennis would have heard the dinghy being started. So next he decided she must have taken off in the dinghy . . . despite "not a chance because of her fear of water," despite "we would have heard the dinghy being started." His final conclusion in *Pieces of My Heart* was the time-worn "banging-dinghy theory," i.e., her hearing the dinghy banging against the side of the boat; slipping on the swim step trying to retie it; hitting the step as she fell, which stunned her; and rolling into the water while the dinghy came loose and floated out to sea.

As Marti pointed out, the "banging-dinghy theory" is transparently implausible. Just for starters, the two ropes that secured

the dinghy were reached from the transom, not the swim step, so why would Natalie have ventured down to the swim step in the first place? I had to agree with that. Natalie being as afraid of water as she was, I couldn't imagine her intentionally getting *close* to dark water. She wouldn't risk it, especially at night.

Chief Coroner Thomas Noguchi observed in his autopsy report that "decedent [Natalie] has numerous bruises to legs and arms." With the "banging-dinghy theory" pretty much ruled out as almost laughable, eliminating the probability that Natalie slipped on the swim step, where did all those "numerous bruises" come from?

Could they have been caused by any of the three men on board the *Splendour* with her that night? We'll never know. Those men were never photographed or even checked by the investigators for bruises, scratches, or any other wounds. It's something that I've wondered about ever since reading the testimonial.

Noguchi speculated that maybe all those bruises were the result of Natalie's desperate efforts, for hours, to struggle out of the cold ocean into the dinghy. But then Marti repeated his belief that the red down jacket Natalie was wearing weighed her down in the water, "causing a probable quick death." Which is it—she tried for hours to climb into the dinghy, or she suffered a probable quick death? Not to mention the fact that a down jacket wouldn't have weighed her down, it would actually have helped keep her afloat. And Marti, by the way, conducted her own experiment and discovered that if Natalie had spent hours clinging to that dinghy making effort after effort to pull herself into it, her wool socks would have come off in the water long before her body was found.

Another point Marti emphasized was the fact that it was approximately 11:05 p.m. when R. J. announced to Dennis that Natalie was missing; but it wasn't until 1:30 a.m., about two and a half

hours later, when the first ship-to-shore call for help went out to the local harbormaster from the *Splendour*, and another two hours, at 3:30 a.m., before the Coast Guard was alerted.

It was so difficult to read that testimonial, and seeing those inconsistencies laid out, wondering if, at some point along the line, Natalie *could* have been saved.

That timeline, and the reasons behind it, were detailed in Dennis Davern's testimonial, which was clearly as painful for him to write as it had been to share it out loud to me over all those years. It was different for me, reading his testimonial through for the first time, because the pain was so visible. I could see how deeply that night had shaped the rest of his life.

IN HIS TESTIMONIAL, DENNIS EMPHASIZED THAT WHILE HE'D NEVER LIED TO THE authorities, or to the attorney R. J. had immediately hired to represent him, he'd also never given any details to them about that night on the *Splendour*. Instead, he'd simply signed and adhered to the statement R. J.'s lawyer drafted. Neither the attorney nor the authorities had asked him more than a few questions. In July of 2008, though, when he and Marti Rulli were writing *Goodbye Natalie, Goodbye Splendour,* he took and passed a polygraph, administered by a credited polygrapher, about the information in that book that he repeated in his testimonial, and he made it clear that he was more than willing to submit to another one if the authorities asked him to.

The first several paragraphs of Dennis's testimonial covered the basics of that Thanksgiving weekend in general, starting with the *Splendour* leaving for a cruise to Catalina at about noon on Friday, November 27, 1981, with R. J., Natalie, Christopher Walken, and Dennis on board.

Dennis observed that it was a tense outing from the very beginning, and R. J. left no doubt in Dennis's mind that he wasn't one bit happy about Natalie's inviting Christopher, her *Brainstorm* co-star, to join them. The tension was palpable enough that Dennis offered Quaaludes, and all four of them took one. For Natalie to take any recreational drug, any medication that wasn't prescribed for her, was so completely out of character that I couldn't even imagine how on edge she must have been.

According to Dennis's testimonial, the weekend, along with the weather, seemed to just get colder and darker from there. On Friday afternoon, Natalie and R. J. argued about R. J.'s insistence on moving the *Splendour* from Avalon to Catalina's more desolate Isthmus. That night, Natalie left the yacht to spend Friday night at the Pavilion Lodge on the island. Dennis accompanied her. He actually tried to talk her out of returning to the yacht, given how uneasy the atmosphere was, but on Saturday morning Natalie decided to return.

After moving the *Splendour* to the Isthmus, Natalie and Christopher left the boat to go shopping and then off to eat at Doug's Harbor Reef Restaurant at the Catalina Isthmus. In their absence, Dennis tried to convince R. J. to cut the weekend short and return to the mainland. R. J. refused, insisting that "Natalie would get her wish fulfilled, a full weekend outing with her co-star." In his testimonial, Dennis described R. J.'s tone as "revengeful as well as ominous."

That night, Dennis and R. J. joined Natalie and Christopher for dinner at Doug's. Dennis and Christopher retrieved two bottles of wine from the *Splendour*, during which they smoked a joint together. After a tense dinner and a few after-dinner drinks, the four of them left the restaurant to return to the *Splendour*. En route, they discovered that the headlight on the dinghy wasn't working,

and they had to use a flashlight to make their way back to the yacht.

Once onboard the *Splendour* again, Dennis secured the dinghy with two ropes to the rear of the yacht and then joined R. J., Natalie, and Christopher for more wine. A conversation between Natalie and Christopher was interrupted by R. J. smashing the open wine bottle on the coffee table and yelling at Christopher, "Do you want to fuck my wife, is that what you want?"

Christopher retreated to his cabin for the rest of the night. Natalie angrily escaped to the master stateroom, R. J. following her minutes later. Dennis heard loud arguing and the thud of things ("possibly people") hitting the walls, went below to the stateroom to try to defuse whatever was happening, and was barked at by R. J. to go away.

At around eleven o'clock, the fight between R. J. and Natalie moved to the back deck of the yacht. They were yelling so loudly that Dennis turned on the radio, hoping to drown out their voices. Dennis glanced out at the back deck just long enough to see that Natalie had changed into her nightgown, and to hear R. J. shout at her, "Get off my fucking boat!"

Dennis became alarmed enough to go to the rear deck, where he found R. J. alone, looking "sweaty, flushed, anxious, nervous, and disheveled."

R. J. announced, "Natalie is missing," and told Dennis to search the boat.

In reading that part of the story for the first time, I was shocked. I remembered the claim in R.J.'s book that he'd discovered she was gone when *he* went belowdecks to look for her. What had happened to that?

Dennis found Christopher asleep in his cabin, and no sign of Natalie anywhere on the *Splendour*. He met R. J. in the wheelhouse,

where R. J. informed him that the dinghy was missing as well. Dennis immediately reached to turn on the searchlight and radio for help, only to be ordered by R. J. to do neither.

This was the first time I learned that R. J. stopped Dennis from turning on the searchlight. Needless to say, it floored me. Isn't that the first thing anyone would instinctively do when someone was suddenly missing from a boat in the middle of what was now a cold, rainy night . . . unless they were responsible for it and were scared of that person being found? I was pretty sure R. J. would have turned on the searchlight if he'd dropped his wallet in the water, for God's sake, but he didn't want it turned on to look for his wife? That didn't sit well with me.

After that, R. J. began pouring scotch for Dennis while explaining that bringing attention to the situation might tarnish his image.

After getting to that part in Dennis's testimonial, I had to stop reading for a while to absorb the idea that R. J.'s image was more important to him than Natalie's life. Than *anyone*'s life. And I'm sorry, but it's not as if he was Martin Luther King, or Mahatma Gandhi. He was the star of a TV series. Even if the press, God forbid, got wind of the fact that Robert Wagner was flawed, the world would probably have still managed to muddle along somehow. Maybe if R. J. had called for help immediately, Natalie could have been saved. That still haunts me. It seemed like another moment when she could have been saved.

According to Dennis, after an hour R. J. began crying and saying, "She's gone, she's gone, she's gone." It took another hour for Dennis to convince him to call for help. Instead of calling for professionals, R.J. radioed the island and said, "Someone is missing from our boat," without mentioning Natalie's name.

The local harbormaster, Doug Oudin, arrived and urged R. J.

to call the Coast Guard immediately. R. J. repeated his concern about tarnishing his image. Finally, at 3:30 a.m., R. J. relented, and the harbormaster radioed the Coast Guard with the missing person report. R. J., in the meantime, was primarily worried about what he would tell the authorities and the press and ordered Dennis to say nothing if and when he was questioned.

The Coast Guard rescue team began their search, with the help of a helicopter at daybreak. At 7:45 a.m. the news was relayed to the *Splendour* that Natalie's body had been found floating face-down. R. J. and Christopher Walken were helicoptered from the boat to the mainland before detectives arrived. At R. J.'s request, Dennis stayed behind to identify Natalie's body and noticed her bruises.

That part also turned my stomach. Natalie was R. J.'s wife. Not once, but twice. His youngest child's mother. All that love and history and fame and success together, and he didn't even want to see her, and hold her one last time, and say goodbye? I didn't understand it when I read that part of the testimonial, and I don't think I'll ever understand it.

Detective Duane Rasure briefly interviewed Dennis and then released him to return to the mainland, where a car was waiting to take him to R. J.'s house. R. J. and his attorney were there and Dennis was told to say nothing about Natalie's death.

A day or two later Dennis signed a prepared statement in an attorney's office, claiming that he knew nothing about Natalie's disappearance from the yacht. Detective Rasure came to the attorney's office and accepted the statement without asking questions.

R. J. asked Dennis to stay at his house, to retrieve the *Splendour* from Catalina, and to clean out everything in it. It was during that clean-out that Dennis found Natalie's earring in a corner of her and R. J.'s stateroom.

Dennis had actually already told me the story of that earring.

Natalie had gone shopping at a jewelry store in Avalon on the day before she died. She bought a gold chain with a fourteen-karat-gold piece of "pirate's gold" for Dennis and matching earrings for herself. She wore those earrings to dinner at Doug's Harbor Reef Restaurant that night, and it was one of those earrings that Dennis found on the floor in the master stateroom . . . days after the police had searched the yacht. I guess they hadn't collected it as a possible piece of evidence.

Dennis went on to state that he continued living at R. J.'s house for a year; that R. J. secured acting jobs for him for the next year or so; and that finally his conscience began to torment him so much that he confided in his trusted friend Marti Rulli, confessing to her that he believed there was foul play involved in Natalie's death.

He doesn't claim to have seen exactly how Natalie ended up in the ocean, and he promises to cooperate with authorities if and when they pursue the case, including submitting to another poly-graph test at their request.

I still remember thinking what a great job Dennis did with his testimonial, and how grateful Natalie would have been to him. She was fond of him and considered him a friend, and in the end, while it couldn't have been easy for him, he definitely honored that friendship.

AFTER READING DENNIS'S TESTIMONIAL, I ALSO REMEMBER TURNING TO THE TESTI-monial of a man named Roger Smith and thinking, "Who?" I didn't recognize the name at all.

Roger Smith, as it turned out, was a Catalina Baywatch Isth-mus lifeguard paramedic who was on duty the night Natalie died. He was the man who pulled my sister out of the water, and his name didn't ring a bell? I wondered why I hadn't heard of him

before, and why he hadn't been a part of the police report I read.

I reviewed Detective Rasure's police report. Nope, no mention of a Roger Smith. The investigators apparently hadn't bothered to question the person who brought Natalie's body on shore. No wonder the 1981 investigation only took two weeks. That part riled me up, and made me wonder if anyone else had not been interviewed. Was it possible there were multiple people with important information who just hadn't been questioned?

According to his testimonial, Roger joined the professional search and rescue team off Catalina at around 5:00 a.m. the morning after Natalie disappeared from the yacht. Six hours after R. J. told Dennis she was missing and refused to let him call for help. So it devastated me to read that Roger believed she could have been saved if she'd been found earlier, especially when the Baywatch Isthmus boat full of rescue equipment was only a hundred feet from where the *Splendour* was moored. In Roger's expert opinion, based on the fact that her fingers were still pliable when he removed her rings and she showed no signs of rigor mortis, she might have been alive in the ocean for several hours before she died.

He commented that her eyes were still open, and that he closed them and covered her with a blanket.

Those final images of my sister have stayed with me to this day: the removal of rings from those slender fingers, those hands I'd held, hands that had zipped up my dresses since I was a little girl; that had put makeup on me and gently wiped tears from my cheeks to comfort me when I cried; that had rubbed my shoulders, which she also laughingly referred to as "our" shoulders because we had an identical habit of tightening them up around our ears when we were stressed out; her impossibly big, beautiful dark brown eyes, still open when she was found, at peace, I hoped, not terrified . . .

I was so glad to know that someone took the effort to give her

those last pieces of dignity, and I knew I'd never forget the name Roger Smith.

According to Smith's testimonial, Sheriff's Deputy Kroll was with Roger after Natalie was found and before the detectives arrived on the scene. They talked to R. J. together and asked why it had taken so long for him or anyone else on the yacht to call for help. R. J.'s reply was something to the effect that they thought she was boat-hopping.

Much of Roger's testimonial described the negative career repercussions of his involvement in the search for and recovery of Natalie's body. He concluded his testimonial with, "So the famous Natalie Wood is gone. She died because of politics and poor decision making on many peoples' parts, as she cried for help for hours that night."

Roger was a very accomplished man. Not only had he been in charge of the Catalina Baywatch Isthmus rescue boat operation for ten years, but he was also one of the world's first lifeguard paramedics. He was a professional. An expert. The man who pulled Natalie's body ashore from the ocean and helped Deputy Kroll remove her red down jacket. The man who was sensitive enough that, instead of carrying her body through the gathering crowd on the island who'd begun hearing the news, he discreetly took her to the entrance of the decompression chamber at the U.S.C. Marine Science Center near the Isthmus, where he'd treated any number of diving disease victims.

But not once was he interviewed by the detectives covering Natalie's case. The media part I could understand—I'd seen how intense and scathing the coverage could be—but why not the detectives? Why wasn't he brought into the investigation?

In sharp, surprising contrast, while I'd never heard the name Roger Smith before, I did recognize the name "Marilyn Wayne"

when I read her testimonial. According to Detective Rasure's report, as an "ear-witness" on a boat called the *Capricorn* that was moored near the *Splendour* that night, Marilyn Wayne was interviewed by investigators on December 3, 1981.

But according to her testimonial . . . no, she wasn't. According to her testimonial, she was *never* interviewed by investigators. Not on December 3, 1981, not ever.

Marilyn Wayne stated that she and businessman John Payne were asleep aboard the *Capricorn* when they were awakened a few minutes after 11:00 p.m. by the sound of a woman's voice crying for help. The cries seemed to be coming from the boat moored about forty feet away, which she didn't learn until the next day was the *Splendour*.

No one answered when they called the harbor patrol. They then called the sheriff's office in Avalon and were assured that a helicopter would be on its way, but no helicopter showed up.

They could hear loud music playing, which they assumed must be coming from a party on a nearby boat, during which they heard a voice, "slurred, and in an aggravated tone," yell what they thought was something like, "Oh, hold on, we're coming to get you." Shortly after that, the woman's cries for help went silent.

Early the next morning they saw a police boat near the *Splendour*. It was only when they returned home to Newport Beach that they heard the news about Natalie's body being found on the Catalina shore, and they were sure it was her voice they'd heard the night before.

Marilyn shared the experience with a few colleagues at the stock brokerage where she worked, and next thing she knew she got a call for an interview. Not from Los Angeles County Sheriff's Department investigators. From the *Los Angeles Times*. She willingly granted the interview, believing she had what could be useful

information and hoping it would be noticed and followed up on by the authorities.

Nothing.

She then read Coroner Thomas Noguchi's published theory on Natalie's "accidental drowning" and, based on what she had heard that night, knew that his timeline was off. She called him to share her story and correct him. He talked to her, with no result at all.

While Detective Rasure had still never spoken with Marilyn, he began to refer to her in public as "someone seeking her name in the media," which understandably insulted her. She, like Roger Smith, would likely much rather have been quietly, privately interviewed by the proper authorities. "I never gave my full account until I was contacted almost twenty years later by author Suzanne Finstad," she said, "while she researched for her biography on Ms. Wood, titled *Natasha*." She was subsequently contacted by Marti Rulli for research on her book *Goodbye Natalie, Goodbye Splendour* and found that her timeline of the arguing on the *Splendour* and the loud music she heard was consistent with the timeline of Dennis Davern's account.

Three days after Natalie's death, Marilyn stated, she arrived at the stock brokerage where she worked and, as always, stopped to check her "client box." (Client boxes allowed clients to drop off messages for their brokers through a slot in the front of the box, labeled with the brokers' names. Brokers opened their labeled boxes from the back.)

On that morning Marilyn found a torn piece of paper in her box with the scribbled message, "If you value your life, keep quiet about what you know." Since the Natalie Wood drowning was almost all everyone was talking about, Marilyn suspected the note was a reference to Natalie's case. She promptly reported the threat to an attorney.

After Natalie's death, Marilyn didn't suspect foul play. She perceived R. J. as a grieving widower, mourning the loss of his beloved wife to a tragic accident at sea. That perception changed a few weeks later, when she and John Payne found themselves having dinner in the same Beverly Hills restaurant as R. J. and his mother. Thanks to the exhaustive media coverage of the death of Natalie Wood, Marilyn and John had become recognizable faces in town, and the restaurant's maître d' discreetly asked if they'd prefer to be moved to a table in another room. She and John chose to stay where they were. She saw R. J. look at them and recognize them from a few tables away, and they thought about walking over to offer their condolences but didn't want to intrude.

As the evening wore on, though, it became more and more curious to Marilyn and John that R. J. never approached *them*. He was still taking the public position that Natalie had simply vanished from the *Splendour* and he had no idea how or why. But here he was, just several feet away from the two people who may have been the last to hear her voice, and who were the first to call for help. No thank-you or even a nod of acknowledgment? Not a single question? Or had it been his slurred voice they'd heard that night along with Natalie's, yelling back that "we're coming to get you." It was possible he didn't need to ask them questions because he already knew the answers. But no one could say for sure.

Marilyn ended her testimonial by simply suggesting that it was high time R. J. be thoroughly interrogated and offering her assistance in "a full and proper investigation." As she put it, "If Robert Wagner wants the world to know he had done nothing wrong, he should be made to prove it."

And then came Marianne Pesci's testimonial. Another name I'd never heard before, but this time with good reason. Marianne Pesci was a clinical psychologist, not connected to Natalie's case in

any way; a fresh, objective pair of eyes with absolutely no stake in the game, recruited to offer her "psychological profiling" of R. J.'s "revelations and actions," and "his demeanor since the death," which she said, "falls in the category of clinically suspicious behavior."

It was interesting to read a testimonial by someone who wasn't at all personally connected to the case, but more interested in human nature and behavior. Surely, I thought, she could be more objective than me, or the other people who had been deeply and personally invested in the case. Some of the things she wrote really jumped out at me.

For one, she pointed out R. J.'s failure to either deny or acknowledge any of the publicly-revealed details given by eye- and ear-witnesses, like Dennis Davern and Marilyn Wayne.

She also read through R. J.'s 2008 autobiography, *Pieces of My Heart,* and pointed out that R. J. admitted to arguing with Natalie before she went missing. This fact was never mentioned to the authorities when they briefly interrogated him. She was also concerned by some of the things he revealed in that book, and what they said about him. There were things like "silencing" a photographer who took unsolicited pictures of his friend David Niven, hanging around outside Warren Beatty's house with a gun, hoping he'd walk out so he could kill him over Warren's affair with Natalie. In the multiple pages of the acknowledgments section of the autobiography, Natalie wasn't mentioned. Not once.

And then, of course, Marianne's testimonial included pieces about the case. Things like Davern's statement about R. J.'s smashing a wine bottle in a jealous rage on the *Splendour,* and R. J.'s failure, from the beginning, to demand a more thorough investigation. Not only that, Marianne felt he made efforts to keep others from talking about it and asking questions to further the investi-

gation. According to various witness accounts, R. J. had immediate concern about protecting his image when Natalie went missing from the yacht. Marianne describes this as "gravely suspicious."

Marianne Pesci concluded with the declaration that all of her statements were true and correct, and confirmed her willingness to cooperate with authorities concerning the Natalie Wood case if they believed she could be of any help.

After reading through all of the other testimonials, after feeling my heart sink and ache and *break* all over again, it was my turn to write. I felt some excitement—finally, I could do something for Natalie—and also I felt deep fear.

It was scary. I wasn't new at writing. I'd written all my life for my own enjoyment. I'd collaborated with author Wayne Warga on my 1984 book, *Natalie Wood: A Memoir by Her Sister.* I'd written some poetry. I'd revised more film and television scripts than I can even remember during my development and production career. But while I had a lot to share and a *lot* to say regarding the death of my sister and its aftermath, I'd also never written something with such high stakes, that mattered so much to me. I couldn't help but feel I'd be letting Natalie down if I didn't get it right.

My submission read as follows:

I, Lana Wood, a citizen of the USA, California, hereby state as follows:

I make this declaration for the purpose of inducing the Los Angeles County Sheriff's Department to re-investigate the facts and circumstances surrounding the death of my sister, Natalie Wood, on November 29, 1981, and to re-open the case for appropriate action as warranted.

On November 29, 1981, when I heard the news that my sister had drowned off the coast of Catalina Island, my mind was filled with confusion over the scant details offered officially and

personally. After learning witnessed details from Dennis Davern, the *Splendour* Captain who has contacted me on several occasions throughout the years since my sister's death, I believe that a thorough, official investigation is warranted with a reopening of the Natalie Wood case.

I have also learned new, disturbing details from the Coast Guard Captain, Mr. Roger Smith, who retrieved my sister's body from the ocean. In his expert opinion, he believes my sister lived for many hours in the ocean, and his claim that Robert Wagner said he did not call for help for Natalie Wood because he "thought she was out boat hopping" is outrageous. Wagner also claimed to Roger Smith that he did not call for professional help to protect his image.

Roger Smith claims he was never interviewed by the case detectives, despite the fact he had vital information to offer to the case. When he tried to become vocal with his account, he claims he was demoted and transferred off the Island.

I feel it is never too late to gather these facts that are now in the media, but apparently had slipped through the cracks during the initial investigation.

I believe that a reopening of the case will not only bring closure to the unanswered, lingering questions, but it will also bring true justice for Natalie Wood and/or for Robert Wagner. The remaining questions and suspicions surrounding the entire case brought to light by the 2009 book *Goodbye Natalie Goodbye Splendour* (by Marti Rulli and Dennis Davern) need to be officially investigated. A thorough investigation will reveal what is fact and what is theory, because I believe my sister's death case was closed based on theory alone. There seemed to be a rush to close the case to avoid media invasion.

My questions include:

1. Why was my sister's body full of bruises? A closer look into this fact might reveal appropriate answers.

2. Why was the case closed so quickly?

 According to Dennis Davern, a participant of the cruise in question, there was an argument aboard the yacht that was transpiring at the time of my sister's alleged disappearance from the yacht. Robert Wagner has since admitted in his 2008 autobiography that, indeed, an argument had transpired on November 28, 1981, between him and my sister.

3. Many new details have arisen since my sister's death from Dennis Davern, who witnessed what transpired before my sister drowned; from Roger Smith, the coast guard captain who retrieved Natalie's body; and from Marilyn Wayne, a nearby boater, who claims she heard my sister calling out for help at the precise time Dennis Davern claims an argument was in full force. Marilyn Wayne and Roger Smith say they were never interviewed by the authorities in regards to the case, and Dennis Davern claims he was hardly questioned by detectives. These three witnesses continue to be ignored by authorities.

4. Why was Robert Wagner sent home before having his body checked or being interrogated in relation to my sister's death? He was told to go home and grieve, and I do not believe that constitutes a thorough investigation.

5. Why wasn't an official timeline established in regards to the events leading to my sister's death? To my knowledge, the first comprehensive timeline was established by author Suzanne Finstad in her Natalie Wood biography, *Natasha*, published in 2001.

6. While Wagner is still available for questioning, I am requesting he be asked official, detailed questions in relation to my sister's death case that remains officially vague and closed.

I declare that all of my statements and requests herein above are true and correct and are based on my personal ambition to learn facts relating to my sister, Natalie Wood's, death from official sources. I feel it is unfair to Natalie's blood relatives to have had to learn factual, proven information from authors publishing their own investigations of my sister's death case. The case warrants professional attention, and I submit my request respectfully.

I am willing to cooperate with authorities concerning the Natalie Wood case, if there are any questions I can answer that would provide information pertinent to the case.

Signed by Lana Wood 2011

The petition, with all of the testimonials, was posted online. And I was amazed at how many people responded to it—upward of seven hundred people added signatures! All of those signatures, along with the testimonials, were submitted to the Los Angeles County Sheriff's Department.

I waited with bated breath. I kept going back and forth between being excited and hopeful that Natalie would receive justice, and being scared. Terrified, really. Was this our last chance to seek justice?

On Thursday, November 17, 2011, almost thirty years to the day since Natalie died, the LACSD announced that they were reopening the case.

It was breathtaking news, in headlines all over the country. I was overwhelmed. It took me days to even wrap my head around the significance. For the first time in years, I felt I *could* have some hopefulness about Natalie's case; the police's getting involved meant they too would see the contradictions Marti and Dennis and I had talked about so often, questions that various newspapers and articles were raising. Even though some of the accounts

strongly implied that R. J. was at the center of the story—that he had *deliberately* taken Natalie's life—I couldn't believe that. Obviously Natalie and R. J. argued that night. Obviously there was a lot of alcohol involved, on both their parts, and obviously things got ugly.

Really, all I wanted, more than anything, as I told CNN, was for the truth to come out. The real story.

Maybe now that the case had been reopened, it finally would.

9

"An almost unbelievable story . . ."

ooking back, I know there wasn't just one moment, just one "tipping point," that made the difference, that impelled me to change my position from "interested bystander" to "activist," even though it felt like it at the time. Instead, it was a culmination of things it became impossible to ignore anymore, no matter how much safer it had felt for more than three decades to only open my eyes every once in a while.

It was the stunning news of Natalie's case's being reopened. The rush of renewed hope, clashing with the dread of more meaningless noise and publicity, and the possibility that it might all lead exactly nowhere again.

It was the profound impact of reading the information in the testimonials that made it happen. I'd heard so much of it already from Dennis. But seeing it on paper, in black and white, made it more stark, more real, more painfully easy to picture every moment of my sister's last night alive and the awful hours that followed . . . and a sense of betrayal, after I'd assumed for all these years that,

despite all the stories to the contrary, detectives and coroners don't really shrug their way through an investigation when the subject at hand is the end of someone's life.

It was the sweet, painful clarity of Natalie's abbreviated memoir, holding it in my hands and reliving the wealth of memories and the precious, once-in-a-lifetime love she and I always knew we could count on between us.

It was losing Mom and that hollow sensation that my family was dwindling away.

It was my therapy sessions and my therapist's ongoing efforts to encourage me to be more objective when it came to R. J. "Maybe," he pointed out, "after needing Natalie's approval since the day you were born, you transferred that need to R. J. when she wasn't here anymore. But look at everything he's taken away from you for no good reason. I'm not advocating that you hate him. I'm just advocating that you take a long, hard, realistic look at him and work on letting go, so that when and if this reopened investigation turns up evidence you don't want to hear, you'll be prepared. Let's face it, what more can he do to you that he hasn't already done?"

It was the widespread media excitement about new life's being breathed into the thirty-year-old mystery. The *Hollywood Reporter,* on November 17, 2011, described the reopening of the case as a "shocking development." The *Los Angeles Times,* on November 19, 2011, observed that more than forty journalists attended the sheriff's department press conference announcing the reopening of the case, meaning that the thirtieth anniversary of Natalie's death "suddenly received the stamp of actual news." And on November 18, 2011, CNN quoted R. J.'s publicist Alan Nierob as saying that the Wagner family "fully support the efforts of the L.A. County Sheriff's Department and trust they will evaluate whether any new information relating to the death of Natalie Wood Wagner is valid,

and that it comes from a credible source or sources other than those simply trying to profit from the thirty-year anniversary of her tragic death." He added that no one from the sheriff's department had contacted R. J. or anyone in his family about the case.

All of those things and much, much more, I'm sure, made me literally wake up one morning knowing that I was done sitting on the sidelines. I couldn't spend one more minute of one more hour of one more day wishing that "someone" would get to the bottom of my sister's death.

I had no illusions that I could be that "someone." Literally millions of words had been written and filmed about the "enduring mystery of Natalie Wood." It had been investigated by more people than I could begin to count, many of them with a lot more skill, expertise, and contacts than I could ever hope to cultivate. I could definitely learn more than I knew, though. I could educate myself, start asking questions, and see where they led. I could send a message to my daughter and my grandchildren that even when it hurts, you don't turn away from facts, you face them, and when it's important, you do something about them. Even if they led nowhere but a series of rabbit holes, at least I'd be able to look myself in the eye—and Evan, and my grandchildren, and Natalie someday on the other side—and know that I tried as hard to get answers as she would have tried for me.

IT WAS ON THE AFTERNOON OF THAT SAME DAY WHEN A KNOCK AT THE DOOR OF THE Fillmore house revealed two men in suits standing there, asking for Lana Wood.

They introduced themselves as Detective Kevin Lowe and Detective Ralph Hernandez of the L.A. County Sheriff's Department's Homicide Bureau, and they wondered if they could come in

and talk to me. It was like I'd somehow summoned them there. I wanted to shout, "*God*, yes! *Please* come in and talk to me!"

We sat at my kitchen table for hours. They asked a million questions. About Natalie. Natalie and R. J. Natalie and me. Natalie and our family. That last Thanksgiving in 1981. What did I know about that last cruise on the *Splendour*? Had I talked to R. J. about it? Did I know Christopher Walken or Dennis Davern? They even wanted to see family photos, especially candid ones. They got a huge kick out of the shots of a poolside barbecue at Natalie and R. J.'s house, with family and friends and, oh, yes, by the way, Sir Laurence Olivier. I gave them a copy of Natalie's unfinished memoir.

They couldn't have been nicer, more attentive, or more thorough. I remember thinking when they left that this reopened investigation was in good hands. They came back three or four times over the next several weeks and invited me to call them whenever I wanted to ask for updates. There were things they wouldn't be able to discuss with me, of course, but they'd tell me what they could as their hard work progressed. They were determined. They were smart. They cared. They wanted justice for Natalie almost as much as I did; I felt certain of that.

The conversations with the detectives also motivated me. I'd resisted the temptation to ask Kevin and Ralph, as they insisted I call them, where the hell they'd been for the last thirty years. They were hardly the original detectives on the case, after all, so why hold them accountable for someone else's investigation? It wasn't something I could stay bitter about, not when these guys had shown up to do the right thing.

Since I'd read the first police report, which covered what the detectives had done in 1981, I knew there were some gaps in the information it covered. But if these visits from Kevin and Ralph were

any indication of investigative protocol, I couldn't help but wonder what else those initial detectives *hadn't* done. I wasn't interested in finding out so that I could bash them in the media or track them down and give them a good scolding. I just wanted to understand how we got to where we were—and more important, how we'd be able to move ahead.

A CLOSE CONFIDANT WHO WAS WITH ME EVERY STEP OF THE WAY ON THIS JOURNEY offered up a friend of hers, a retired LAPD detective I'll simply call Frank, so he won't be accused of being an aspiring publicity hound. He was kind enough to sit down with me one day and review both the first police report and the testimonials. Let's just say he was shocked but not surprised. In any investigation, especially a high-profile case like this one, he pointed out, you're supposed to do everything you can, from the moment you get there, to make sure it's all done right, by the book. Not this time.

For starters, it made no sense to him that R. J. and Chris Walken, two of the three eyewitnesses, were immediately "transported from the Isthmus of Catalina Island via Sheriff's helicopter to the Aero Bureau Headquarters." They should have been forced to stay on the island until they were questioned. As Frank put it, "It's not like the media was going to get there any time soon. I mean, they're at the Isthmus, which isn't exactly the most populous, accessible place on Catalina."

And once they arrived at Aero Bureau headquarters, R. J. and Chris should have been separated before they were interviewed. Granted, they'd had hours on the *Splendour* between the time Natalie went missing and the time her body was found to get their stories straight if that's what they were inclined to do, but two eyewitnesses being interviewed together can influence each other's

answers, even if there's no intentional deception going on. It's not indicated in the police report whether or not they were in separate rooms when they were questioned, and it should be.

R. J.'s interview began at 9:54 A.M. He explained that after he, Natalie, Chris, and Dennis returned to the *Splendour* after dinner on the island, they gathered in the salon before Natalie went to her bedroom. "Shortly thereafter they noticed she and the Zodiac missing. [Mr. Wagner] first called to see if she had gone back to the restaurant, and the next thing he recalled they were unable to find her and people were searching. Mr. Wagner was in an emotional state at the time of this interview, so it was terminated at this time." First of all, at *what* time? Chris's interview began at 10:00 A.M. Does that mean R. J.'s first interview about the death of his wife lasted all of six minutes? But something else was even more glaring, according to Frank: "Since when do you stop questioning a key witness just because they can drop a tear?"

The interview with Chris was just as confusing to him. "He recalled that after they were aboard the boat [after dinner on Catalina], he and Robert Wagner got into a small 'beef.'" A small "beef" about what? That comment wasn't pursued? Really? "He left the cabin and went outside on deck for a few minutes. When he returned, Victim Wagner was sitting there, and she seemed to be disturbed." Again, that wasn't pursued? Natalie, a.k.a. "Victim Wagner," was Chris's friend. He cared about her. Didn't he ask her if she was okay or what she was disturbed about? According to the report, no questions were asked about that either; Chris simply went on to say that "she then went to her room, and he thought she had gone to bed." He remembered Dennis's saying that both Natalie and the dinghy were gone, which he thought happened at around midnight, but he didn't hear a motor or a small boat. "He next remembered a shore boat coming alongside and Mr. Wag-

ner went ashore looking for the victim. He recalled Mr. Wagner returning and learning that neither she nor the dinghy had been found." How much time passed between Dennis's announcement that Natalie and the dinghy were missing and the shore boat's coming alongside to pick up R. J., and what was Chris doing during that time? He wasn't asked. "This interview was terminated at this time." At *what* time? How long was he interviewed? That should have been noted in the report.

Frank also pointed out, after reading Dennis's revised statement in the petition about R. J. and Natalie's loud fight in their room and on the deck (on which he passed a polygraph), that Chris apparently didn't hear the fight in a nearby cabin but heard the shore boat arrive. To be fair, during that initial interview, the investigator knew nothing about a fight, so he didn't pursue it and point out how illogical that was. But the whole description of that night makes it obvious that R. J., Chris, and Dennis had hours before they were interviewed if they decided they needed to get their stories straight.

"And maybe it means something, maybe it doesn't, but what's with Wagner's insistence on moving the yacht from Avalon Bay to the Isthmus at night, in a cold rain?" Frank asked. "For what? Avalon's about restaurants and shops and tourism. The Isthmus is more about hiking trails and camping and snorkeling. It's pretty deserted compared to Avalon Bay. Whatever the reason, though, that's apparently what caused the first fight between R. J. and Natalie. His wife was so upset about it that she went to a hotel onshore rather than spend the night on the boat, so why keep pushing it? Why not just give it up and stay moored where you are? Wagner wasn't asked about that?"

What may have driven Frank craziest of all, though, was the fact that there was no chronological, step-by-step account in the report

of how the investigation proceeded, and the passages about how the *Splendour* and the Zodiac were handled once the detectives arrived on the scene. As he put it, "This was a death investigation. You don't know when you first get there if you're looking at an accident, a suicide, or a homicide. So you need to start with an assumption of foul play, an assumption that you're dealing with a crime scene, and work your way back from there. You can always dial it down, but once it's been potentially compromised by other people tromping around, possibly destroying, hiding, or just moving evidence from one place to another, it's impossible to dial it up again. You secure the crime scene or scenes. Of course, in 1981, DNA wasn't a factor yet, but you still have forensics done, collect blood, fingerprints, hair, clothing, whatever else might be of evidentiary value."

He even laughed when he read the statement in the report that "the main salon was in disarray and showed evidence of broken glass on the floor, however there was no real indication of any disturbance." Yes, according to the report, "upon completion of the original investigation aboard the vessel *Splendour,* it was secured under the control of the Los Angeles County Sheriff's Department," an investigation that at the very least overlooked the earring in the corner of R. J. and Natalie's stateroom. And the Zodiac, which had been used by restaurant cook Bill Coleman to search for Natalie after it was found against the rocks on the Catalina shore, was "ultimately transported to the Isthmus and maintained by Deputy Kroll." There's no mention of whether or not it was forensically examined and, if so, what was or wasn't found.

"Also, about this Marilyn Wayne interrogation that never even happened, according to the petition. Let's say, purely for the sake of argument, that she really was just trying to get her name in the papers. That doesn't mean she doesn't have anything valuable to contribute to the investigation. You don't dismiss what she, or any-

one else, has to say because you've decided, based on nothing, that they might be a fame whore."

At that point, out of some combination of incredulity and frustration, I asked Frank what the possible explanation might be for all this apparent sloppiness and corner cutting. This couldn't be normal for a professional death investigation, please, God.

He took no pleasure in reluctantly answering, "They might have been starstruck. It happens."

"What happened to wanting to be extra vigilant when it's a high-profile case?"

"That happens too. But sometimes—and I don't know these guys, so this is just a guess—it goes the other way, and they want to give celebrities every break and every other bit of extra attention they possibly can."

Which prompted him to tell me an almost unbelievable story (with an emphasis on the word "almost"). It seems that before joining the LAPD, Frank was a bodyguard for a very, very influential Hollywood celebrity and his family. He never told me who it was. But one night the family discovered that their mailbox had been knocked down. They asked Frank to call the police, which he did, privately thinking they were overreacting, but hey, they didn't pay him to argue with them. He called 911 and explained the situation, including, of course, the name and address of the complaining mailbox owner. Within minutes, two squad cars, sirens blaring, screeched to a halt in front of the house, and four uniformed officers spent more than an hour conducting an in-depth investigation of a knocked-over mailbox, including photos, fingerprints, and any and all potentially relevant tire-track impressions. In case that didn't cover everything, a detective in a suit and tie showed up at the house the next morning with some follow-up questions. To the best of Frank's knowledge, the case remains open to this very day.

Obviously, I'd been around more than long enough to know how common it is for celebrities to get special dispensation from the authorities. I'd just never understood it. But as Frank explained it, the reasons vary. Some cops just like to see their names in the paper. Others think of it as bragging rights among their fellow officers, and/or an opportunity to think that a celebrity "owes them one." Still others are looking for potential off-duty security work, which can pay pretty well, or a nice little on-camera appearance, or a technical consultant credit on a series, or they might just happen to have a great idea for a screenplay . . .

"So in this case," Frank concluded, "you're investigating the death of Natalie Wood, a major movie star, and the first two guys you interview are Robert Wagner, a big-deal TV star, and Christopher Walken, who won an Oscar for '*The Deer Hunter*.' It shouldn't matter, but with some cops, even good ones, it just does."

I felt confident in assuring him that the detectives working the reopened case, Ralph Hernandez and Kevin Lowe, wouldn't fall into that trap. After meeting them several times and having several phone conversations with them, I was sure (and still am) that they had enough integrity and objectivity to take a thorough, professional approach to the investigation. In fact, in one of my most recent phone conversations with Ralph, he and I had reviewed the various stories R. J. and an eyewitness had told about that awful night in 1981:

- *The wine bottle was broken due to rough seas (R. J., in the initial police report)*
- *R. J. broke the wine bottle during an argument with Christopher Walken about Natalie's career after Natalie had gone to bed (R. J., in his book* Pieces of My Heart*)*
- *R. J. broke the wine bottle during an argument with Natalie*

and Christopher Walken in which he flew into a rage about the apparent closeness between them, with Natalie still present (eyewitness Dennis Davern, in Goodbye Natalie, Goodbye Splendour, *and in his testimonial)*

- *Natalie probably slipped and fell off the boat while trying to secure the dinghy to the* Splendour *(R. J., in his book* Pieces of My Heart*)*
- *Natalie probably got in the dinghy to go boat-hopping (R. J., to Deputy Kroll and Roger Smith, described in Roger Smith's testimonial)*
- *Natalie probably got in the dinghy to go back to the bar on the mainland (R. J., in the initial police report)*

AT FRANK'S SUGGESTION, WE WENT THROUGH THE LIST TOGETHER. LET'S SEE . . .

We could obviously rule out the wine bottle's being broken due to rough seas, since R. J. had finally admitted that he was the cause of the broken wine bottle.

We could rule out R. J.'s breaking the wine bottle after Natalie had gone to bed. Dennis had told me himself in one of our phone calls that he saw broken glass fly all over Natalie when R. J. smashed that bottle.

We could rule out Natalie's slipping and falling off the *Splendour* when she was trying to secure the dinghy. Dennis had explained to me more than once, and in his testimonial, that securing the dinghy didn't require going anywhere near the swim step where she supposedly slipped, and he specifically stated that when the foursome returned from dinner on the mainland, he personally tied the dinghy to the rear wall of the yacht with not one but two lines.

The "probably took the dinghy to go boat-hopping" and "probably took the dinghy and went back to the bar" theories were too idiotic to even consider, for any number of reasons. She would never have climbed down to the dinghy by herself, especially in the middle of a cold, rainy night; she'd never been in the dinghy by herself; and going out socializing in her nightgown and socks just would never have happened.

Frank cut to the same bottom line Ralph had when we finished going through the list, the bottom line that kept echoing in my head as more and more information came to light: "Why so many different stories, when there's really only one version of the truth? "

FROM THE DAY WE MET AND SAT DOWN TOGETHER WITH THAT FIRST POLICE REPORT, Frank was a great sounding board and a great help in general. He even admitted in one of our many phone conversations that he might not be as objective as he should be about R. J. It had nothing to do with the investigation and everything to do with a minor incident during his celebrity-bodyguarding days.

It seems his very-big-deal boss threw a very-big-deal party one night, one of those typical crowded, star-studded, see-and-be-seen Hollywood gatherings, and Frank and his fellow bodyguards were all on duty. Natalie and R. J. were among the guests.

When the party was winding down, Frank spotted Natalie and R. J. making their way toward the door. Being an attentive employee, he took it upon himself to escort them down the long driveway to the valet stand to retrieve their car. Once they were in the capable hands of the valets, Frank turned to head back to the house, but R. J. stopped him, reached in his pocket, and handed him a tip.

Frank glanced at it. It was two one-dollar bills. He caught a

glimpse of Natalie, who was standing behind R. J., looking embarrassed but not saying a word.

"What did you do?" I asked.

"What I wanted to do was shout, 'Wow, two whole dollars?! Gee, thanks, Mr. Wagner, now Mom can have that operation!' What I did do was hand him back his tip; say, 'It's okay, we're good, thanks anyway'; and walk away. And I admit it, all I could think, all the way back to the house, was, 'What an asshole.'"

R. J. always was a notoriously bad tipper. That story made me laugh, and it felt great—it had been too long since I'd laughed.

Natalie never told me that story, but she did tell me a similar one that had embarrassed her. It had always been my observation that R. J. was dismissive toward people he thought were inferior and/or couldn't be of any significant help to him, and incidents like this just confirmed it as far as I was concerned.

R. J. and Natalie were on their way to a meeting with a studio executive at Columbia one morning, and the executive had sent his assistant to escort them from the parking lot to his office. As they walked toward the building, R. J. asked the assistant where he might find a restroom. The assistant gave him directions, after which he turned to her with what he probably thought was his patented Robert Wagner charm and added, "Yes, believe it or not, sometimes even *we* have to use the restroom."

Natalie was mortified and managed to sneak an apologetic glance to the assistant. But as usual, she didn't say a word about it to R. J.

I shared that story with Frank to reassure him that the two-dollar tip was nothing personal, it was just R. J. being R. J., and "Even *we* have to use the restroom" became a popular running joke between us.

And I couldn't resist adding an amusing bit of trivia from a

Hollywood see-and-be-seen party I'd attended with R. J. and Natalie. I was sitting at the bar in whoever's mansion it was, talking to Rock Hudson. Underneath that impossibly gorgeous movie-star exterior, Rock was a down-to-earth Midwestern boy at heart, fun and funny, without a pretentious bone in his body. At one point, we both happened to be watching R. J. across the room, glad-handing his way around the show-business royalty, acting as if he were running for mayor, and I noticed Rock shaking his head and quietly chuckling. I looked at him, smiling, and I didn't even have to ask what he was chuckling about.

"I know he's your brother-in-law, Lana, and I mean no offense, but . . . I've known R. J. for years. Not well, but we're both under contract at Universal, and we run into each other all the time. He's always seemed to be kind of full of himself, so just to try to bring his swelled head back down to size, I've stopped calling him 'R. J.' and started calling him 'Skippy.'"

That put Frank on the floor and became another running joke between us, and I loved knowing that, even though she'd never mentioned it to me, Natalie was probably aware of Rock's "Skippy" nickname for R. J. and got a huge kick out of it when R. J.'s back was turned.

Whoever coined the adage "Laughter is the best medicine" knew what they were talking about. Sharing stories like that with Frank and laughing with him always lifted my spirits and, even if only for a few short minutes, took my mind off the police investigation, which sometimes seemed as if it would never end.

OF COURSE, TIME WENT ON, AS DID MY CONVERSATIONS WITH KEVIN AND RALPH. WE were in touch several times a month, and they were deeply invested in Natalie's case. They were also generous with as much informa-

tion as they could give me without ever breaching their profes-
sional confidentiality, which both frustrated me and made me
admire them even more. So, not wanting to put either one of them
on the spot, I called Frank instead when I dug around and found
a document Ralph had mentioned a couple of times without going
into detail: a "supplemental autopsy report," dated May 20, 2012.

I didn't know any more about reading autopsy reports than I'd
known when I read the first one, which is why I enlisted Frank to
go through it with me. I did know enough, though, to do a double
take when I saw, on the very first page, that the cause of Natalie's
death had been changed from the original "accidental drowning"
to "drowning and other undetermined factors."

I didn't exactly understand what that meant, but eliminating
the word "accidental" seemed pretty significant to me.

10

"I'm no expert, but I doubt it."

was scared of what could emerge in reading this revised, updated autopsy report but glad to have someone by my side to talk me through it. Frank came prepared when we sat down at my dining room table with Natalie's supplemental autopsy report. He brought pages of notes from the first autopsy report, the first police report, the petition that reopened the case, and even a quote from Dr. Thomas Noguchi's 1983 book *Coroner:*

"In any case of unusual death it is a first duty of medical examiners to suspect murder."

"Apparently Dr. Noguchi didn't find Natalie's death unusual," Frank observed. "A bruised woman drowns in the ocean in her nightgown and socks in the middle of the night. Yeah, that probably happens all the time." He rolled his eyes, took a long sip of coffee, and added, "No wonder he was demoted." Then he slid a page from the first autopsy report in front of me and pointed to a section that covered "general evidence collection."

"What does it say about nail scrapings and nail clippings?" he asked me.

I looked at the X's in the boxes beside those two entries. They were both in the "Not Collected" column. So either the coroner accidentally forgot to check those boxes, or he neglected to gather the nail scrapings and nail clippings.

Frank explained that collecting nail clippings is "like, autopsy 101" and said, "Was there foreign tissue under her nails, like maybe rubber from the dinghy if she tried to climb into it when she was in the water? Or how about skin tissue from a fight with someone on the *Splendour*? Of course, the cops never bothered to check for injuries on any of the three men who were on board with her, and we didn't have DNA in 1981. But we've got it now. We could easily find out whose skin tissue it was if Noguchi had bothered to collect and examine those nails."

So much for my ability to read an autopsy report and understand what I was looking at. I hadn't noticed that. Or, if I had, the significance of it hadn't hit me.

"Not that it would have done any good even if they had been collected, apparently," he went on. "Take a look at this."

He turned to a chart in the report that listed evidence from the autopsy, with a column headed, "Item still in our custody?" The following items had the word "No" beside them:

AUTOPSY REPORT	
Hair Kit	No
Pubic Hair Kit	No
EDTA/Whole Bid	No
Blood Swatch	No
Modified SAK	No
Medical Evidence	No
Autopsy Blood	No
2 additional tubes of blood	No
Bile	No
Urine	No
Liver	No
Kidney	No
Stomach	No
Intestinal Contents	No
Nasal Swabs	No
1 Jar containing Neuropathology blocks	No
1 Jar containing regular Histology blocks	No

Items with the word "Yes" beside them:

Neuropathology slides x 5	Yes
Regular slides x 5	Yes

Again, without really knowing what I was looking at, that seemed like a lot of evidence that wasn't "still in our custody." Frank emphatically confirmed that yes, it certainly was. And besides . . .

"They disposed of items that would hardly have taken up any storage space at all," he said. "It's not like the Robert Kennedy door frame and ceiling tiles."

The story he told me was apparently still an occasional source of incredulity among his fellow detectives while he was on the force: After the Robert Kennedy assassination in a pantry at the Ambassador Hotel in 1968, the LAPD found three bullet holes in the ceiling and two more in the door frame to the pantry. The trajectory of those holes suggested that there might have been two shooters instead of just one, Sirhan Sirhan, who was ultimately convicted of killing Robert Kennedy and is serving a life sentence. Any further investigation into the assassination was severely hindered by the fact that the door frame and ceiling tiles that were collected as evidence at the time no longer existed—they weren't just disposed of, they were incinerated by the LAPD. The chief medical examiner–coroner in charge of the Robert Kennedy case was, coincidentally, Dr. Thomas Noguchi.

According to Frank, because Dr. Noguchi officially declared the cause of Natalie's death to be "accidental drowning," the coroner's office was only required to store all those autopsy specimens for three years. But if he'd classified it as a homicide or an unde-

termined death, the requirement would have been to store them indefinitely, and the coroner and investigators on the reopened case would have had a whole lot more evidence to analyze, with the added bonus of DNA in their arsenal. Without that, the next steps were . . . well, severely limited.

And then there was the matter of the bruises. When the supplemental autopsy report was released in May of 2012, the acting chief medical examiner–coroner/interim director, Dr. Lakshmanan Sathyavagiswaran (according to Detective Ralph Hernandez, he's simply referred to as "Dr. L") wrote in his report that he was concerned about the "non-accidental mechanism for certain bruises of the upper extremities" that "appeared fresh and could have occurred before [Natalie] entered the water."

Which sent Frank off on something else in his notes that had really caught his eye.

"Again," he said, "I'm just a retired detective, not a trained medical examiner, but check this out: There's a note in the original autopsy that Natalie's bladder contained three hundred ccs of urine. I looked it up, and it turns out that's a lot of urine, especially for a woman as small as she was. Now, we're talking about the ocean, in the middle of the night in late November. Average water temperature, about sixty-four degrees, sixty-five, and there's a thing called cold-water shock. Among a lot of other things, cold-water shock should have caused her to void her bladder the second she hit the water. But her bladder was still full when they found her all those hours later."

I asked if he was suggesting she was already dead when she hit the water.

He shook his head. "The cause of death was definitely drowning, so obviously she was still alive, although cold-water shock could

also have caused her to involuntarily inhale water and drown almost immediately. What I am suggesting is that maybe she was already unconscious when she hit the water. Maybe the cries for help Marilyn Wayne heard came from the back of the boat, not from the freezing ocean, when Natalie realized she was losing her fight with R. J. and was about to go overboard. If she was conscious, I think she would have automatically emptied her bladder. That didn't happen, so what other explanation could there possibly be?"

It was comforting, a little, to think that Natalie might have been unconscious when she landed in that dark, churning sea. The obvious question, though, was what made her lose consciousness. The urine had never been mentioned in the news, nothing like that. It was essentially overlooked information, and something that—had the original cops paid any attention to it—surely would have pointed to the fact that Natalie could very well have been unconscious.

Frank read from the autopsy report that she had "superficial abrasions on her left forehead, left eyebrow, and the left upper cheek area . . . But there was no evidence of head trauma." He looked at me and added, "Unconsciousness, from superficial abrasions? Like I said, I'm no expert, but I doubt it."

I was especially intrigued by the "full bladder" issue, so after Frank left I called Ralph, knowing he was very familiar with both the first and second autopsy reports, and asked what he thought about it. The word he used was "huge."

"I'm not sure how or if it would hold up in court as absolute proof that Natalie went in the water unconscious," he told me. "I imagine a defense attorney would have no trouble finding some expert to contradict it, or at least leave room for reasonable doubt. But yeah, to me, it's huge."

That struck me. A new theory, decades after Natalie's death. A *huge* new theory, potentially.

We talked about the fingernail cuttings ("I'll never understand how or why Noguchi overlooked that") and the "non-accidental mechanism for certain bruises of the upper extremities," some of which, in Ralph's opinion, looked "assaultive in nature" and one of which, on Natalie's arm, "looks almost like a handprint." I'd never seen the autopsy photos. I never will. And Ralph assured me it was a wise decision on my part—"If it were a family member of mine, I wouldn't want to see them either," he said.

Finally I asked him a question that had been nagging at me since Frank and I had started going through the autopsy reports together.

"Do you think there's a chance that Dr. Noguchi was pressured to skate through this autopsy and come up with his 'accidental drowning' conclusion?"

Ralph didn't even take a breath. "We'll never know, Lana, and we'll also never get anywhere if we waste time trying to chase down a bunch of speculation that would never hold up in court."

Point taken. I dropped the subject.

(A few years later, by the way, in 2016, Dr. Noguchi sat for a deposition in a civil case brought by an attorney named Sam Perroni, who wanted access to the confidential police files on Natalie's death. Dr. Noguchi was asked under oath if he'd collected her fingernail clippings as part of his postmortem examination. His answer was, "I don't remember." This from the man who, with the two simple words "accidental drowning," irreversibly compromised the thorough investigation into my sister's death that she—that everyone—deserves.)

The more closely I started looking into what had happened to

Natalie more than thirty years earlier, the more infuriated I got at the number of people who apparently saw nothing wrong with dancing around the truth—which made meeting Marilyn Wayne a refreshing change of pace.

MARILYN WAYNE WAS AN "EAR-WITNESS" TO THE FINAL MINUTES OF NATALIE'S LIFE, the woman on a boat moored near the *Splendour* whom the police claimed to have questioned a few days later, the woman Detective Rasure dismissed as someone who was "seeking her name in the media."

She and I met for lunch, and my impression of her was that she was anything but a "fame whore"; she had only come forward back then because she genuinely wanted to help with the investigation. She was adamant about the timeline she'd given in the petition to the sheriff's department, that it was shortly after eleven P.M. when she heard a woman yelling for help—a timeline that matches up perfectly with Dennis's account of that night and with the coroner's estimated time of death, around midnight on November 28, 1981. Because Dennis would have turned on loud music by eleven P.M. on the *Splendour* to drown out the arguing between R. J. and Natalie, I thought she probably misconstrued exactly what she heard. With the likelihood that Natalie was unconscious when she went into the water, Marilyn might have heard her yelling for help from the back of the *Splendour before* she left the boat, if her argument with R. J. had turned physical and she was frightened of what she thought he was about to do.

Marilyn was also adamant about the fact that she'd left three or four messages at the sheriff's office before anyone bothered to call her back.

"If I just wanted my name in the papers, wouldn't I have been calling the *Enquirer* instead of the sheriff's department?" she asked

me. Good question, and I felt sorry for her that Detective Rasure had been so publicly insulting toward her.

I felt even sorrier for her that she was a little frightened of R. J. again, now that the case had been reopened and was back in the press. As she mentioned in her testimonial, three days after Natalie died, Marilyn had found a written message in her client box at work: "If you value your life, keep quiet about what you know."

It was understandable but so unfortunate that she didn't still have the note more than three decades later. Ralph and Kevin could have had it checked for fingerprints and maybe even DNA, and questioned the person who wrote and delivered it to find out who put them up to it. Wouldn't that have been interesting? But it's certainly not Marilyn's fault that it no longer exists, thanks to "accidental drowning/case closed."

After our lunch, I forgot my sweater when Marilyn and I left the restaurant. I didn't even notice it was gone until a few days later, when it arrived in the mail. From Marilyn. Who'd been thoughtful enough, and honest enough, to pick it up and send it to me. It was a nice sweater. She could have just held on to it, and I would never have known. I remember thinking at the time that this wasn't a woman whose integrity Detective Rasure, of all people, had any business questioning.

In fact, it was probably that lunch and its aftermath that compelled me to do something I'd been avoiding for decades: I made myself watch a televised interview about my sister's death. I'd never done it before, and I've never done it since. Well-meaning friends and fans would send me VHS tapes (remember those?) and DVDs of newsmagazine TV shows featuring Natalie's case, which I would squirrel away the instant they arrived, even if they were shows I'd participated in. Just the thought of watching them was and still is excruciating.

But all this talk about Detective Rasure reminded me that a few years earlier, someone had sent me a copy of a 2011 episode of *48 Hours*, filmed shortly after Natalie's case was reopened, and I was very curious to know if they'd interviewed Rasure and, if so, how he was feeling about his handling of the investigation thirty years ago.

I FAST-FORWARDED THROUGH THE SHOW UNTIL, SURE ENOUGH, THERE HE WAS, SER-geant Duane Rasure, looking much less like a cop than like the Arizona horse rancher he'd become since he retired in 1985.

"I still get questioned to this day about the case," he said. "Did he really kill her, or didn't he? No. No. She fell off the boat and drowned accidentally. If it was suspicious, I would have worked the case as a murder. I didn't have any suspicions that anybody had injured or killed or drowned her. None whatsoever. I don't think there was any cover-up. Maybe not the full truth, but I don't think there was any intentional cover-up at all. Natalie went to go to bed. Robert Wagner and Christopher Walken stayed there in the galley talking for a while. Robert Wagner went to check, and he found her missing. About the same time, now, the captain on the outside of the vessel saw that the Zodiac was missing. They assumed that she got in that Zodiac and went ashore. When I hear the story about what the captain, Dennis Davern, has to say, I can only believe partially that there was an argument, there wasn't any fighting, the smashing of the bottle could have occurred. I think Dennis Davern is exaggerating this whole incident to sell his book. The only information I found out about what Dennis Davern claims he saw, he should have told me at the time. That's a murder investigation. He's almost saying that Robert Wagner pushed

her overboard. They were together, and she disappeared? That's a murder investigation. But I don't believe him. There was no confrontation between the two of them, Robert Wagner and Natalie Wood. If I would have had the evidence that Robert Wagner killed Natalie Wood, I would have arrested him personally. I stand by the investigation I conducted completely. The poor lady drowned."

I suppose it shouldn't have surprised me, but it did. Even three decades later, with all the new information that had come out, particularly in the testimonials, he was still standing by his investigation "completely." An investigation in which, by his own account, he interviewed R. J. for a few minutes and then sent him home and failed to interview people he should have; and, just as he'd dismissed Marilyn Wayne as someone who was just trying to get her name in the paper, he accused Dennis of exaggerating the whole incident to sell his book.

The one comment I did agree with—and so did Kevin and Ralph, thank God—was, "They were together, and she disappeared? That's a murder investigation."

Still, watching that interview made me feel sick. I felt that I shouldn't have been surprised, but I was, and I just hated to see someone being so dismissive of all of the discrepancies I now knew all too well.

I was so worked up after watching that interview that I decided to call Detective Rasure myself and ask if he'd at least bothered to read the supplemental autopsy report that was issued in 2012, a few months after his comments on *48 Hours*. Ralph told me I was too late—it was 2016 by the time I saw that interview, and Detective Duane Rasure had died two years earlier.

Kevin and Ralph had reminded me repeatedly in our many conversations that there were always setbacks in any investigation,

but reopening an investigation on a death that happened decades ago was bound to come with even more setbacks than usual, from failing memories, to witnesses who had long since disappeared, to witnesses who'd passed away, to witnesses who were still maintaining their right to stonewall the investigators. Like R. J., for example. Kevin and Ralph had made several attempts to question him. They even went to his home in Aspen, but he wouldn't come to the door. Perfectly within his rights, of course, just a little ironic in light of a statement from his attorney Blair Berk: "Mr. Wagner has fully cooperated over the last thirty years in the investigation of the accidental drowning of his wife in 1981. Mr. Wagner has been interviewed on multiple occasions by the Los Angeles Sheriff's Department and answered every single question asked of him by detectives during those interviews."

"Things like this are a marathon, not a sprint, Lana," Ralph reminded me. "We get discouraged sometimes too, believe me. But getting discouraged doesn't mean giving up, so hang in there and rest assured, we're *not* giving up, and neither should you."

I had no intention of it, and I had all the faith in the world in Ralph and Kevin and their team. But the truth was, I still felt as powerless as ever. No matter how hard I tried, and what bright ideas and theories I might come up with, who was I kidding—after all these years and the countless people who'd been working on Natalie's case, did I really think I was going to make some kind of difference in getting to the bottom of it?

Some mornings I'd wake up energized, ready to attack a list of people to call, with possible brainstorms I wanted to run past Ralph, or Dennis, or Frank, or my therapist, or . . .

Other mornings I'd wake up hopeless, depressed, and almost unbearably anxious, thinking I'd give anything for a crystal ball

to tell me what was going to happen so I could stop this endless, exhausting wondering.

Looking back, I realize it's a blessing that I didn't have a crystal ball. If I'd known what was right around the corner, what was headed toward me like a freight train, I probably would have said, "Just shoot me now, because there's no way I'm going to survive that."

11

"A lot of theories, and a lot of speculation . . ."

The landscape at home had changed a lot in the years since the investigation into Natalie's death was reopened. My son-in-law, Eddie, continued to work full-time, but it became impossible for me to maintain a five-day-a-week nine-to-five job anymore.

The requests for TV and magazine interviews and podcasts were flooding in, and I wanted to take every legitimate opportunity to help keep the investigation in the spotlight. *Dr. Phil, Inside Edition, The Dr. Oz Show, Today, Nancy Grace, Piers Morgan Live*—you name the show, I was probably on it. It wasn't easy or enjoyable, being called upon time and time and time again to sit in front of cameras on national television to talk about my dead sister and be asked many of the same questions I'd already answered a thousand times before. It was also stressful having to consider every word that came out of my mouth so that I wouldn't be misunderstood or attacked by R. J. again.

But it held true to what I had promised myself I would do for

Natalie—and it really did seem important, like something Natalie would have done for me without a moment of hesitation. Still, doing press didn't come without its issues. In fact, the press in general was so aggressive that I had to call the nonemergency local police number and have a patrolman get rid of news crews that thought blocking my driveway was a great way to inspire me to open up.

To make up for the loss of my steady, much-needed income as best I could, I gratefully accepted roles in several independent films.

And at the core of these changes and my need for a more flexible schedule was the undeniable reality that Evan was falling apart. The issue was drugs. She was horribly unhappy with everything and everyone. Her temper would rage out of control, and I was generally the recipient. She was still determined to be in charge, as opposed to being the girl who never left home, but she'd become incapable of taking care of her children and the household, which pretty much left it all up to me. Driving the kids to and from school, attending their school meetings and activities, making sure they did their homework, being in charge of grocery shopping and cooking and cleaning . . . In other words, at the age of seventy, I essentially became the mom to my eighteen-year-old, sixteen-year-old, and twelve-year-old grandchildren, while my daughter sank deeper and deeper into her opioid addiction.

The kids, in the meantime, were struggling with everything from the changes in their mother, to adjusting to our recent move to Reseda, to my stress overload, to just being teenagers, acting out with rebelliousness, skipping school, and drama with schoolmates.

Evan had been diagnosed as bipolar, but she much preferred pain pills to the prescribed medication she refused to take. I finally convinced her to let me give her my hour with my therapist. She

stuck with him for about five sessions, until he told her something she didn't agree with and she refused to go back. She was also the only family I had left, and I clung to her. I rarely did anything without her, and her friends and mine became as interchangeable as Natalie's and mine had been.

She developed a second addiction to the shopping channel and eBay. She became obsessed with antique jewelry, clocks, bizarre antiques, an antique samurai sword—you name it, she *had* to have it, spending money as fast as Eddie and I could earn it. Even when she emptied my modest savings account not once but twice, I continued to turn myself inside out to try to be her best friend and keep as much peace in our home as I possibly could. (In other words, looking back, I kept right on enabling her, because I was afraid of her and afraid of losing her and didn't know what else to do.)

Evan's anger seemed to escalate when Natalie's case was reopened and I started to get more involved in the investigation. Ralph and Kevin interviewed her once, briefly, when they came to the house, and she wasn't openly uncooperative, but the truth was, she had no interest in any of it and actually resented the amount of my attention it took away from her. I'm sad to say that Evan didn't like her aunt Natalie. I think part of it was that she knew how much I loved Natalie, which made her a competitor in Evan's eyes. Another part, that I deeply regret, might have come from her being privy to the one time in my life when I can remember being truly infuriated with Natalie, an event that centered around the death of our father.

CONTRARY TO WHAT'S APPARENTLY BECOME "COMMON KNOWLEDGE" ABOUT OUR family, we most certainly didn't live off Natalie's income. Dad left

the house every morning at four thirty for his job as a very talented set builder at the studios. He never missed a day of work and, in fact, worked so hard to support us that he had chronic heart problems.

He was a quiet, introverted man who spent most of his time at home reading historical books or sitting alone after dinner playing his balalaika and having a small glass of vodka. But to dispel another myth about him, he was *not* an alcoholic. The only times he ever drank to excess were on rare weekends when he and Mom were having problems and his violent temper would flare up, and Mom would climb out a window to get away from him, or push me out a side door and tell me to go to a neighbor's house until he calmed down.

Dad and I were never as close as he and Natalie were. There were so many things I admired about him and learned from him, though, including his work ethic, his passion for reading, and his complete, down-to-earth lack of pretense. Natalie and I were never quite sure what our parents were doing together—here was Mom, a social butterfly who couldn't get enough of dressing up, going to parties, seeing and being seen, ambitious to a fault and all about image—and then there was Dad, who hated the whole Hollywood party scene but never stood in Natalie's way and much preferred staying home with his books and his balalaika.

In October 1980, Dad had yet another major heart attack. When they finally moved him home from the hospital, I went to visit him and apparently went into complete denial over the obvious fact that he didn't have much time left. I'd never lost someone I loved before, and I couldn't bear the thought of losing him. So when Natalie called later that day and said, "I've written a eulogy for Dad," I lost my temper and snapped back, "He's not dead, Natalie." She ignored me and pressed ahead with, "Let me read

it to you." I didn't really listen, I just sat silently until she stopped talking, at which point I growled, "That's terrific, but he's still not dead. You do whatever you want, though," and hung up the phone, steaming through uncontrollable sobs. I get that she was trying to prepare herself for the grief, and that I wasn't yet ready to face the inevitable, but that was brutal.

The next month, just under a year before Natalie died, our dad passed away. Once the arrangements were made for his funeral in San Francisco, I called Natalie and asked if Evan, who was six years old at the time, could stay at her and R. J.'s house with her cousins and their live-in nanny Willie Mae while we were all up north saying good-bye to Dad. At that time, I couldn't afford to hire a babysitter for a few days or buy plane tickets to San Francisco for both Evan and me, and it would give Evan a chance to spend time with Katie, Natasha, and Courtney, whom she loved.

Natalie said, "No." No explanation, no apology, just, "No."

I had no choice—I stayed home in L.A. with Evan and missed my father's funeral. It was a tremendous disappointment that I carried with me for years, although I never confronted Natalie about it or loved her any less. I figured she had a reason for saying no, even if I didn't know what it was. Still, it pained me. Of course it did.

I never knew how much Evan overheard of all that or how much she was aware of; I just learned that it was better to not mention Aunt Natalie around her. I felt terrible about it, and partially responsible. Evan's resentment only grew as more and more of my time and attention were directed toward magazine interviews, TV appearances, and long talks with Kevin, Ralph, and Frank about the investigation. It often seemed like I was supposed to make a choice between my sister and my daughter.

I chose both.

IT WAS SATURDAY, JULY 8, 2017. EDDIE WAS AT WORK. EVAN AND THE KIDS AND I were at home. The TV was blaring in the living room. Max was on his computer playing video games. I was in the kitchen making lunch when Evan came wandering in. I barely glanced at her, until she announced, "Mom, I can't feel the side of my face. I feel dizzy."

I turned to look at her, just in time to see her collapse and go into a series of violent convulsions. Terrified, I threw myself on the floor with her and tried to hold her while I yelled at the kids to call 911.

By the time the paramedics arrived, Evan had been without a heartbeat for about twenty minutes. They managed to get her heart started again, tubed her, put her on a ventilator, and sped off to the hospital, while the kids and I followed close behind.

Once she'd been admitted, attended to, and hooked up in her bed, I told the kids to go in and quietly tell their mom how much they loved her. They were as frightened as I was, and I couldn't bring myself to suggest they tell her good-bye—I was desperately clinging to the same hope I wanted them to hold on to. They were sad and silent when they filed back out of her room, and we were in too much shock to say a word to each other as I drove them home.

Evan never regained consciousness or breathed on her own again. She was surrounded by machines, tubes, and a pad that kept her body temperature low. She didn't speak. She didn't move. The doctors who were qualified to test her for brain activity weren't available until the following week, so we just sat with her and held her hand and prayed, day after day, night after night.

It was ten days later when her doctors told me it was time to let her go. I knew they were right. I knew she was gone. But it was still the hardest thing I've ever done in my life to give them permission to pull the plug.

She was forty-two years old when I kissed her one last time. Her date of death from cardiac arrest was officially recorded as

July 18, 2017. I will always believe that she actually died in our kitchen, with my arms around her, before the paramedics even arrived to take her away.

We held a private service for her at the Joseph P. Reardon Funeral Home in Ventura, California. Her father, Richard Smedley, and Richard's wife and children couldn't make it here from Texas but sent a spectacular flower arrangement. I was especially touched by how many of my former colleagues from American Telecom were there, some of whom had been good friends of both mine and Evan's. None of the Wagners were there, nor were they expected.

Evan was cremated. Her ashes are with Eddie, her children, and me in our little house in Reseda, where she lived and died.

If you haven't experienced losing your child, I'm at a loss to describe the soul-searing pain of it. Three years later, as I write this, I still can't find the words. It's unreal, but it's also unspeakably, unavoidably real. The depth and breadth of the grief are overwhelming, like a wide, dark, endless road with no exit ramp.

In my case, it's still a constant mantra of regrets—that she didn't have a more joyful life, that she didn't know peace and health while she was here—and prayers: that she's found that joy, peace, and health on the other side, that I could please, please have a do-over . . .

And that I can always keep the promise I made to her when I said good-bye to her, to take the best care I possibly can of Nick, Daphne, and Max, the children she left behind and loved to the core of her sweet, troubled soul.

Evan's favorite of the antique table clocks she collected sits on a table in our living room. It's broken, with its pendulum just hanging there, and it hasn't had batteries in years. One morning, months after Evan died, the pendulum began gently moving back and forth, and the clock began chiming. For three days it kept

perfect time. Then it stopped, and it's never kept time or chimed again.

And in the kitchen where she collapsed and her heart stopped, cabinet doors occasionally swing open, and dishes are thrown to the ground and smashed when no one's in the room.

I could barely function for months, but not functioning at all wasn't an option. I was living with Evan's widower and my three grandchildren who'd seen their mother suddenly collapse and die. It was a dark, crushing time, and they needed their lives to go on as normally as they possibly could. So did I. They needed me, and I needed them just as much.

There may have been an interview or two in the fall of 2017. I was in such a deep fog of grief that I can't begin to remember. Finally I hit a wall and spread the word that the answer to any further requests to discuss Natalie's case would be a resounding "No!" It wasn't that I didn't care, obviously. It was that I was too unfocused and emotionally exhausted to deal with it, or much of anything else beyond putting one foot in front of another.

On the rare occasions when I was able to focus on Natalie's case, I found nothing there but discouragement. It had been six years since it had been reopened. Detective Kevin Lowe had retired by then, and Ralph was now hard at work with Homicide Bureau lieutenant John Corina. And from what I could tell, the result of those six years and hard work was pretty much zero, other than a lot of talk, a lot of noise, a lot of theories, and a lot of speculation. I kept trying to remind myself of Ralph's comment that this investigation was a marathon, not a sprint, but it seemed to be one hell of a long marathon, with no promise of a finish line. Especially in the wake of losing my only child, I wasn't just in a perpetual state of depressed hopelessness about putting a period on the unknowns of my sister's death; I was afraid to hope at all.

So when Ralph called one morning in early February 2018, I assumed he was just checking in to tell me there was nothing new that he could share with me, which he was kind enough to do once a week or so.

Instead, he was calling with an invitation.

"We're holding a press conference about Natalie's case on Monday," he said, "and I thought you might like to be there."

I asked him what was going on that would warrant a press conference.

"I'd tell you if I could, Lana, but you'll have to wait until Monday."

Curious? Of course I was. Getting my hopes up? It was hard not to, but sorry. Been there, done that.

12

"The last
thing I want to
believe . . ."

O n Monday, February 5, 2018, Lieutenant John Corina of the Los Angeles County Sheriff's Department stepped up to the microphone in front of a battery of anxious reporters, lights, and cameras to make an announcement about the investigation into the death of Natalie Wood.

I opted to stay home, alone, watching the "breaking news" on TV. My heart was in my throat. I didn't know what to brace myself for. Whatever it was, though, I wanted to react to it in private, without the press's circling me in pursuit of a quote they could publish or a photo of me with mascara streaming down my face. This wasn't about me, this was about my sister.

"We've interviewed a lot of new people," Lieutenant Corina began. "People who were on the island, people who were moored near the boat that night or that weekend . . . and it's been extremely helpful. There's actually more than one witness who came forward and heard them [R. J. and Natalie] on the back of the boat arguing . . . and then it goes quiet. So those witnesses,

who were on a different boat nearby, corroborated exactly what Dennis Davern was telling us . . .

"As the investigation progressed we were able to create a time-line and get it down to where he [R. J.] was the last person with her on the back of the boat arguing before everything went quiet, and next thing you know, Davern comes down to check on what happened and there's Robert Wagner in the salon of the boat say-ing, 'Natalie's gone. She's missing.' And then he sends him around the boat to look for Natalie, and it's not that big a boat, and next thing you know he tells him, 'Oh, and by the way, the dinghy's now gone.' It didn't make any sense. No one heard the dinghy start up, no one heard the dinghy take off, she doesn't drive the dinghy, I could go on and on, it didn't add up . . .

"And then, yes, there were bruises on Natalie Wood's body that—that's the coroner's purview, obviously, they're the experts—they say they're non-mechanical, they were caused probably by another person. And yes, of course we want to talk to Robert Wagner, we'd love to hear his side, his version of events. The ver-sion of events he's portrayed in the media and what he told the original investigators and what he's portrayed since then really don't add up to what we've found by talking to other people about that weekend . . .

"This is not a murder investigation, so he's not a suspect. This is a suspicious death investigation . . ."

Which led to Lieutenant Corina's announcement that the Los Angeles County Sheriff's Department was officially naming Rob-ert Wagner a "person of interest" in the death of Natalie Wood.

I kept waiting to feel excitement, or surprise, or relief. It didn't happen. Beyond gratitude to the detectives and these unnamed witnesses who'd come forward, I didn't feel much of anything. "Person of interest" was progress, but "not a suspect" meant there

was still a long way to go before maybe, finally, R. J. would be properly interrogated and go on record with an account of that night that, unlike his previous accounts, actually *did* add up.

Ralph provided some additional information on the two new key witnesses during a podcast he recorded a few months later for American Media Inc., called *Fatal Voyage: The Mysterious Death of Natalie Wood*.

"They're not looking for limelight. They're not looking to have anyone pay them for interviews. In fact, we actually had to seek them out and find them. People have asked us why we believe that they're credible, and actually, their reason for not coming forward is what lends to their credibility." They hadn't come forward in 1981 because Natalie's case had been officially ruled an accidental drowning.

It made me furious with Dr. Noguchi all over again.

WITH ROBERT WAGNER NOW A DESIGNATED PERSON OF INTEREST AND TWO NEW very credible anonymous witnesses giving their accounts of what they saw and heard to the investigative team, Natalie's death was all over the headlines again. The press was swarming. My phone was ringing off the hook with interview requests. And my answer to every phone call and every request was, "No."

It wasn't just that I was still very fragile from losing Evan and that I was trying my best to stay focused on my grandchildren. It was also that I'd abandoned any illusions I might have had, once upon a time, that what I thought mattered, that there was something I could do or say, or some bit of insight I could offer, that would make a difference and finally put an end to all this.

I would have bet that no one could convince me to go on camera again to talk about Natalie, but I would have lost that bet.

It seems that *48 Hours* had booked Ralph, Lieutenant John Corina, and Dennis Davern for a new episode called "Natalie Wood: Death in Dark Water," about R. J.'s being named a person of interest, the two new witnesses who'd come forward, and other updates to the case, and they wanted a few on-air comments from me. Erin Moriarty was going to be the correspondent on the episode, and I had nothing but the greatest respect for her.

I couldn't and wouldn't say no to Detective Ralph Hernandez, after all he'd done and was continuing to do on behalf of my sister and me. All it took was one "please" from him, and I was in.

I MADE MYSELF WATCH THE EPISODE, AND I WAS GLAD I DID. MOST OF THE INFORMA-tion I already knew. Some of it was news to me. And I was reminded what good hands the investigation was in with Ralph, Detective Kevin Lowe, and Lieutenant John Corina.

Before he retired, Kevin traveled with Ralph and Dennis to Hawaii, where the *Splendour* had been moored in Ala Wai Harbor, unused and deteriorating for almost twenty years, and Dennis walked them through a reenactment of what he saw and heard on the last night of Natalie's life. Not until 2018, when R. J. was named a person of interest, did the detectives talk to the press about what those trips uncovered, evidence that Lieutenant Corina said confirmed his suspicions that much of what had been previously reported wasn't exactly what happened. Dennis's reenactment corroborated what witnesses on nearby boats said they saw, and none of them had met or talked to Dennis to get their stories straight.

Ralph and Lieutenant Corina were even thorough enough to track down a man who told the story of the only evidence of alleged violence in R. J. and Natalie's relationship. I'd never heard this story, nor had Natalie ever told me about it. But it seems that

in 1960, when this man was twelve years old, he and his family lived in the same Beverly Hills neighborhood as R. J. and Natalie, and he still remembers one night when Natalie was suddenly pounding on their door yelling, "Help me, help me, he's going to kill me!" She came inside, terrified, wearing a white sweater that was stained with what looked like red wine, but she said she didn't need medical attention. The father went outside and saw R. J., who was looking for Natalie. The father, who thought R. J. seemed drunk, told him that Natalie was okay and was with them, after which R. J. left, not even bothering to go inside to check on her and try to calm things down between them. Natalie didn't feel safe enough to go home until the next morning. I talked to Ralph about that story after the *48 Hours* telecast aired, and he pointed out that while it proved nothing about what happened on the *Splendour* on November 29, 1981, it was solid circumstantial evidence that there was at least one incident of domestic violence between R. J. and Natalie.

One of the anonymous witnesses whose boat was moored near the *Splendour* had actually heard the Friday night argument about R. J.'s wanting to move the *Splendour* from Avalon Bay to the much more desolate Isthmus and Natalie's being so fiercely opposed to it that she had Dennis take her ashore to spend the night at the Pavilion Lodge. That witness commented that Natalie sounded intoxicated and seemed to be the aggressor. I wasn't surprised. Natalie wasn't quick to anger, but when she got mad, she got extremely mad, especially on the rare occasions when she'd had too much to drink. And there were two things that could push her to her limit: any form of cheating, and R. J.'s temper, which, by all accounts, was an issue all weekend due to his jealousy over Natalie's friendship with Christopher Walken. Given enough anger and enough alcohol, I have no trouble imagining R. J., five foot eleven, two

hundred pounds, assaulting Natalie, and Natalie, five foot two, one hundred twenty pounds, fighting back, first in their stateroom, where Dennis heard enough yelling and banging to knock on the door and be told by R. J. to "go away," and then on the back of the boat, where they were heard and seen by the two new witnesses.

Which could easily explain the autopsy report and photos Ralph and Lieutenant Corina briefly described—the fresh abrasions on the left side of Natalie's face, the fresh bruises on her upper body, the four-inch bruise on her right forearm, and the fresh bruises and scratches on her legs, all of which led Ralph, a veteran homicide detective, to observe, "She looked like the victim of an assault."

One of the excerpts from the audio version of R. J.'s book *Pieces of My Heart* had him saying about the "banging dinghy" story, in which he suggested maybe she slipped on the swim step while trying to secure the loose dinghy, "My theory fits the few facts we have." Which had never been more clearly untrue to me than when *48 Hours* showed Dennis, aboard the *Splendour,* beside the cleats where the dinghy had been secured with not one but two lines . . . nowhere near the swim step. And obviously, for the dinghy to be missing at the same time Natalie was discovered missing, someone had to untie it. As Dennis pointed out, "I didn't untie it. Christopher didn't untie it. I don't think Natalie would have untied it." So who does that leave?

Ralph summed up where the case stood in 2018 with a simple, sobering, "We haven't been able to prove it's a homicide, and we haven't been able to prove it's an accident. We still don't know how she got in the water."

Two people, recognized as R. J. and Natalie, on the back of the boat, arguing, enraged. And then there was one. And then there was silence.

It had never seemed more real and more chilling to me than it did on that *48 Hours* episode.

But nothing chilled me quite as much as a clip they showed of a 2008 interview R. J. did for *CBS Sunday Morning* about the night Natalie died:

"Believe me," he said, "if she had called out, or she had made any noises or we'd heard anything, there were three of us there. We would have done something. Nobody heard anything. When you're in love, you're responsible for the other person. She was responsible for me, and I was responsible for her, and this accident that occurred . . . I wasn't there. I wasn't there for her, and that's always within me."

"I wasn't there for her." This from the man who, when he "noticed Natalie missing," refused to let Dennis turn on the searchlights. Who kept pouring scotch for himself and Dennis rather than look for his missing wife, and waited for more than an hour to call and ask people to look for her—not in the dark, stormy ocean, but in town. Who finally reluctantly called the Coast Guard more than three hours after Natalie disappeared. Who didn't identify her body but sent Dennis to do it instead.

"I wasn't there for her" was perhaps the one thing R. J. and I could agree on.

IN 2019, PRESUMABLY IN RESPONSE TO R. J.'S NEW "PERSON OF INTEREST" STATUS, Natalie's daughter Natasha produced a documentary for HBO called *Natalie Wood: What Remains Behind*. By then, of course, I was completely estranged from both my nieces. Friends kept telling me that Natasha was tearing me to shreds in print and on social media. "You've got to read what she's saying about you, you're the 'crazy aunt,' accusing her and Courtney's precious father of hurting

their mother," blah, blah, blah. I went out of my way not to read a single word of any of it. I knew it would just hurt me. I also had no intention of engaging in some ridiculous back-and-forth, "did too, did not" spat with her, which would accomplish exactly nothing except creating further resentment.

So when I was approached to film a segment reflecting on Natalie for Natasha's documentary, I was surprised, and I was very, very torn. I agonized for weeks over it and spent a lot of sleepless nights wondering what to do. I wondered if there was a way in which the documentary could bring us some healing, if it might allow for a neutral opportunity for us to finally talk about my sister and her mother. If that was a possibility, surely doing the documentary would be worth it.

Finally, and not easily, I did the only thing that felt right and wrote a letter to the project's director, Laurent Bouzereau:

M. Bouzereau,
After a great deal of thought and self-examination, I have come to a decision.

I cannot put myself in a situation where the persons making the film don't like me, respect my feelings or want to have anything to do with me.

I am incredibly hurt and have shed many tears and wished many times to be able to be with my sister's children. I do desperately want to keep her memory, her accomplishments, beauty, and capability for love alive.

I sincerely wish all of you involved tremendous success and know you will produce a beautiful film.

I wish things were just a bit different, but sadly, they aren't. Not now, perhaps never.

*Please let Natasha know that I completely understand she
also wishes to keep her pain and her family's at a minimum. I
will always love Natasha and Courtney and hold no anger or
ill will toward them.*

Sincerely,

Lana Wood

I couldn't bring myself to watch the documentary. But in the
intervening years, retired detective Frank and I had become pals.
He did watch it, and he called me the minute it was over, just
to share something he thought might make my jaw drop open as
much as it did his: apparently, in *Natalie Wood: What Remains Be-
hind*, R. J. seemed to have fallen back on his old "slipped and fell
off the boat while trying to secure the dinghy" position.

It amazed us both that after decades to think about it, he chose
one of his explanations that has long since been refuted, totally shot
down.

I'M WELL AWARE THAT MANY PEOPLE, ESPECIALLY R. J.'S DAUGHTERS, WONDER HOW
I can believe he ended Natalie's life.

All things considered, at that point, how could I not? By the
time 2019 drew to an end, the facts seemed to be aligned in such a
way that there was only one thing for me to believe, really.

For decades, I fought believing that R. J. would deliberately
hurt Natalie. It continues to be the last thing I *want* to believe.
What possible pleasure could I take in thinking that the last thing
my sister saw in this life was the furious face of her husband, hover-
ing above the dark water that terrified her, or that the last words she
ever heard were, "Get off my fucking boat!"?

Why would I want to think that this man I've known since I was nine years old, my former brother-in-law, the father of my niece, could cause this to happen?

It wasn't me who turned my back on R. J. It was R. J. who turned his back on me, almost from the moment Natalie died— stonewalling me; excluding me from our family and mutual friends; allegedly blacklisting me in the business; prohibiting Evan and me from living with Mom when he moved her to Barrington Plaza, despite the fact that he knew she was in no condition to live alone; maybe even warning my own mother not to see or talk to me, accusing me of trying to profit from Natalie's death . . . and for what, when the only thing I ever wanted, the only thing I still want, is the answer to the question that's haunted me for four decades now—what happened to my sister?

I didn't want to have to go out in search of those answers myself, but I finally had to, and I did.

Based on everything I've learned, this is what I've come to believe:

I believe that on the night of Saturday, November 28, 1981, R. J., Natalie, Christopher, and Dennis took the dinghy back to the *Splendour* after dinner and drinks at Doug's Harbor Reef Restaurant on the Catalina isthmus.

I believe that they continued drinking when they were aboard the *Splendour,* where the anger that had been building in R. J. all weekend about the closeness between Natalie and Christopher exploded, causing him to smash a liquor bottle and lash out at Christopher.

I believe that Natalie, furious with R. J. over his behavior, stormed down to her and R. J.'s stateroom and changed from her clothing into her nightgown and socks, during which R. J. burst into the room to confront her.

I believe that an alcohol-fueled argument between them escalated into a physical confrontation.

I believe that Natalie, drunk and enraged, grabbed her red down jacket and charged out of the stateroom to the back of the boat, with R. J. right behind her.

I believe that the loud, violent fight continued on the back of the boat, during which she started yelling for help and R. J. delivered a blow to the left side of Natalie's face that knocked her unconscious.

I believe that, suddenly panic-stricken when he realized what he'd done, R. J. made the fatal decision to put Natalie in the water to avoid being held responsible for what had happened.

I believe that he sent Dennis to search the *Splendour* for a supposedly missing Natalie to give himself time to untie the dinghy and put it in the water beside her.

I believe that everything he did afterward, from insisting that no searchlights be turned on, to delaying calls for help with glasses of scotch, to diverting searches from the ocean to the mainland, to coaching Dennis and Christopher on what to tell the authorities, was all about covering up the fact that, in a drunken, jealous, rage-filled moment, he'd ended the life of Natalie Wood.

I'M ENOUGH OF A REALIST TO KNOW THAT WHAT I BELIEVE DOESN'T REALLY MATTER, and to know how unlikely it is that, despite the years of hard work by a lot of good, determined people, this case will ever make its way to a courtroom. There's no "smoking gun" here, and there never will be. It would take a district attorney who believes in the potential success of a strong circumstantial case while the few remaining material witnesses are still alive. And it's not my dream to see R. J. prosecuted anyway. I would just like him to be interrogated,

finally, under oath to see where it leads . . . or, better yet, for him to stop refusing to talk to the investigators, stand up, and own the truth, whatever it is, of how Natalie ended up drowning in that dark, cold water forty years ago.

I'm also well aware that I've been portrayed over and over again as the "crazy aunt" who should just let it go after all this time has passed.

I wish I could.

It's not "closure" I'm after. That word is such an overused cliché I'm not sure I think there even is such a thing. But there's no healing, or peace, or justice in unanswered questions.

There's no forgiveness when there's no accountability.

I'm seventy-five years old. Since I was thirty-five I've been without my sister, my best friend, my confidant, my protector, my compass, my greatest source of laughter and pride and playfulness, the one person who shared a wealth of memories that were only hers and mine, who made me feel safe and valued. When I was with her, I was home. I belonged.

And then one day, with no warning and no chance to say goodbye, she was gone. I won't apologize for doing everything I can, in my sadly limited power, to try to find out why.

For myself, but most of all, for Natalie.

I'VE BEEN LIVING FOR FORTY YEARS NOW WITH THE HEAVINESS OF PICTURING EVERY second of my sister's life, her terror, her anger, her struggle to stay alive . . . and the final, ultimate betrayal by the person she trusted with her most intimate moments; the person with whom she shared her heart, her home, a beloved daughter, and a lifetime of unforgettable accomplishments; the person I believe caused her greatest, most terrifying nightmare, drowning in dark water, to come true.

It's Natalie's life, taken away so much sooner than it should have been, that weighs on my heart and always will.

Hers is a story that should have ended in joy, when the truth is, it actually has no ending at all. Like so many other "enduring mysteries," it will be talked about, speculated about, written about, and replayed dozens of times to come.

After all, it's Hollywood.

ACKNOWLEDGMENTS

This book would not even exist if it weren't for the help, friendship, and skill of Lindsay Harrison. You . . . are the tops! Funny, too!

It also wouldn't exist without Catherine Falk, who got the ball rolling by introducing me to publicist Roger Neal; my literary agent Jennifer De Chiara; writer Caroline St. Clair; and the HarperCollins publishing team, led by the unflappable, persistent and brilliant Lisa Sharkey, Anna Montague, and Trina Hunn.

My heartfelt thanks go out to them, and to so many others . . .

Detective Ralph Hernandez, retired detective Kevin Lowe, and the late lieutenant John Corina, all of the Los Angeles County Sheriff's Department, for their tenacious, skillful, compassionate investigation into my sister's death . . .

Dennis Davern, Marti Rulli, and Suzanne Finstad, for all the obvious reasons . . .

Former bodyguard and retired detective "Frank," my police and autopsy report "interpreter" . . .

My dear friends I was unable to tell about my decision to write

a book. Phyllis Cupparo, the tireless Italian. Patricia Lang, my spiritual leader. Dr. Norman Worsley, whose invaluable friendship has never included the words, "It's past my bedtime," or, "Can I talk to you later?" My generous, loving, supportive "first responder" Phebe Moore. My dear longtime friend Sherry Castillero, to whom I'll always be so grateful. Jill Alexander McBride, a great friend since elementary school. Everyone at the John Wayne Museum, my perpetual costar Darby Hinton and our pal Dan Haggerty, who always made me laugh. Cheryl McSweeny, such a loyal friend to my daughter and me. My trusted friend Sheryl McCollum, founder of the Cold Case Investigative Research Institute. John Balph, and my buddy Brian Downes and his beautiful daughter and cat. My family's patent, generous hosts Denny Marquez and Ralph Meyers. The epitome of "there when I needed him," Alan Feinstein . . .

My brilliant, clever daughter, Evan, gone too soon. I'll love you and grieve you forever and pray you're with Natalie.

My darling grandchildren, Nick, Daphne, and Max. The joys and tears we share are too many to enumerate. Just know I couldn't live without you all . . .

Bean, the silliest stray ever, precious and loyal to a fault, and all my other fur babies, even though they put me second on their lists . . .

My son-in-law Eddie Maldonado, who's really put up with a lot, sometimes handling it well, other times . . . eh . . . But he's never abandoned me. We're all so flawed, but in the end, that's what makes us who we are . . . even though I occasionally wish I were Carol O'Connell . . . Donna Tartt . . . Stieg Larsson . . . never mind, the list is too long . . .

And to Natalie, from your proud sister. Rest in peace. I'll never forget.

FILMOGRAPHY OF
NATALIE WOOD

The Moon Is Down (film) 1943

Happy Land (film) 1943

Tomorrow Is Forever (film) 1946

The Bride Wore Boots (film) 1946

The Ghost and Mrs. Muir (film) 1947

Miracle on 34th Street (film) 1947

Driftwood (film) 1947

Scudda Hoo! Scudda Hay! (film) 1948

Chicken Every Sunday (film) 1949

The Green Promise (film) 1949

Father Was a Fullback (film) 1949

No Sad Songs for Me (film) 1950

Our Very Own (film) 1950

Never a Dull Moment (film) 1950

The Jackpot (film) 1950

Dear Brat (film) 1951

Kraft Theatre (TV series) 1951

The Blue Veil (film) 1951

Chevron Theatre (TV series) 1952

The Schaefer Century Theater (TV series) 1952

The Rose Bowl Story (film) 1952

Just for You (film) 1952

The Star (film) 1952

The Pride of the Family (TV series) 1953–1954

The Pepsi-Cola Playhouse (TV series) 1954

Public Defender (TV series) 1954

The Reluctant Redeemer (TV movie) 1954

The Silver Chalice (film) 1954

Mayor of the Town (TV series) 1954

Four Star Playhouse (TV series) 1955

The Ford Television Theatre (TV series) 1955

One Desire (film) 1955

Max Liebman Spectaculars (TV series) 1955

Rebel Without a Cause (film) 1955

General Electric Theater (TV series) 1954–1955

Studio One in Hollywood (TV series) 1955

Camera Three (TV series) 1955

Kings Row (TV series) 1955-1956

The Searchers (film) 1956

Warner Brothers Presents (TV series) 1956

A Cry in the Night (film) 1956

The Burning Hills (film) 1956

The Kaiser Aluminum Hour (TV series) 1956

The Girl He Left Behind (film) 1956

Conflict (TV series) 1957

Studio 57 (TV series) 1954–1957

Bombers B-52 (film) 1957

Marjorie Morningstar (film) 1958

Kings Go Forth (film) 1958

Cash McCall (film) 1960

All the Fine Young Cannibals (film) 1960

Splendor in the Grass (film) 1961

West Side Story (film) 1961

Gypsy (film) 1962

Love with the Proper Stranger (film) 1963

Sex and the Single Girl (film) 1964

The Great Race (film) 1965

Inside Daisy Clover (film) 1965

This Property Is Condemned (film) 1966

Penelope (film) 1966

Bob & Carol & Ted & Alice (film) 1969

The Candidate (film) 1972

The Affair (TV movie) 1973

Peeper (film) 1975

Cat on a Hot Tin Roof (TV movie) 1976

Switch (TV series) 1975–1978

From Here to Eternity (TV miniseries) 1979

The Cracker Factory (TV movie) 1979

Hart to Hart (TV movie) 1979

Meteor (film) 1979

The Last Married Couple in America (film) 1980

The Memory of Eva Ryker (TV movie) 1980

Willie & Phil (film) 1980

Brainstorm (film) 1983

FILMOGRAPHY OF
LANA WOOD

The Searchers (film) 1956

Playhouse 90 (TV series) 1957

Goodyear Theatre (TV series) 1958

Alcoa Theatre (TV series) 1958

Have Gun—Will Travel (TV series) 1958

Marjorie Morningstar (film) 1958

The Real McCoys (TV series) 1958

Five Finger Exercise (film) 1962

Dr. Kildare (TV series) 1964

Wendy and Me (TV series) 1964

The Fugitive (TV series) 1964

Violent Journey (film) 1965

The Girls on the Beach (film) 1965

The Long, Hot Summer (TV series) 1965–1966

Bonanza (TV series) 1967

Peyton Place (TV series) 1966-1968

For Singles Only (film) 1968

The Felony Squad (TV series) 1969

My Friend Tony (TV series) 1969

The Wild Wild West (TV series) 1967–1969

Rowan & Martin's Laugh-In (TV series) 1969

Scream Free! (film) 1969

Black Water Gold (TV movie) 1970

The Over-the-Hill Gang Rides Again (TV movie) 1970

Marcus Welby, M.D. (TV series) 1971

O'Hara, U.S. Treasury (TV series) 1971

Monty Nash (TV series) 1971

Diamonds Are Forever (film) 1971

Justin Morgan Had a Horse (film) 1972

The Magical World of Disney (TV series) 1972

Night Gallery (TV series) 1972

A Place Called Today (film) 1972

Mission: Impossible (TV series) 1972

QB VII (TV miniseries) 1974

Goodnight Jackie (film) 1974

Who Is the Black Dahlia (TV movie) 1975

Sons of Sassoun (film) 1975

Baretta (TV series) 1976

Nightmare in Badham County (TV movie) 1976

Little Ladies of the Night (TV movie) 1977

Corey: For the People (TV movie) 1977

Speedtrap (film) 1977

Grayeagle (film) 1977

A Question of Guilt (TV movie) 1978

Police Story (TV series) 1974-1978

Fantasy Island (TV series) 1978

The Next Step Beyond (TV series) 1978

David Cassidy—Man Undercover (TV series) 1979

Starsky and Hutch (TV series) 1976-1979

Big Shamus, Little Shamus (TV series) 1979

Captain America II: Death Too Soon (TV movie) 1979

Nero Wolfe (TV series) 1981

Capitol (TV series) 1982

Satan's Mistress (film) 1982

The Fall Guy (TV series) 1984

The New Mike Hammer (TV series) 1985

Divas of Novella (TV movie) 2008

Tales from Dark Fall (TV series) 2009

The Book of Ruth: Journey of Faith (Video) 2009

War of Heaven (short) 2010

Deadly Renovations (film) 2010

Last Wish (short) 2010

Donors (film) 2014

Bestseller (film) 2015

Killing Poe (film) 2016

Subconscious Reality (film) 2016

Wild Faith (film) 2018

The Marshal (film) 2019

The Executive (film) filming

ABOUT THE AUTHOR

Actress/producer Lana Wood is the only sibling of iconic movie star Natalie Wood, whose tragic drowning on Thanksgiving weekend of 1981 remains one of Hollywood's most legendary mysteries and a seismic event in her sister's life.

Lana made her acting debut at the age of seven, when she played the niece of John Wayne in his classic John Ford Western *The Searchers*. She went on to achieve a career that includes approximately a hundred television and film appearances, including the costarring role of Plenty O'Toole opposite Sean Connery in the James Bond film *Diamonds Are Forever*.

Lana Wood lives in Southern California with her late daughter's widower and her three grandchildren, Nicholas, Daphne, and Max.